POLAROID MANIPULATIONS

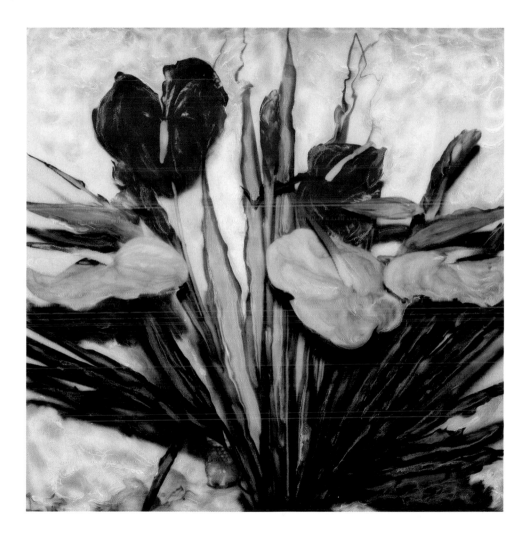

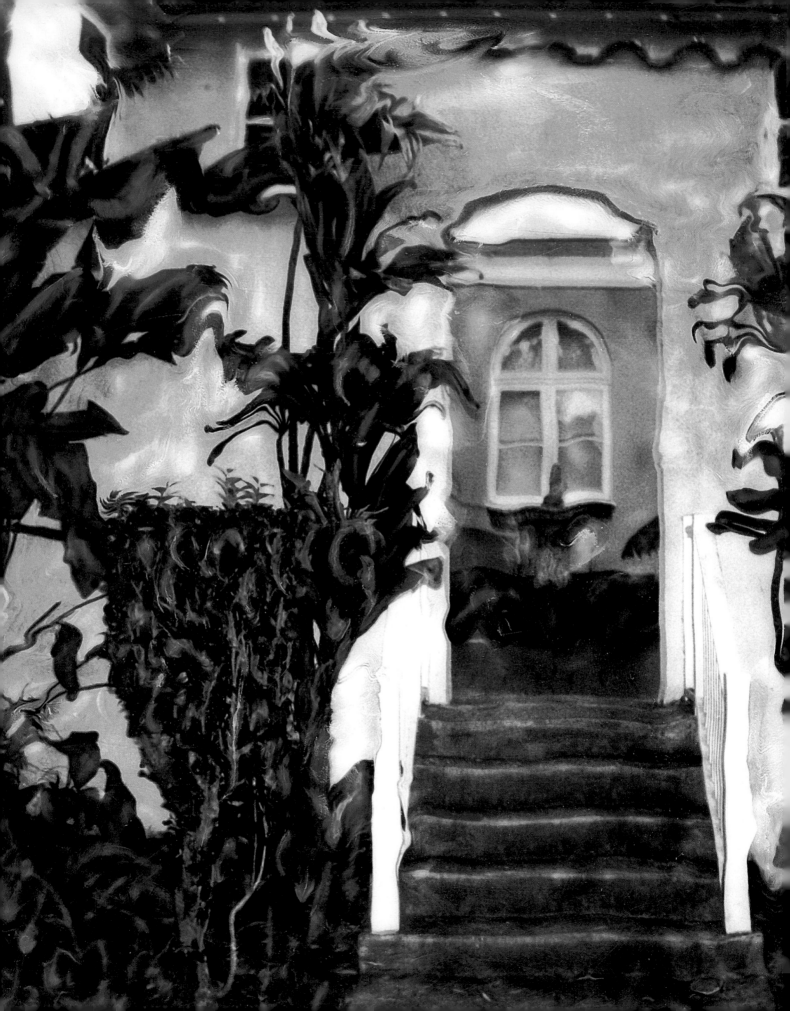

POLAROID MANIPULATIONS

A COMPLETE VISUAL GUIDE TO CREATING SX-70, TRANSFER, AND DIGITAL PRINTS

Kathleen Thormod Carr

AMPHOTO BOOKS

AN IMPRINT OF WATSON-GUPTILL PUBLICATIONS ■ NEW YORK

To my loving partner, Phil Monette

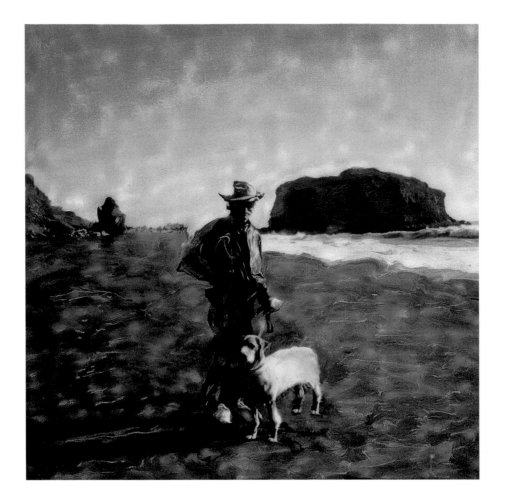

Page 1: *Tropical Bouquet* (2000); page 2: *Courtyard, Hawaii* (1999);
page 4: *Goat Rock Afternoon* (1998); page 6: *Boat, Belize* (1998); page 9:
Medieval Village (2001); page 10: *Sensación Sin Equal* (1999); page 72:
Gondola Sunset (2001); page 120: *Waterlily, Thailand* (1999); page 154:
Arc de Triomphe, Paris (Michael Going, 1990). (All images are SX-70
manipulations except for *Gondola Sunset*, which is an image transfer.)

Senior Editor: Victoria Craven
Project Editor: Alisa Palazzo
Designer: Barbara Balch
Production Manager: Ellen Greene

First published in New York in 2002 by
Amphoto Books, an imprint of Watson-Guptill Publications,
a division of VNU Business Media, Inc.
770 Broadway, New York, NY 10003
www.watsonguptill.com

All images are by the author unless otherwise noted.

Library of Congress Cataloging-in-Publication Data
Carr, Kathleen Thormod.
 Polaroid Manipulations : a complete visual guide to cre-
ating SX-70, transfer, and digital prints / Kathleen Thormod Carr.
 p. cm.
Includes bibliographical references and index.
 ISBN 0-8174-5555-8 (paperback)
 1. Instant photography—Handbooks, manuals, etc. 2. Polaroid
transfers—Handbooks, manuals, etc. 3. Photography, Artistic—
Handbooks, manuals, etc. I. Title.
 TR269 .C37 2002
 771'.4—dc21
 2001007877

Manufactured in Malaysia

Acknowledgments

I am very grateful to the many people who have been helpful in writing this book. First, I would like to acknowledge and express my deep appreciation for Rich DeFerrari—my Polaroid technical guru—who worked at Polaroid for twenty-four years. Any time I had a question, if he didn't know the answer (which he usually did), he would find out for me. He also photographed the early SX-70 Sonar prototype and the gold-plated model from Steve Swinhart's extensive Polaroid collection, and he asked Steve to loan me some books that I wasn't able to find for my research. Thank you, Steve.

I would also like to thank Steve Pfaff at Daylab Corporation for providing the Daylab units to use and photograph, and for reviewing the Daylab information. For helping to bring me up to speed on the digital options and for reading the digital chapters to make sure the information was correct and understandable, much appreciation goes to Darren Briggs and Pete Carucci at Skylark Images; Bob Cornelis and Rick Miller at Color Folio; and artists Theresa Airey, Wendell Minshew, and Joanne Warfield.

Many thanks go to Bob Stender who worked with me in his studio on the lighting and setup for the product photography and the step-by-step procedures. Barbara Elliott, one of my students whose life was transformed after getting in touch with her creativity, has been very helpful as the "hands" in the step-by-step procedures, and in assisting me with scanning and cataloging the images. I also want to acknowledge my Polaroid "smooshing" sister, Joan Emm, for suggesting that this book be written and for her encouragement and recommendations.

Margaret Pearson Pinkham kept the artist and supplier files, resources, and communications—as well as my office—in order during the days of seemingly endless writing. Sally Tomlinson, Rich DeFerrari, Qalbi, and my partner Phil Monette helped in clarifying the manuscript. Sally's encouragment during the writing process and her final preliminary edit were invaluable. Phil also loaned me some cameras from his collection for the photographs and helped keep the computer running efficiently. I appreciate his patience and caring during the process of writing this book.

The Pace Wildenstein Gallery in New York provided the Lucas Samaras photo-transformation image (page 15). Diana Lee, an accomplished artist, created the color wheel (page 37) and drawings of the SX-70 camera and film layers (pages 13 and 47). Thanks also go to Marty Kuhn and George Holderied for granting me permission to use information about Polaroid SX-70 and 600 series cameras and accessories from their websites.

Many manufacturers and suppliers offered information and materials for evaluation. I would especially like to thank Epson America, Inc., for providing a 1680 scanner and 2000P printer for evaluation, along with the following companies: Ampersand Art Supply (clay board); AutoFX Software; A.W. Brandess-Kalt Aetna Group, Inc. (Marshall's paints); Bookmakers International; Brightcube; Canson, Inc. (Canson papers and Rembrandt pastels); Caran d'Ache; CIS Continuous Inking Systems; Colorblind; Cress Photo; Daniel Smith Artist Materials and Supplies; DecoArt; Design A Card/Art Deckle; Fiskars; Fuji Photo Film, USA, Inc.; Graphik Dimensions Ltd. (picture frames); Griffin Mfg. Co. Inc. (burnishers and cutting tools); Hunt Corporation (Conté pencils and crayons); Rupert, Gibbon & Spyder, Inc. (Pearl-Ex); Legion Paper; Lineco (archival supplies); Loew-Cornell, Inc. (ceramic tools and burnishers); Master-piece Artist Canvas, Inc.; Nielson Bainbridge; Polaroid Corporation; Preservation Technologies (Archival Mist); Pro Tapes & Specialties; Rosco Laboratories (lighting materials); Savoir-Faire (Sennelier, Fabriano, Cretacolor); Speedball Art Products Co.; Verilux, Inc; and Wacom Technology Corporation.

And lastly, I'd like to acknowledge Amphoto senior editor Victoria Craven, for her support and unwavering enthusiasm about this book, and Alisa Palazzo, for her excellent editing and for being such a joy to work with.

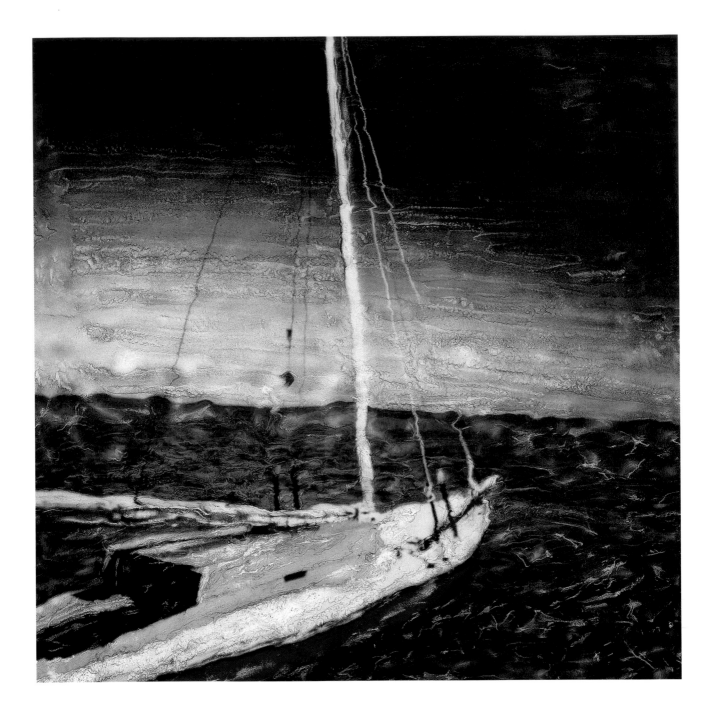

CONTENTS

INTRODUCTION

The urge to create—to use our minds, hearts, and hands in unison,
to work with materials, to express ourselves and our observations,
our deepest longings, our greatest aspirations, our joys, our sorrows—
is one of the most basic of human impulses.
—DAVID ULRICH, The Widening Stream: The Seven Stages of Creativity

The creative process has fascinated me for years. Every time I create a new piece of art that I like, or teach a workshop and see a participant light up with excitement after having made a Polaroid transfer or SX-70 manipulation, I realize how important having some form of creative outlet is to the human psyche. Making art can be essential for our well-being, if not our sanity, especially in times of stress or chaos around us. I always feel much more joyful and able to handle the rest of my life if I make the time to do photography.

One of the things I love about working with Polaroid films is the immediacy of results—that, and the fact that it doesn't require a lot of expensive darkroom equipment. The setup is quick, and I can have a piece of art in minutes. As with other arts-and-crafts techniques, practice makes perfect. However, with Polaroid films the simplicity of technique, the element of surprise, the happy accident that can happen at any point, and the nature of the process itself allow beginners as well as "experts" to create masterpieces right away. Some of my first attempts with Polaroid transfers and SX-70 manipulations are still my favorites. This is why I teach workshops and write books—to inspire people to get in touch with their creativity through easy and fun techniques that also have enough substance to provide ongoing creative opportunities for the serious artist and photographer.

This book has come into being because of the need for a thorough, well-illustrated how-to book on SX-70 manipulation. With the success of my last book, *Polaroid Transfers: A Complete Visual Guide to Creating Image and Emulsion Transfers* (Amphoto Books, 1997), which filled the need for a book on creating image and emulsion transfers, I was asked to write a companion volume. So, this book is a complete visual guide to creating SX-70 manipulations. In addition to the fascinating history, illustrated step-by-step procedures, creative techniques, and handcoloring of SX-70 manipulations covered in part I, I wanted to include additional information I've learned about Polaroid transfers since writing my previous book. Current equipment, more creative techniques, and advanced step-by-step procedures are detailed in part II.

With the digital revolution upon us, I also felt it was important to devote a section of the book to making digital prints of your Polaroid art. It has been the next step for me in working with Polaroid materials, because I wanted to create larger, limited-edition prints of my transfers and SX-70 manipulations that would also last longer than the dye found in color photographs. In the last few years, the opportunities and choices for creating digital prints that can last over fifty years have grown exponentially. Learning enough to proceed can be a bit daunting, so in part III I've simplified the process and presented a straightforward path to getting started in this exciting new digital field. You'll learn key information about scanning your Polaroid art; working with Adobe Photoshop; and choosing a printer, inks, and media, or finding a digital studio that will print your artwork for you.

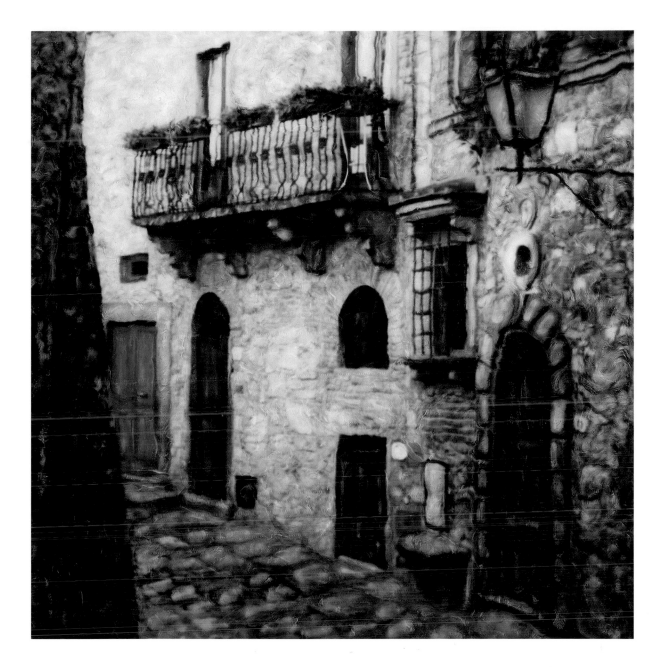

The Gallery section in part IV showcases the inspiring work of twenty acclaimed Polaroid artists, with statements from each about their work. Explore their various styles, subject matter, and creative approaches to SX-70 manipulations, image and emulsion transfers, and digital enhancements—from use of the 20x24 camera for transfers to wet negative scanning to alternative surfaces and more. My hope is that your imagination will be stimulated by what you find in the gallery and in the examples of creative techniques throughout the book.

Working creatively with Polaroid materials is exciting and rewarding for beginners as well as for professional photographers and artists. Each one of you will develop a style and method that is uniquely yours, and the best part of it is that there's no one "correct" method for working with Polaroid films. Most of the processes that have been developed with Polaroid materials were discovered by accident, or by deliberately breaking the rules to see what would happen. I encourage you to explore your creativity with these Polaroid techniques, and enjoy the process.

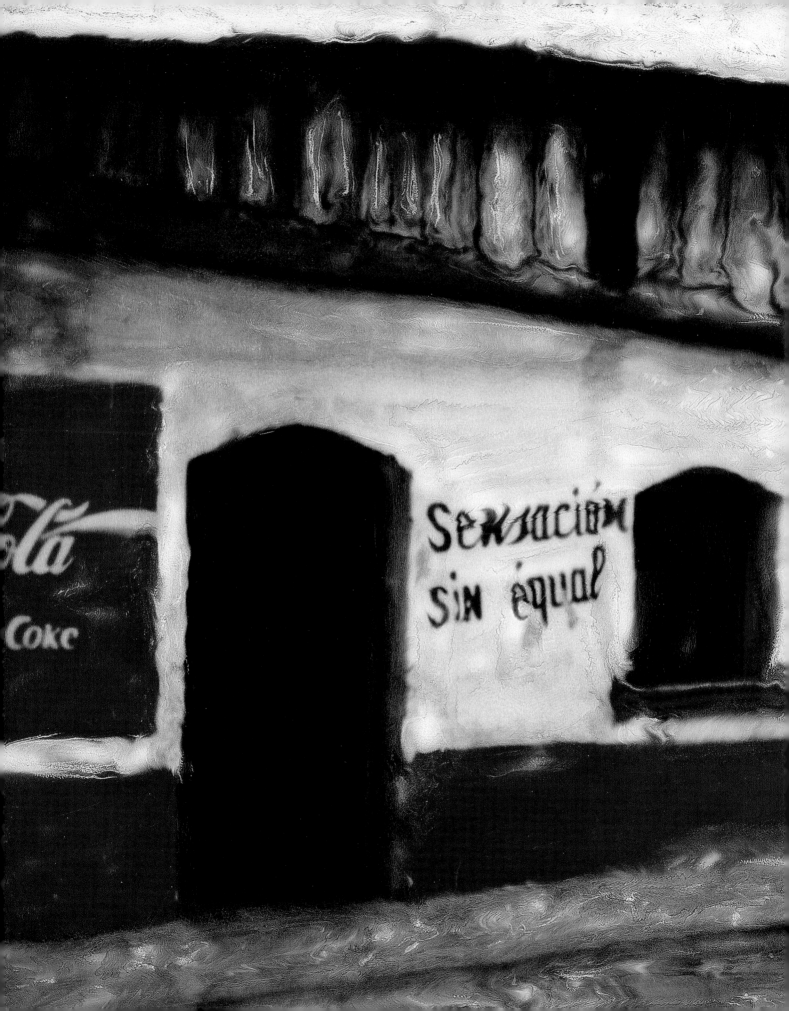

SX-70 MANIPULATION

SX-70 manipulations have been called many things, from painterly photography (see Elizabeth Murray's book by the same name), photo impressionism, Polaroid etchings, pola-painting, and altered Polaroids to Lucas Samaras' photo transformations and more.

I fell in love with the look of the SX-70 manipulated print long before I ever tried the technique. In 1991, I had just learned to create Polaroid image transfers when I saw Thia Konig's image *Radical Changes in Moscow.* It appears to be a Russian cathedral, but with a palm tree, and it captivated me. (The photo was actually taken at a miniature golf course in California.) At that time I was completely involved with transfers, and then began teaching workshops and writing the book *Polaroid Transfers.* I had to put my fascination with SX-70 manipulation on the back burner until a few years ago, and I've been working with SX-70 prints almost exclusively since 1998. I'm hooked. I find it so enjoyable, creative, and fun—like a breath of fresh air—and very simple to do. Every time I think I've seen it all in terms of what can be done with SX-70 manipulation techniques, my students amaze me. When combined with digital techniques in Photoshop, the sky is really the limit.

I still like some of my earliest work the best—before I had gained more control of the result and settled into a more conservative style of manipulating. I also have noticed that when my students are learning the technique, they are more open to trying different approaches. Sometimes the results are incredible. I encourage you to stay in "beginner's mind" as long as possible and not limit your creative options too soon. Leave the critic behind, because the worst that can happen is that you'll make a print you don't like. Experiment, and remember to have fun!

History of the SX-70 Camera and Film

The introduction of the SX-70 camera and film in 1972 was the fulfillment of Dr. Edwin Land's original vision of instant photography, which he conceived in 1943. He and his three-year-old daughter had been for a walk and taken some photographs when she innocently asked why they couldn't see the pictures right away. He wondered why he hadn't thought to ask that same question. Being the genius that he was (with over 500 patents and numerous inventions), within two hours he had a plan worked out for developing an instant camera and self-developing film. It took thirty years and many cameras along the way to create his dream.

The SX-70 camera revolutionized instant photography. Gone were the throwaway negatives and developer pods generated by the Polaroid peel-apart films. The positive, negative, and chemicals were all part of the print—an "integral" film. Land's original instructions to his engineers were few: compact, integral, single lens reflex, garbage free.

The SX-70 camera was named for a military code designation used in the early days of Polaroid's

This wood prototype of the SX-70 camera (circa 1970) was probably carved in the Polaroid model shop, where wood models were made to the camera specifications before production.

PHOTO © POLAROID CORPORATION

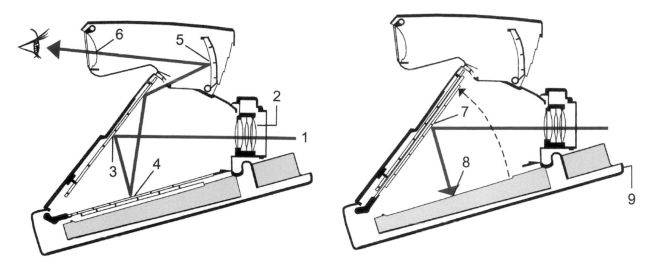

The left-hand diagram shows the path of the light as it enters the camera lens and how, through an arrangement of mirrors and aspheric optics, it reaches the eye. The right-hand diagram shows that when the shutter button is pressed to make an exposure, the shutter closes and the motor moves the viewing mirror up against the back of the camera, revealing a "taking mirror" on its reverse side. The shutter opens and takes the picture, and the light is reflected to the film. DIAGRAMS © 2002 DIANA LEE

development work that led to the one-step camera system. Dr. Land and his team had to completely reinvent the concepts of camera and film. He wanted the camera to fit into a shirt pocket. The story goes that overnight the lab was filled with shirts with pockets of all sizes. So, the external dimensions by which the engineers had to abide for designing the camera were actually determined by Land's tailor! A myriad of seemingly irreconcilable technical requirements had to be resolved for this camera, and the film is nothing short of miraculous. Reading *The Polaroid Story* by Mark Olshaker and *Land's Polaroid* by Peter C. Wensberg has given me such respect for the dedication and technology needed to create the SX-70 camera.

The first model was a stylish brown leather and plastic chrome design. Sir Laurence Olivier presented the SX-70 camera to the public in a television commercial (the first commercial he ever consented to do). Candace Bergen, James Garner, and Mariette Hartley also did commercials to promote the camera. Industrial film producer Charles Eames made a 20-minute film on the SX-70 camera's scientific and humanistic uses. *LIFE* magazine featured Land taking pictures of children on the cover of its

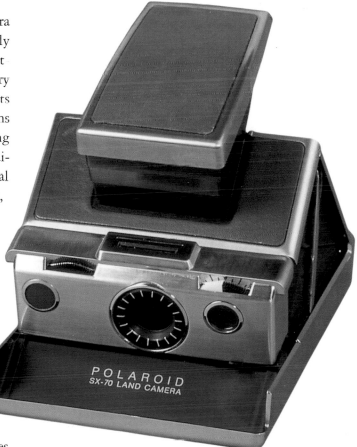

The original SX-70 model, introduced in 1972, was a revolutionary design for a folding single-lens-reflex (SLR) camera that would fit into a pocket. It was made with real leather.

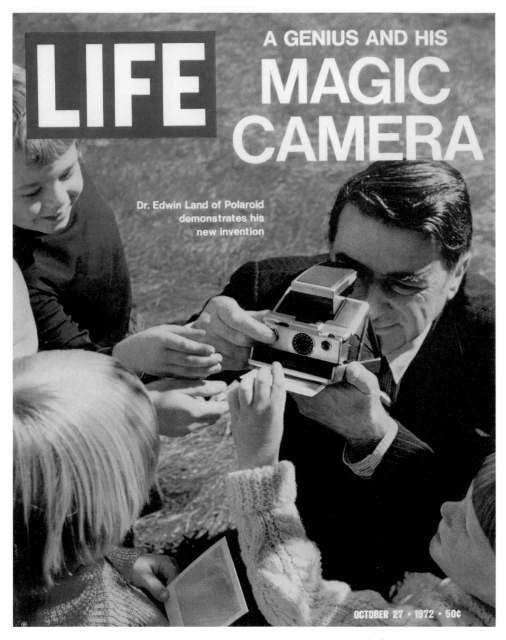

Dr. Edwin Land on the cover of LIFE *magazine (October 27, 1972) with the new SX-70 camera.*
PHOTO © RENTMEESTER/TIME PIX

October 27, 1972, issue. Well-known photographers Walker Evans and Ansel Adams incorporated SX-70 images into their work. Evans, noted for his dignified black-and-white images of everyday people and objects, told a group at Yale in 1974, "I'm feeling wildly with [the SX-70 camera]. A few years ago I would have said that color is vulgar . . . and now I intend to come out with it seriously. You photograph things that you wouldn't think of photographing before. I don't even know why, but I find that I'm quite rejuvenated by it." Ansel Adams served as a consultant to Land and Polaroid from 1948 until his death in 1984. He personally tested every new camera and film type, and trained many of the company's photographers; he called the SX-70 camera system "an absolute miracle." Other well-known photographers and artists, such as André Kertész, Andy Warhol, David Hockney, Mary Ellen Mark, Duane Michals, Robert Heinecken, Ralph Gibson, and Jim Alinder, also worked with the SX-70 camera.

The Development of the Manipulation Process

One unplanned feature of SX-70 film opened up an unexpected avenue of creativity. The film emulsion didn't harden quickly—in fact, it was still soft and pliable for around five days after the film was exposed. As a result, the image could be distorted by pushing the soft emulsion around with various tools. Several stories have circulated about how this was first discovered. One involves a golfer who put an SX-70 print in his golf bag while playing, and a tee pressed into the print and changed it. When the golfer pulled out the print and saw what had happened, he used the golf tee to continue altering the print. Then there's the standard story about someone who put a print in his pocket next to a pen, resulting in the pen altering the print, but there's no agreement on the actual discovery. After Polaroid's customer service received numerous calls, Dr. Land saw this flaw as a defect and set about to fix it. Meanwhile, artists and photographers such as Lucas Samaras, John Reuter, Les Krims, Norman Locks, and Michael Going began experimenting to see what could be done with this unique emulsion, much to Land's chagrin.

After Lucas Samaras was given an SX-70 camera, he pioneered several styles of manipulating the film with his "Photo Transformation" series from 1973 through the later '70s. Using himself as the subject, he pushed around the emulsion of his self-portraits in a wavy style, or scratched much of the image with various tools, leaving a small section untouched for a hand, mouth, or eye to contrast with the manipulated areas in some fashion (see above). He also utilized colored gels during exposure and heated the film before its exposure to alter the colors during development.

John Reuter approached SX-70 manipulation in a completely different way. Although influenced by Samaras, he was drawn to juxtaposing photographic realities with those of painting, drawing,

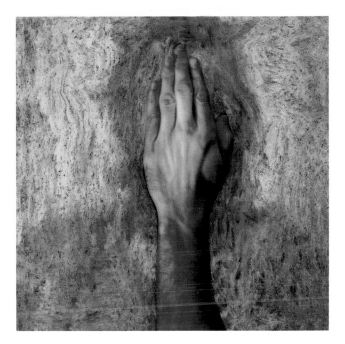

LUCAS SAMARAS.
PHOTO TRANSFORMATION DEC. 17, 1973
Lucas Samaras pioneered new photographic techniques by manipulating the emulsion of the SX-70 print. COURTESY PACE WILDENSTEIN GALLERY, NEW YORK, PHOTO ELLEN PAGE WILSON

and montage. In 1975, he learned of the collage stripping technique from Rick Valicenti, a graduate colleague at the University of Iowa. By cutting apart the SX-70 print and peeling away the backing, he was able to cut around the image outlines he wanted to keep and pull away the emulsion of the undesired elements, leaving clear Mylar in those areas. He then collaged these areas with other images or painted the images in from behind. Another SX-70 film technique Reuter discovered, but never named, was similar to the current emulsion transfer process (also called emulsion lifts), used now with Polacolor peel-apart films. (For more information about Reuter's early SX-70 work, see pages 184–185.)

As he explains: "I cut the edges off the SX-70 print and put it in hot (not very) water, used a cotton

JOHN REUTER. IN SEARCH OF DADAMAX. 1978
This example of artist John Reuter's technique is an SX-70 manipulation collage that Reuter made by separating the SX-70 print, scraping away parts of the image, collaging and painting with acrylic paint from the back, and then reassembling the print.

ball to rub off the titanium dioxide and then placed the emulsion on watercolor paper and rubbed the polyester surface until the image transferred to the paper. I then either sliced it with a knife to shape it or moved it with a paintbrush. I would use an empty SX-70 frame, coat the emulsion with acrylic gel medium, and pick up the emulsion into the blank frame. Once [it was] dry, I would back-paint the image with white paint to restore opacity, and paint in the rest of the image frame or collage into it." When Polaroid changed the SX-70 film structure in 1979 and renamed it Time Zero film, the ability to peel away the transparent and flexible emulsion was lost.

Norman Locks often photographed family, friends, and household objects with his SX-70 camera, and preferred to wait until the second or third day before manipulating his prints. By then, the emulsion had hardened enough for him to outline his subjects with lines he drew with a dental tool or stylus, scratching backgrounds and adding abstract patterns. Try to find his out-of-print book *Familiar Subjects* (Headlands Press, 1978). Michael Going was the first photographer to successfully take SX-70

manipulation into the commercial realm, with assignments from the Princess Cruise line, Hyatt Resorts, *Sports Illustrated,* and *Time,* among others (see pages 168–169 for more on Going).

One interesting early SX-70 story involving Ansel Adams was told to me by Rich DeFerrari, my Polaroid information guru. In the early '70s, Adams was working for Polaroid, shooting the early 8x10 film. Ed Gaffey, a Polaroid applications specialist, would go out and stay with Adams for a couple of weeks and do all of his processing. While Gaffey was working on early 8x10 film, someone dropped by to show Adams his portfolio. (Many photographers would do this.) There was a manipulated SX-70 print in the portfolio, and the photographer showed it to Adams, saying that it had hardened overnight and asking if Adams knew what to do to get it soft again. Privately, Adams asked Gaffey, who said he had heard that possibly heating it would work. Adams put the print in his Radar Range (an early microwave). This was not a good idea, since SX-70 prints are made with metallized dyes wrapped with foil. Sparks flew, edges were scorched, a horrible smell arose. But, the emulsion softened and the photographer was able to further manipulate the print, to both Adams' and Gaffey's amazement!

In 1979, *SX-70 Art,* a wonderful collection of SX-70 photography edited by Ralph Gibson, was published by Lustrum Press. It included such photographic luminaries as Walker Evans, Mary Ellen Mark, Duane Michals, and John Reuter, as well as André Kertész, Andy Warhol, and Lucas Samaras. Isaac Asimov wrote the preface, and in the introduction, Max Kozloff states about SX-70 images, "They not only present, they affirm the dreamlike space, the abrupt contrasts, and the mute, inorganic color of the medium as special, transforming agents of reality. . . . In the end, though, whether the photographed material is allowed to be itself, or whether it is acted upon to serve various symbolic aims, we're invited to treat the results as artistic objects." In addition, Polaroid's series of books *Selections* (numbers 1-5) showcased images from the vast Polaroid Collection; many SX-70 images were featured in *Selections 1* (Verlag Photographie, 1982).

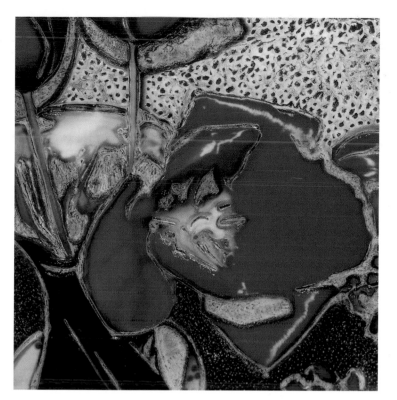

NORMAN LOCKS.
TULIPS IN VASE. 1976
Norman Locks created lines on his SX-70 prints to give an abstract look to snapshots of household subjects. By waiting one to three days before drawing on his prints, he could achieve hard scratched lines and patterns.

In 1979, Polaroid replaced SX-70 film with Time Zero film in an attempt to speed up development time (hence the name, Time Zero) and eliminate the yellow staining and cracking of the emulsion, which had become a problem. The new film was thinner and hardened more quickly, after only one or two days rather than five or more days. Polaroid continued to make more affordable models of SX-70 folding and hard plastic cameras through 1981, including the Sonar autofocus models, and then switched to 600 series cameras, designed for the faster 640 ISO films, which hardened much more rapidly. (If you are very quick, you can do a limited amount of manipulating with this film; see Joan Emm's manipulated Platinum 600 print on page 164.)

SX-70 manipulation techniques were popular in the '70s and early '80s, even though they were not condoned by Edwin Land, who still regarded this process as a reflection of a film defect. In the early '90s, there was growing interest in revitalizing many alternative photographic processes, including SX-70 manipulations and other processes using Polaroid films.

Today, secondhand SX-70 cameras abound on online auction sites and in photographic swap meets. You can even find them at thrift stores and flea markets at bargain prices. You probably have one stashed away in your closet or attic. Many of my students are delighted to realize that their fathers' old relics are actually SX-70 cameras in perfect working order.

In the Appendix, I provide a section on all the SX-70 camera models made, listing the features that distinguish them from one another. Also listed are the accessories and flash units available, and a summary of the 600 cameras that can be adapted to use the Time Zero film for manipulations (see pages 196–200). Most of the information in that section is from Marty Kuhn's The Land List website at www. landlist.org, an awesome collection of information on Polaroid cameras, accessories, and films. I hope this will help you find the equipment that best suits your needs.

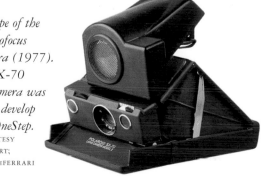

The prototype of the SX-70 autofocus model camera (1977). A 1974 SX-70 Model 2 camera was modified to develop the Sonar OneStep.
CAMERA COURTESY
STEVE SWINHART;
PHOTO RICH DEFERRARI

Exposing the Image

This chapter explores the different ways to expose an image onto Time Zero film so that you can manipulate the print. You can take a picture directly with an SX-70 camera or easily convert a 600 series camera to use Time Zero film. There is a variety of available cameras from which to choose. You can also use a Daylab slide printer to expose a 35mm slide or medium-format transparency image onto the Time Zero film, using a special Daylab base made to hold the film. If you have a darkroom and an enlarger, another way is to projection-print your slide or transparency onto the Time Zero film, and then put the film sheet into an SX-70 or 600 series camera for processing (or use the Daylab base). I'll cover these processes in more detail, with illustrated step-by-step procedures for each method.

ORCHIDS I. 2000
This image was photographed with an SX-70 camera.

Polaroid 600 Series Cameras

If you don't already have an SX-70 camera, the easiest and least expensive way to get started is to purchase a 600 series camera at a discount department store or drug store, or to find one at a thrift store or flea market. The best models (no longer made) have sonar focusing and a built-in flash. They will have the word "sonar" on them and have a round, gold sonar focusing area. Other models have a fixed-focus lens that focuses from four feet to infinity. A few models offer fixed focus with a close-up setting that allows you to get from two to four feet away. (See Appendix for information on the different camera models.) Of course, these cameras don't offer the same options available on the folding SX-70, 680, or 690 cameras, but they are simple to use.

If you decide that you want to pursue SX-70 work and be able to take SX-70 pictures more creatively, you can look for a used SX-70 camera. Until then, with a 600 series camera you'll just need to make two easy modifications in order to use the Time Zero film instead of the 600 films designed for these cameras. The 600 films aren't a good choice for manipulating as the emulsion hardens too quickly.

Modifying the 600 Camera for Time Zero Film

It's very easy to convert an inexpensive Polaroid 600 camera to accept Time Zero film for SX-70 manipulation. First, you need to cover the metal guide in the film compartment to be able to load Time Zero rather than 600 films. (The guide is a safeguard to prevent you from loading the wrong kind of film). Second, you need to put a two-stop or 0.6 neutral-density filter over the exposure meter of the camera so that it will read the 150 ISO of the Time Zero film rather than the 640 ISO of the 600 films. This same procedure can be used to modify a model 680 or 690 SX-70-style folding camera.

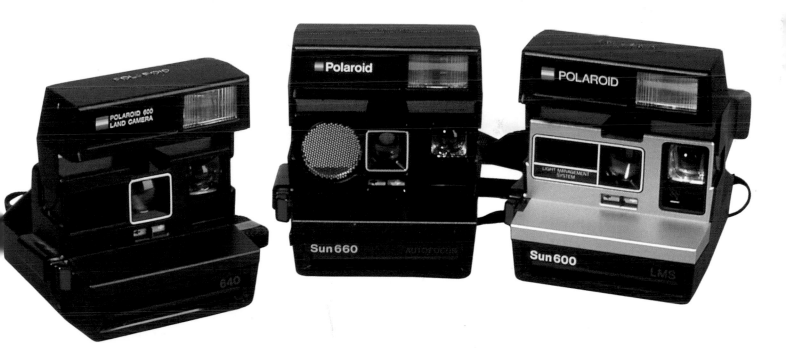

Some older model Polaroid 600 cameras: 640, Sun 660 with sonar, and Sun 600 LMS.

Modification Procedure

Supplies

600 series camera
black card from a used film pack
 (or an exposed Time Zero or
 600 print)
Time Zero film pack
2-stop (0.6) neutral-density filter
scissors
Scotch tape

Loading the Film

1. Open the film compartment of the camera by sliding the lever on the right side of the camera forward. The film drawer will drop open.

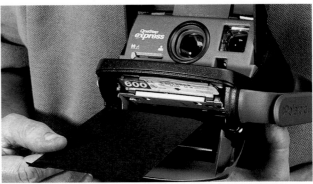

2. Take the black card from a used film pack or an exposed Time Zero or 600 film print (you can also cut a stiff piece of cardboard to the same size as the print), and insert the card or print halfway into the film compartment, covering the metal guide.

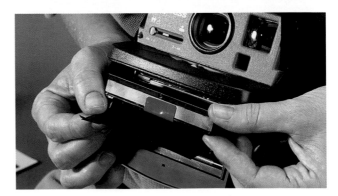

3. Start to load the Time Zero film pack into the film compartment. The black-card side of the film pack should face up, and the blue tab on the bottom should face out. As you slide the film pack over the card, remove the card or exposed print. Push the film pack in all the way until you hear a click.

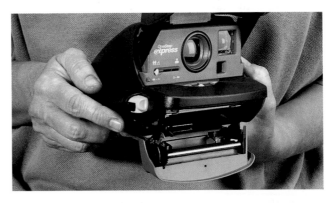

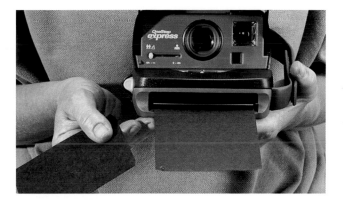

4. Close the film door, keeping your hands away from front of camera. The black card (in the film pack) that protects the film automatically ejects as you do this. The picture counter on the back of the camera will now show the number of exposures in the film pack; it will read 10. *Note:* If you remove, or partially remove, and then reinsert a partially used film pack, the counter will reset to 10, no matter how many pieces of film are actually left.

Adjusting the Camera Exposure Meter

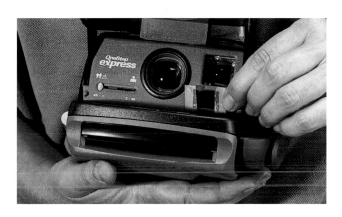

Cut a small piece of the 2-stop neutral-density filter just big enough to cover the camera's electric eye exposure meter, leaving enough room to tape it on without the tape covering the meter or lens. Tape it over the eye. You're now ready to start photographing on Time Zero film. If you plan to use only Time Zero film in your 600 camera, you can permanently remove the metal guide, so you don't have to use a card or print to load Time Zero film. Using a pair of needle nose pliers, pull out the guide. To use 600 film again, reinsert the guide.

TIPS FOR PHOTOGRAPHING WITH 600 AND SX-70 CAMERAS

Take pictures in bright light—sunlight or diffused light from an overcast sky. Even light gives best results. Avoid dappled sun, or both sun and shade in an image. If subject is too contrasty, you'll lose detail.

Move in closer than your first inclination. The viewfinder makes things look closer than they actually are. *Note:* For the hard plastic cameras, don't get closer to your subject than four feet; the camera won't focus closer than four feet unless you have a close-up setting of up to two feet. The folding 680, 690, and SX-70 models focus to 10.4 inches.

Keep the background simple, and keep your subject close to the background.

Choose subjects and scenes with large areas of strong color.

Use fill flash in daylight if possible.

Use the Lighten/Darken control to expose for your main subject if you have uneven light and can't use fill flash. Otherwise, the exposure meter will read the background rather than your subject. With dark backgrounds, set the control a mark or two toward Darken (more black showing on the control); with a bright background, set it a mark or two toward Lighten. Each mark equals one ½-stop exposure.

Make sure camera rollers are clean. Dirty rollers cause problems with prints. (See page 41 for cleaning.)

SX-70 Folding Cameras

If you already have a folding SX-70 camera, you may want to refer the Appendix to learn about the different features of your particular camera model. If you plan to buy an SX-70 camera, read this section before purchasing so that you will know what features are available and choose accordingly.

With a folding SX-70 camera, you have much more control over your image results than with an inexpensive 600 series camera. First, having a single-lens-reflex (SLR) camera means that what you see through the viewfinder is what your picture will look like. You can focus and see what is actually in focus, and the composition is much more accurate than with a non-SLR camera on which the viewfinder is separate from the lens.

The SX-70 lens is optically excellent—a four-element 116mm f/8 coated glass lens that focuses down to 10.4 inches. It was the finest lens ever designed and built by Polaroid. Shutter speeds range from 14 seconds or more to 1/175 sec. Autoflash

exposure is based on focus distance, and there are many useful accessories, including a 1.5 telephoto lens, close-up lenses, a filter holder for filters, and even a self-timer.

Later models generally have more features, such as split ring focus, distance marked on the focus ring, tripod socket, neck strap lugs, fill flash capability (beginning with the Alpha model), and sonar autofocus. Special edition cameras were more heavy duty and had a longer warranty. They have a blue shutter button rather than a red one and are usually more expensive. Note that the Model 3 is not an SLR. It has a separate viewfinder so that you can't see what's in focus. You have to guess whether your subject is in focus by setting the distance. The Model 3 is certainly better than one of the inexpensive hard plastic Time Zero cameras that were made from 1976 on, such as the Pronto!, OneStep, Button, and others. However, if you have the choice, opt for an SLR.

Using the SX-70 Folding Camera

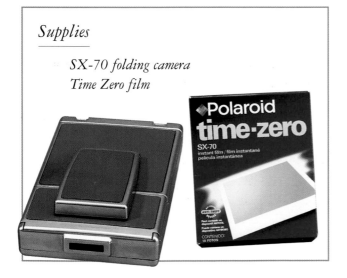

Supplies

SX-70 *folding camera*
Time Zero *film*

Opening the Camera

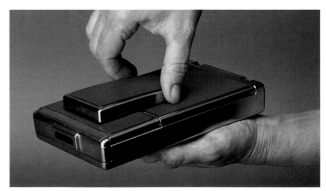

1. Hold the camera in the palm of one hand, with the viewfinder cap on top. With the other hand, grasp the small end of the viewfinder cap on the sides with the grooves.

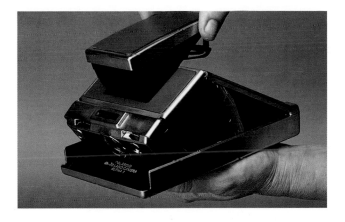

2. Pull the viewfinder cap straight up until the cover support bar on the side moves forward and locks into place. *Note:* You may also need to push the top front of the camera back to lock the support bar.

Loading the Film

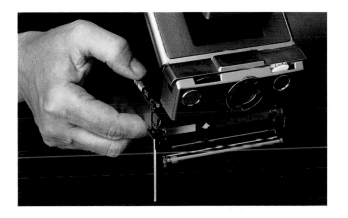

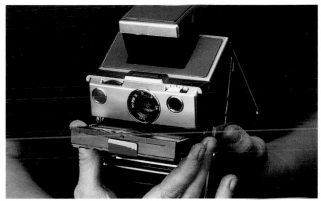

1. Push down the yellow bar with the arrow on the right side of the camera. The film door will drop open. If there's an empty film pack already in the film compartment, remove it by pulling the blue tab.

2. Holding the film pack by its edges only, load the film with the black card facing up so that the blue tab will be facing out when loaded. Slide the film all the way into the film compartment.

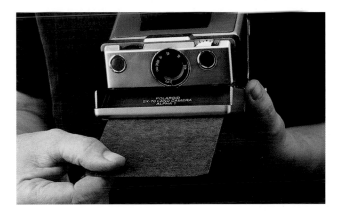

3. Close the film door, keeping your hands away from the front of film door, and the black film cover card will eject immediately. The picture counter on the back of the camera will now read 10. (As with the 600 series cameras, if you remove, or partially remove, and then reinsert the film pack, the counter will reset to 10 no matter how many pieces of film are actually left.) *Note:* The batteries are in each film pack, not in the camera.

Holding the Camera

With your left hand, hold the camera behind the hinge of the film door. Don't touch the bellows or block the picture exit slot where the picture comes out of the camera. Tuck your right thumb behind the shutter without touching the bellows. Place your right forefinger on the focus wheel, with the other fingers of that hand curling into your palm. Look through the viewfinder. If you don't see all four corners of the frame, you need to center your eye behind the eyepiece. Move your eye or the camera until you see all four corners.

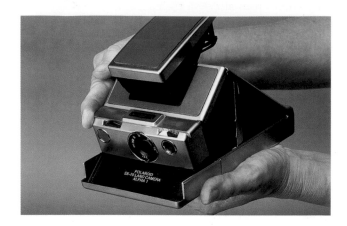

Setting the Controls

Set the Lighten/Darken control at normal, where the black/white line is straight up at the black triangle. To focus the manual cameras, or when using the manual mode of the sonar model, look through the viewfinder. Turn the focus wheel until you see the clearest and sharpest image of the most important part of your subject. The split-circle focusing aid is in the lower center of the viewfinder on all but the oldest SX-70 and the sonar camera models. It's helpful to fine-tune your focusing, especially in dim light and when using a flash. Place the split circle over a distinct vertical line in the important subject area. If the line looks broken, turn the focus

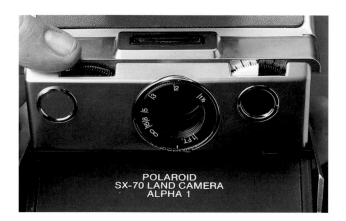

wheel back and forth until there's one continuous vertical line. The SX-70 camera focuses from 10.4 inches to infinity.

Taking the Picture

1. After focusing with the split-circle focusing aid, you may need to reframe the image to get the composition you want. Then, gently push the shutter button until the picture comes out. Make sure you're not blocking the picture from ejecting. *Note:* If you let go of the shutter button too soon, no picture will be taken.

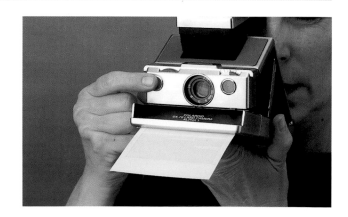

2. Remove the picture and watch it develop. The colors will get richer until development stops after anywhere from about 5 to 15 minutes. Yellow is the last color to completely develop on the film.

At temperatures lower than 60°F or higher than 85°F, the development is affected and images may be darker and bluer, or lighter and more yellow than normal.

Closing the Camera

1. To close the camera, push the support bar on the side toward the rear of the camera.

2. Press down on the viewfinder cap so that both sides of the camera close.

THE EFFECTS OF TEMPERATURE AND LIGHT ON TIME ZERO FILM

Taking Pictures in the Cold. Below 60°F, your prints may be too dark and too blue. Keep the camera and film warm in your coat until you take the picture, then put the developing picture back in your coat or warm pocket while developing. If your image is too dark and too blue, you can turn the Lighten/Darken control one or two marks toward Lighten so that more white is showing on the dial (each mark is equivalent to a ½-stop), and take another picture.

Taking Pictures in the Heat. Above 85°F, the effective light sensitivity of the film increases, and your picture may be too light and too yellow. Don't let your picture bake in the sun while it's developing. If your image is too light, you can turn the Lighten/Darken control one or two marks toward Darken so that more black is showing on the dial, and take another picture.

When to Use a Tripod. If there's blurriness or camera movement, there wasn't enough light, and the shutter speed is too slow for handholding the camera. Either put the camera on a tripod, steady it on a flat surface, or use a flash. When using a tripod, the camera can make automatic time exposures up to 14 seconds or more. For best results, use the Remote Shutter Button #112 accessory, and press the shutter button for at least one second. Or, just carefully press the shutter button.

Using the SX-70 Sonar OneStep Camera

The main difference in using the sonar version of the SX-70 camera is that you don't need to focus the camera unless you choose to use the manual override. There are several situations in which you should set the focus manually. When shooting through glass, for example, the sonar sound wave won't reach your subject and the lens will focus on the glass. This may happen when shooting through screens or bars, too. Also, when you are shooting at an angle toward glass or another flat smooth surface, the sound waves may reflect away from the camera, causing incorrect focus. Before taking a picture in these situations, lightly press the shutter button part way and hold it there. Look in the viewfinder and if the subject isn't in focus, use the manual override.

To set manual override, press the bottom of the manual focus switch. The red bar on top of the switch shows that you've disconnected the sonar focusing system. To reactivate it, press the top of the switch in or close the camera. The lens will reset for sonar focusing when closed. For manual override, instructions are the same as with the manual SX-70.

When in use, the automatic focus sonar focuses on the central part of the scene. If what you want in focus is not in that central area, you need to reframe so that what you are going to focus on is in the center of the viewfinder. Press the shutter button part way and don't let go. The camera will hold the focus of your subject while you move back to your original composition. Then, press the shutter all the way.

On the Sonar OneStep you can choose to focus manually by setting the manual focus switch so that the red bar is showing.

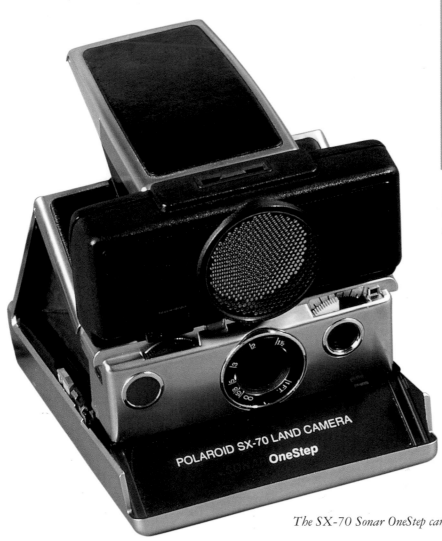

The SX-70 Sonar OneStep camera.

Using a Flash with the SX-70 Camera

You'll need a flash or tripod when the light isn't bright enough for the 150 ISO film speed—this is usually indoors, in deep shade, or approaching nightfall. The flash will cover a range from 10.4 inches to 20 feet, depending on the particular flash unit. The focus determines the brightness of the flash. However, when working up close, a diffuser and exposure correction are necessary—otherwise the print will be too light. At distances over 10 feet, the image may be too dark. If you're photographing several people, it's best to have them all at the same distance from the camera. Otherwise, depending on where you focus, those closer will be too light and those farther away will be too dark.

Try to have the background near your subject; if it's too far away, it will be dark. Also, if you aim the camera at a reflective surface—such as a mirror, glass, or a shiny wall—a reflection of the flash will appear in the picture. To avoid reflections, stand to one side and photograph your subject at an angle.

You can also use a flash in daylight as fill flash with the SX-70 Alpha or later camera models. A few earlier models were retrofitted to use fill flash as well. Best results are attained with subjects four to six feet from the camera, but you can use fill flash up to 12 feet away. Use fill flash in bright sunlight to fill in harsh facial shadows, or when your subject is backlit or in shade.

There are a variety of flash units made for the folding and hard plastic model SX-70 cameras. Some styles were made only for particular models. All manual models have a straight-line flash socket and need a straight-line connector on the flash unit to fit. There are also U-shaped connectors that will only fit into a sonar model SX-70 flash socket. The

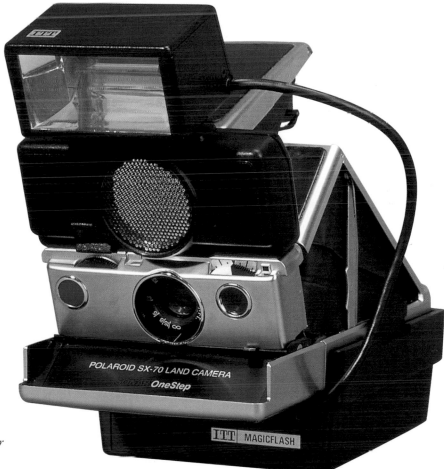

SX-70 Sonar OneStep camera with ITT Magicflash. Two models of this flash were made—for both the non-sonar and sonar SX-70 folding models.

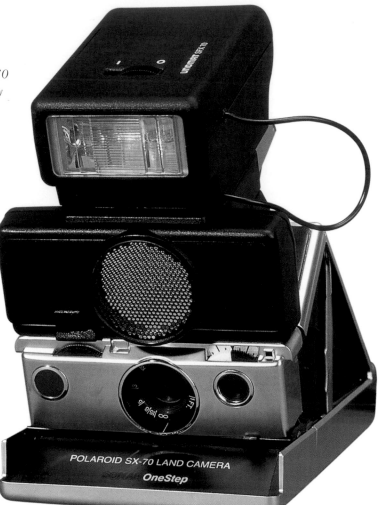

SX-70 Sonar OneStep camera with Unomat flash. Currently available, the Unomat SFX Flash can be used on any SX-70 camera—folding or plastic—by using the included brackets.

extra four contacts give increased voltage to perform the additional function of sonar focusing while using a flash, and they also prevent the camera from taking a picture until the flash is ready. My favorite older flash, the ITT Magicflash, has units for both the manual and sonar models. The flash uses four AA batteries and slides on underneath the camera. It has a tripod mount, which is handy if you have an earlier SX-70 model without a tripod socket.

A new flash made for all models of the SX-70 camera is currently on the market through Cress Camera (see Resources for information). Called the Unomat SFX 70, it slides onto the view-finder cap of the folding models. It also has two adapters that allow it to fit the various hard plastic models. It's small and lightweight, and is the flash I now use.

Polaroid SX-70 Back for Mamiya Medium-Format Cameras

If you photograph with a medium-format camera, you can get a Polaroid SX-70 back for the Mamiya RB-67 and the Mamiya RZ-67 camera models so that you can use either the Time Zero or Polaroid 600 films and take advantage of an excellent lens system. The image is reversed, however, because these film formats require a mirror in the camera lens light path. Without the mirror, the print reads reversed from left to right. This SX-70 film back is model MF-6, made by NPC using the Polaroid CB-72 motorized film chamber. You can special-order it from photographic dealers (see Resources).

Using Daylab Slide Printers with the SX-70 Base

The Daylab SX-70 base, introduced in 1998, allows Time Zero film to be exposed from a 35mm slide (or a medium-format transparency on the Daylab 120). Daylab models that can be used with the SX-70 base include the Daylab II, Daylab Jr., Daylab 35, Daylab 35 Plus, and Daylab 120. The Daylab 35 and the Daylab Jr. are fixed-focus units for exposing 35mm slides onto 3¼ x 4¼-inch Polaroid peel-apart and 3 x 3⅛-inch Time Zero films. The Daylab II, 35 Plus, and 120 can also be used for the peel-apart 4x5 and 8x10 formats because they have adjustable bellows. In addition, you can crop to use just part of an image. All the Daylab models, except the Daylab II, have flash exposure. (See pages 94–98 for more information on the different Daylab models.)

A 35mm image will crop to a square on the Time Zero film, so choose slides that work compositionally as a square. When I use my Nikon, if I think I'll want to use that image to make an SX-70 manipulation, I take two exposures—one filling the frame with my normal composition and the second composed a bit wide to allow for cropping later.

A key advantage of using your regular 35mm or medium-format camera and a Daylab slide printer to create images for manipulation is that you can photograph with all of your lenses and a more accurate light meter, which offers greater choice in composition and subject matter. Also, it's much easier to make another print of the same slide if you don't like the cropping, exposure, how you've manipulated the image, or if you just want to try something different.

With the Daylab II, the enlarging bulb is tungsten—a much warmer light source than the flash exposure (daylight-temperature light source) on the other Daylab models. You'll need to add cyan filtration to neutralize the reddish cast. Start with 30 cyan, and adjust for the image and your color preferences.

With the other Daylab models that have flash exposure, you don't need to add any filtration unless

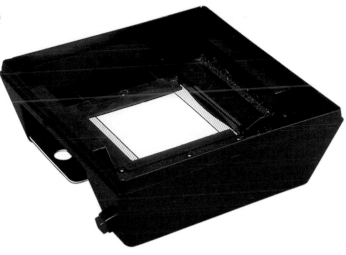

Daylab SX-70 base. This base fits on the Daylab slide printer models, allowing you to expose slides onto Time Zero film for manipulating.

you want to. You can remove a color cast or add color. Note that when you add filtration, you won't be able to preview the results of your filtration with the viewing light on because the filtration works only with the printing bulb.

Since the film speed of Time Zero film is approximately twice that of Polacolor films, you'll need to adjust the exposure for one stop less light, or two increments toward Darken with the Exposure Compensation dial. Remember that when going from a *positive* image (your 35mm slide) to a *positive* print (the Time Zero print), to lighten your print you *add* light or exposure by moving the dial toward (+) or Lighten. Conversely, when darkening an image, move the dial toward the (-) or Darken position. This is opposite to printing with negatives, which goes from a *negative* image to a *positive* image.

Be sure that the room temperature is between 60°F and 85°F (15°C and 30°C), otherwise the color balance and exposure will be off. If the room is colder, your images will be darker and bluer. If it's warmer, the images will be lighter and yellower. You can compensate by adjusting the exposure with the Exposure Compensation dial if necessary. When the Time Zero film has been refrigerated, let it come to room temperature for an hour before using it.

Using the Daylab 35

The simplest Daylab model for SX-70 use is the Daylab 35, so I'll begin with that model here for the step-by-step procedure using the SX-70 base. Additional information is included at the end for using Daylab models that have bellows for focusing and cropping. A step-by-step procedure using the Daylab 35 Plus with 4x5 film pack can be found on page 101.

Supplies

> *Daylab 35 slide printer (if you're using another model with bellows, you'll need to focus the image, and some of the settings may be different, so see notes at the end of the procedure)*
> *Daylab SX-70 base (purchased separately)*
> *Time Zero film*
> *Properly exposed 35mm slide*

Loading the Film

1. Hold the SX-70 base so that the white card is facing down and the slider is on the right side. Push the slider forward to open the film door.

2. Turn the base over so that the white card is now facing up. The film door will drop open. Make sure the white card is pushed in all the way, completely covering the opening.

3. Hold the film pack by its edges only. Load it with the black card facing up so that the blue tab faces out when loaded. Slide the film all the way into the film compartment until you hear a click. (Of course, if there's an empty film pack in the compartment, remove it by pulling the blue tab before loading a new pack.)

4. Close the film door. Place the base on your work space so that the words Daylab Instant Slide Enlarger are in the front, the two alignment tabs are on the left and right sides, and the red button is on the left side near the front. *Note:* Some models have a blue button farther back on the left side.

5. Place the Daylab 35 enlarging head (facing toward you) onto the base, with the side tabs lining up with the tabs on the base. Plug the power supply into the back of the enlarging head and into the wall power outlet.

6. Push the red (or blue) button, keeping your hands away from the front of the film door on the right. The black film cover card will eject immediately.

Setting the Controls

1. Set the Film Type Selection switch on the left (marked 1-2-3) at 3 for Time Zero film. Setting 3 is for ISO 75 Polaroid film. *Note:* In May 2001, the setting was switched from 1 to 3 for Time Zero film. If you have a Daylab 35, Jr., or 35 Plus purchased before May 2001, use setting 1.

2. Set the Exposure Compensation dial at two increments (one stop) below 0 in the minus (-) or Darken direction to compensate for the 150 ISO of the Time Zero film.

3. Leave the filtration settings at 0, unless you want to add color for effect. (See the color filtration information on pages 36–37.)

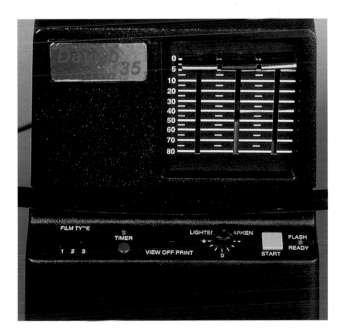

Composing the Slide

1. Place your 35mm slide in the slide carrier, viewing side up and upside down (shiny side up, emulsion side down toward the Polaroid film—which is *opposite* to how you place the slide for transfers and peel-apart films). Position vertical slides horizontally, otherwise the cropping may not be correct. Then, insert the carrier into the slot in the middle of the enlarging head.

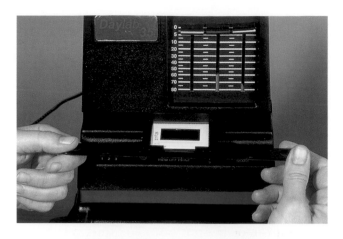

2. Set the View-Off-Print switch to View. The viewing light will come on.

3. Open the previewing door to see your image projected onto the white card area inside. This white card protects the unexposed film underneath from light. If you have trouble seeing your slide, turn off the room light or put a dark cloth over both your head and the Daylab to block the room light while composing. *Note:* Don't use the Daylab outside or near a window; your film could fog. Daylabs were designed to be used in indoor room light.

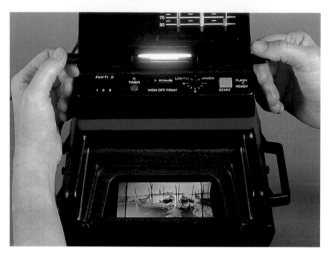

4. Align the slide in the viewing area (right) by moving the slide carrier in the opposite direction you want, since it's a mirror image. So, move the slide carrier to the left to crop the right side, or forward to line up the back edge. Compose your image in the square area in the center of the white card. Make sure there are no black edges showing on the top and bottom, or if there are, center your image between them (some slide mounts show less of the image area).

Exposing the Image

1. Close the previewing door. Turn the View-Off-Print switch to Print. When the green Ready light comes on, pull out the white card as far as it will go. Press the orange Start button. You'll see a flash (if not, press the Start button again because you didn't make the exposure).

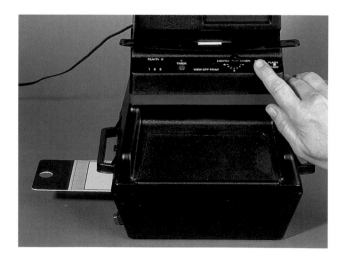

2. Immediately push the white card all the way back in. (If you leave it out, you could accidentally expose your next sheet of film.)

3. Press the red (or blue) button on the left side of the base. Your print will eject out of the film slot on the right side of the base. After the film develops, you're ready to start manipulating your image. *Note:* If your image is too light, move the Exposure Compensation dial an increment to the minus (-) setting; if it is more than a ½-stop too light, keep turning the dial past the minus (-) setting, approximating the distance for another increment or two. If your image is too dark, move the Exposure Compensation dial an increment toward the 0 setting; if it is more than a ½-stop too dark, keep turning the dial past the 0 toward the plus (+) or Lighten setting for another increment or two.

4. After the ten prints have been exposed, when you push the red (or blue) eject button, no print will come out. Remove the base, open the film door, remove the empty film pack and load another pack of film.

EXPOSURE TIP

If your exposure is anything other than the SX-70 "normal"—that is, no filtration and one stop (two increments) to the minus (-)—I recommend writing what your setting and filtration were in pencil on the slide mount. This way, if you decide to work with the slide again, you have a starting point from which to make a successful print the first time.

Cropping and Focusing for Daylab Models with Bellows: Daylab II, Daylab 35 Plus, and Daylab 120

1. Crop the image by turning one or both of the knobs located on each side of the enlarger head (they're the same control). Raise the enlarger head to increase the image size for tighter cropping, and lower it to reduce the size of the image.

2. Focus the image by turning the same knobs slowly in the opposite direction that you turned them for size cropping. That is, after raising the enlarger head, you need to lower it slightly to bring the image into focus. Conversely, after lowering the head, you need to raise it slightly to focus. *Note:* It can be confusing at first, because as you raise the enlarger head, the image may first get smaller before it gets larger, and vice versa. This is because two functions of an enlarger—changing

the size and changing the focus—are combined into one knob. When changing the size, the focus mode is still operating. You'll get used to it.

3. For using the Daylab 35 Plus only, set the Film Type Selection switch on the left (marked 1-2-3) at 3 for Time Zero film (not 1 as for the other models)—unless the unit was purchased before May 2001, in which case set the switch at 1.

Projection Printing with an Enlarger

If you have a darkroom and enlarger, you can projection print directly onto Time Zero film. I recommend purchasing the Daylab SX-70 base. It's much easier to focus, crop, expose, and develop the image. Condenser or diffusion color head enlargers work well; however, avoid using a cold light enlarger.

If you're using a dichroic color enlarger, you can dial in any color filtration corrections. With a condenser enlarger, you'll need to add color gel filters. Color printing (CP) filters are placed between the light source and the slide, and come in five-unit increments of magenta, cyan, yellow, red, blue, and green. You can also get 3x3-inch Rosco color correction Cinelux sampler packs. Color correction (CC) filters are used between the lens and film or paper and are more costly and unnecessary. Safelights cannot be used for color film.

If you don't use the Daylab SX-70 base, you'll need either an SX-70 or a converted 600 camera to process the exposed film. If using a converted 600 camera, remove the metal guide, so you don't need to use a card to load film in the dark. You need an empty film pack and white card cut to the size of the black cover card that'll be inserted in the film pack to crop and focus. Then in the dark, you expose your image on the full pack of film and load it into your camera. The camera will eject the film. Below are the methods of projection printing with an enlarger.

Using the Daylab SX-70 Base or Film Pack

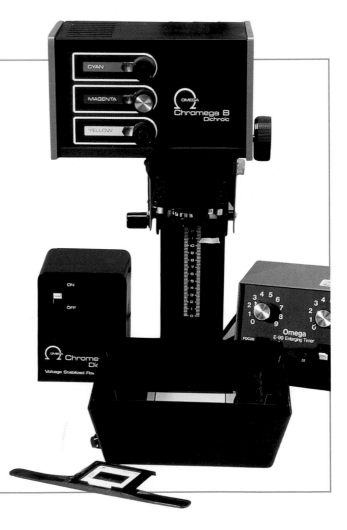

Supplies

> darkroom (must be completely dark)
> properly exposed 35mm slide (or medium-
> or large-format transparency)
> Time Zero film
> Daylab SX-70 base
> condenser or dichroic diffusion head enlarger
> (not a cold light enlarger)
> enlarging timer
> color printing (CP) or color correction (CC)
> filters, or Rosco Cinelux sampler pack
> (for condenser head enlarger only)

Additional Materials for Film Pack and Camera Method

> SX-70 or 600 series camera
> empty pack of Time Zero film
> white card cut to size of black film protector
> masking tape

Cropping the Image

1. Place your slide or transparency into the negative carrier as you would a negative. If you have a 35mm slide carrier, use that for 35mm slides.

2. Load the film into the Daylab SX-70 base. Place the base under the enlarger so that the words Daylab Instant Slide Enlarger are in the front. Crop and focus the image onto the white card (right). Move the base around to get the composition you want.

If using the film pack and camera instead of the Daylab base (below), insert the white card into the empty Time Zero film pack, making sure it is above the silver bars inside. Place the film pack under the enlarger, and crop and focus the image. Put tape around the outline of the film pack to mark the spot. You may need to place a small wedge

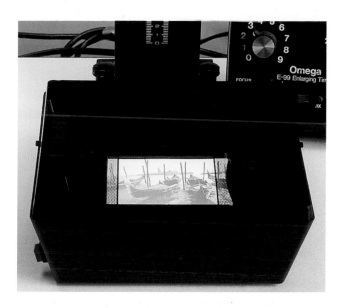

under one side of the film pack to make it level. Once you position the wedge, tape it down.

3. Set the *f*-stop of the enlarger to *f*/16½ as a starting point. (Different enlargers and bulbs will give different results, so experiment with what works for you.) Then, set the timer for three seconds.

4. On the Daylab base, push the red (or blue) button on the left side of the base to eject the black cover card. *Note:* For the film pack method only, load the full film pack into the camera; the black cover card will eject.

5. Turn off the room lights, including all safelights.

6. Pull out the white card on the left side of the Daylab base.

For the film pack method, remove the full film pack from the camera and put it under the enlarger, replacing the empty pack (above). Be sure to follow the taped outline you made for proper composition.

7. Start the timer and expose the film.

8. With the Daylab base, push the white card back in and push the red (or blue) button to eject the film.

For the film pack method, load the film pack with the exposed image into the camera. The camera will automatically eject the top sheet of film with your exposed image.

9. Turn on the lights and watch your image develop. Development takes 5 to 15 minutes. Yellow is the last color to completely develop. If the exposure isn't correct, adjust the *f*-stop or timer to increase or decrease the amount of light. When projecting from a positive slide or transparency to a positive print film, what you see is what you get. If you add more light by adding more time, or opening up the aperture, your result will be lighter. If you decrease the amount of light by closing down the aperture to a higher number, or you expose for fewer seconds, your print will be darker. If the color balance isn't correct, add appropriate color filtration.

Color Correction with Slide Printers and Enlargers

If you want to correct or change the color balance of your image, you can do this when exposing your slide or negative onto the Polaroid film with color filtration. You can also use color filters with the accessory holder #113 on folding SX-70 cameras. With the exception of the Daylab EZ and 120, if you're using a Daylab slide printer or color diffusion enlarger, you can simply dial in the filtration on the

dichroic color head. Otherwise, you'll need to use color gel filters. I've included a brief overview of color theory with white light so that you'll be able to understand how to use filtration.

Light is composed of colors that behave and mix differently than pigment colors. The red, green, and blue wavelengths that make up white light are called the additive primary colors. When mixing two of the

additive primaries together in equal proportions, you get three more colors: cyan, magenta, and yellow.

blue + green = cyan
blue + red = magenta
green + red = yellow

These resulting colors are called the subtractive primary colors and are used in color printing and color correction. The subtractive primary colors are the complements—opposites on the color wheel—of the additive primaries. Cyan is complementary to red, magenta is complementary to green, and yellow is complementary to blue.

All colors can be made by combining subtractive colors in different combinations. When using color filters, think of all the filters in terms of subtractive colors. For example:

30 blue = 30 magenta + 30 cyan
20 green = 20 yellow + 20 cyan
10 red = 10 yellow + 10 magenta

If all three subtractive filters were used simultaneously in equal proportions, any color would be canceled out and gray would be created, which is called neutral density. Use only two filters at a time unless you want neutral density. Adding neutral density is necessary when the exposure is too bright and you need to tone it down, as can happen, for example, when projection printing with an enlarger. Since the Polaroid film is more sensitive than printing papers, you may need neutral density—in addition to a small aperture setting—to avoid overexposed images.

All of this translates into simple guidelines. If you want more of a particular color, add it (or the colors that create it) in units from 0 to 80 on the Daylab slide printers, or 0 to 160 units on most color head enlargers. Or, subtract the color's complement, if you've already added it. If you want less of a particular color, subtract it if you've already added it or add its complement. For example, if you want more yellow, add yellow or subtract cyan and magenta. If you want less yellow, subtract yellow or add cyan and magenta. If you add a lot of color, you'll need to increase the exposure to compensate for the density of the filtration you're adding. (See pages 86–87 of *Polaroid Transfers.*)

This color wheel shows the three subtractive primary colors—cyan, magenta, and yellow—along with the colors in between them that are created by combining those two surrounding subtractive primaries. You can also locate a color's complement directly opposite it on the color wheel; note that complementary colors neutralize each other when mixed together.

The Kodak Color Print Viewing Filter Kit is a good way to see beforehand what you'll get by adding filtration. You can hold a filter or combination of filters over your slide or manipulated image to get an idea of how the image will change.

Troubleshooting

Whether you're using a camera or one of the Daylab printers, there are a few things that can go wrong when exposing Time Zero film. Most of them are easy to correct if you know what the problem is. I've listed the most common problems and their solutions here.

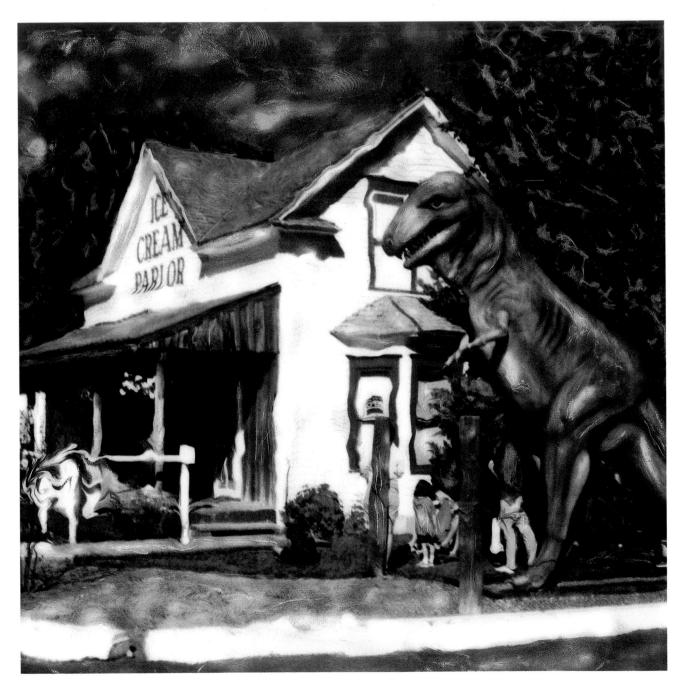

T-REX, MONTANA
I photographed this with an SX-70 camera and colored it in Photoshop.

Camera Problems

For all cameras, holding the camera incorrectly can cause a number of problems. For folding cameras, hold the camera as shown on page 24.

Horizontal Creases, Yellow Areas, and Featherlike White Areas

When your fingers block the picture exit slot, this can cause a piece of film to get jammed, causing one or any combination of the above to happen. Open the film door in subdued light and gently rotate the rollers to move the film backward or forward through the rollers. Don't try to remove the film without first opening the film door.

Incomplete Image or Incorrect Exposure

The former can be caused by a finger in front of the lens. For the latter, a finger in front of the electric eye may cause the camera to set an incorrect exposure.

Foggy, Dark, or Black Image

A finger placed in front of the flash or flash bar may fog the picture by reflecting the flash into the lens. Or, with a flash bar, a finger may block the flash entirely, resulting in a picture that is too dark or entirely black.

Streaky Light Patterns, Foggy Upper Image, or White Picture

Fingers on the camera bellows (for folding cameras) can cause the mirror to get blocked, resulting in pictures with foggy or streaky light patterns. Also, the top part of the image can be fogged or, if outdoors, pictures can be white.

Blurry and Unsharp Images

This can be caused by not holding the camera steady when taking a picture. If there isn't enough light, a slow shutter speed will accentuate this problem. Use a tripod, accessory pod, or flash in low light.

Horizontal creases, yellow areas, featherlike white areas, or a combination of these things are the result of fingers blocking the picture exit slot.

Camera and Daylab Problems

Yellowish or Light Areas

Check to see if the film is expired. Time Zero film usually doesn't last more than twelve months past its expiration date, even when refrigerated during storage. Refrigerate the film as soon as you get it. If you have more than one box that's expired by six months or more, use it for those wild experiments, or as Elizabeth Opalenik says, for "spirit photography." (See the image at right; if yours looks similar and is on outdated film, that is the cause.)

Partial or Total Bluish or White Fogged Look

A fogged print can be caused in several ways. One is opening the film door when there's film in the camera or Daylab SX-70 base. The brighter the light in which you do this—especially if you start to pull the film pack out—the more fogged your image will be, but only the top piece of film will be fogged.

ELIZABETH OPALENIK. SPIRIT FILM *Outdated film can create unusual effects with streaks and areas of yellow.*

Another cause is forgetting to push the white card in after exposing the film in a Daylab slide printer and either turning the View light on, opening

A bluish or white "fogged" look on part or all of an image is caused by partial exposure to light or, sometimes, heat. The fogging in this image occurred during transportation of the Daylab SX-70 base while film was in it.

the previewing door, or removing the enlarging head. Again, only the top piece of film will be fogged.

Letting the film get too hot is another culprit. This can happen by leaving your camera or film baking in your car, or in the sun, on a hot day. It can also happen by having the film, camera, or Daylab too close to a warm object (such as a warming tray or heating pad) prior to film exposure.

Keeping the Daylab slide printer too close to bright window light or a bright light source can also yield these results. The Daylab models are made for normal, indoor room light and the film can fog if the light is too bright. Move the Daylab away from the bright light, cover the window, or cover the Daylab with a dark towel or cloth.

Completely Black Print

No exposure was made. This usually happens with the Daylab slide printers when the white card is not pulled out before making the exposure (by pushing the Start button). No light has reached the film, therefore it is black. With the Daylab models, if the View-Off-Print switch is in the "off" position when pushing the Start button, no exposure is made so the print is black.

With the Daylab models, if the Start button isn't pushed, or is pushed before the green Flash Ready light is on, or is not pushed hard enough to trigger the flash (or if the print light doesn't come on with the Daylab II), no exposure is made and the print will be black.

With a camera, make sure your finger isn't covering the electric eye or the flash. If the film is black on every picture, the camera might be malfunctioning. Remove the film pack and reload it, or try another film pack. If the problem persists, get the camera repaired or replace it.

White Print

The print is completely overexposed. This usually happens with the Daylab slide printers when you pull the white card out while the View-Off-Print switch is still in the View mode. This will also happen with the Daylab models if you pull the white card out while the previewing door is open, or if the door gets opened

before the card is pushed back in, or the enlarging head is removed while the white card is still out.

If you remove the film pack from the camera or the Daylab base when film is still in the pack, the top piece of film will be completely overexposed.

Partially Missing Picture

This can happen when the pod of chemicals is damaged before the film goes through the rollers. This may cause the white developer gel to leak onto the rollers, the picture exit slot, and the back of the picture. *Note of caution:* Do not get the caustic developer gel on your hands. If you do, wash your hands right away, or wear thin rubber or latex gloves to prevent this.

If there is developer gel on the back of the picture, clean the rollers. It's best to do this while the film pack is still in the camera to prevent dust from entering the film compartment. Open the film door and depress the light shield to expose the rollers. Use a finger to rotate the rollers, which should move freely. Remove any specks of dirt from them with a clean, lintless cloth or paper towel, moistened only with water and only if necessary. Pay special attention to the raised ends on the top rollers, where dirt may collect. The rollers need to be kept clean, so inspect them every time you insert a new film pack.

Clean the picture exit slot by inserting the black film cover (or a clean piece of paper of the same size) in front of the rollers and under the light

Clean the rollers if part of your image is missing.

shield. Push until it comes out through the picture exit slot. Move it in the slot until all the developer chemicals are removed. Don't force the slot open because it can be permanently bent to the point that it can no longer perform its function.

If there is any white gel on the back or front of a picture, wipe it off gently after the image has fully developed.

Two Undeveloped Film Pieces Came Out Together
The film pack or the top piece of film has been bent or damaged. You may need to clean the rollers. Often this happens when trying to reinsert the black card in order to move the film pack into another camera or Daylab base without exposing the top piece of film. The rest of the film pack will probably be okay. The film pack may also be bent or damaged, so the film ejects improperly. In this case, replace the pack.

Yellow and Red Repeating Dots
These dots down a print indicate that the rollers are dirty. Open the film compartment and clean the rollers with a lintless cloth or paper towel. (See the cleaning instructions that appear on the previous

Repeating yellow and red dots down a print—such as those running down the left side of this SX-70 image— are caused by dirty rollers.

page). If the gel has dried on the rollers, dampen a paper towel—with water only—and work the gel loose, making sure that none of it falls into the film compartment.

Film or Black Card Isn't Ejected

If the camera or Daylab base does not make its usual motor noise, the battery in the film pack may be dead or too weak to eject the film. Try another film pack. If it works, then the problem was the battery. If the film is not expired, call Polaroid Customer Service at (800) 343-5000 and ask for a replacement film pack. Have the film with you when you call.

If the camera makes its usual noise but doesn't eject the card or film, the problem still may be with the film. Try another film pack. If the problem persists, it may be a problem with the camera. Try opening and closing the camera a few times, and see if that solves the problem. If not, call Polaroid Customer Service before sending the camera out for repair; they may be able to suggest something.

Motor Keeps Running and Ejects All the Film Out of the Film Pack

There's probably a broken piece in the roller assembly. If it's a Daylab base, Daylab will repair it at no charge if under warranty. Call or e-mail Daylab to check on what to do. If it's a camera under warranty, send it back for repair or replacement. If it's an old camera, there are several facilities—such as Precision Camera—that repair SX-70 cameras. (See Resources.)

Camera (or Daylab Base) Stops Mid-Cycle

The motor is not getting enough power to continue. There are two possible causes: (1) Not holding the shutter button (or the red or blue button on the Daylab base) in until the picture comes out. Try again, holding the shutter button in longer. The camera should complete the cycle. If not, open the film door in dim light or darkness and pull the pack out about an inch, just until the picture counter (on the camera) resets. Push the pack back in and close the film door. The camera should complete its cycle, ejecting the top piece of film, which may have been exposed to the light when the pack was partially pulled out.

Or, (2) a weak battery in the film pack. Batteries weaken as they age, and if the film is old or outdated, the battery may have just enough power to start the cycle. If you have an empty pack of film with a good battery, put it in to complete the cycle so that you don't lose film from the new pack. Then load a new pack of film into the camera or Daylab base. If the pack won't go in easily, don't force it. If the black card cover is sticking out of the pack and the door won't close, remove the card cover and then close the door. Or, if the card cover is ejected only part way, open the film door and remove it from the rollers by turning the rollers forward. Never try to force the film card through the rollers without first opening the film door. Call Polaroid's Customer Service to get the film replaced, unless it's expired.

For a folding SX-70, 680, or 690 camera, if none of the above makes the camera complete its cycle, *do not try to close the camera.* This may damage the picture-taking mirror, which is in the mid-cycle position. Get the camera repaired.

Daylab Base Problems

Partially Black Image, or Black Lines or Bars at Top, Bottom, or Sides

The slide is incorrectly aligned on the white card in the Daylab slide printer. If you don't match the top and bottom edges of the slide to the top and bottom edges of the white card, you'll get a black line or bar where the slide isn't touching the edge of the card. On the sides, the square cropped area in the middle should show the composition of your image. (See page 117 for an image transfer example of this problem.)

Half Black Image

The white card was not pulled out all the way, so only the area that was uncovered was exposed. Or, the base is on backward or sideways. Check to make sure that the tabs on the side of the base and enlarging head are lined up and that the red film-ejecting button is on the front left side of the Daylab base.

Manipulating the Image

There are as many ways to manipulate SX-70 images as there are people who manipulate them. Truly, there is no right way. It depends completely on what effect and style you prefer. Polaroid has a great video that shows how to manipulate SX-70 images, starting before the image has been developed. Some photographers wait four to five hours before beginning to work on the print, and still others start as soon as the image has developed, keeping the print warm continuously.

ISTANBUL SUNSET. 1999
Made from a 35mm slide of the Blue Mosque in Istanbul, the SX-70 manipulation was colored in Photoshop before this final 20x20 Iris print was output.

The step-by-step procedure that follows shows you what I do, and also includes some other possibilities. Please don't limit yourself to what I've described. This is one process that you learn only by doing and trying different methods. In this way, you'll discover what excites you and brings your images to life. Start with your least favorite prints while learning what techniques and tools you like. Keep the manipulated prints you don't like—they make great practice pieces for trying out bold techniques for which you wouldn't risk a favorite image, or for learning handcoloring or separating the print.

I sandwiched the original color slide (taken in 1972) with a sunset slide for more impact.

I exposed the slide onto Time Zero film with a Daylab slide printer, adding yellow and magenta filtration to emphasize the color. This is the resulting SX-70 print from that slide.

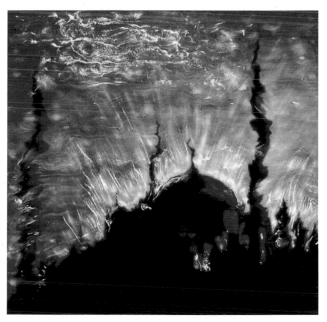

I then manipulated the Time Zero print with a wooden ceramic tool and a burnishing tool.

Tools and Techniques

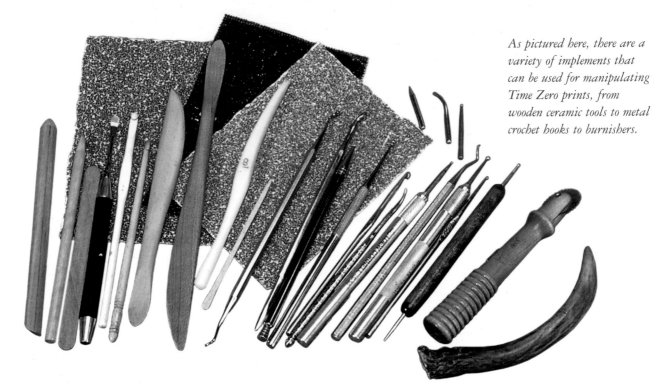

As pictured here, there are a variety of implements that can be used for manipulating Time Zero prints, from wooden ceramic tools to metal crochet hooks to burnishers.

There are a great many tools that you can use: old dental implements, crochet hooks, knitting needles, type burnishers, wooden ceramic tools, nut picks, golf tees, spoons, butter knives, pens with no ink, pen caps, chopsticks, keys, nails, large paperclips, coins, wooden cuticle sticks, your fingernails, lost wax jewelry tools, toothpicks, and popsicle sticks. All very low-tech! I even use leather and metal stamping tools with letters, numbers, and symbols. Catherine and David Peters of the Monet Miracle have created a wonderful wooden tool specifically for manipulating SX-70 prints (see page 50). It has six distinct edges, each designed for a different effect, and is very comfortable to hold. Some tools may make your wrist hurt after using them for a while, so find tools that are comfortable to use.

In addition to knowing your tools, it is helpful to understand what is actually happening to the film when you push around the layers of emulsion with differing amounts of pressure. (See diagrams opposite.) With slight pressure, you can move the colors in the color image layer. More pressure mixes the white reagent into your colors, and even more

pressure reaches the blue-, green-, and red-sensitive layers of the film and allows you to mix those colors, even if they aren't in that area of the image. Very hard pressure (easily applied when the image has just developed and the emulsion is very soft) brings you all the way to the black backing, creating those unwanted black marks you can unintentionally get.

Work on a clean, smooth, hard surface for best results. If I want to add texture to my image, I usually do this right away by putting a piece of heavy-grit sandpaper or a screen under the newly developed SX-70 print before rubbing it with a tool. Let your imagination run wild here for textures to use. A wooden dowel with an angled end works best for creating texture. By rubbing the angled end back and forth across the area where you want texture, you can make "stars" in a dark sky or texture an overexposed sidewalk, thereby saving a potentially uninteresting area of your print. Dark areas show white texture, and light areas show black when adding texture. By putting a rubber stamping foam pad under your print, you can even use trinkets and costume jewelry to emboss shapes into the emulsion.

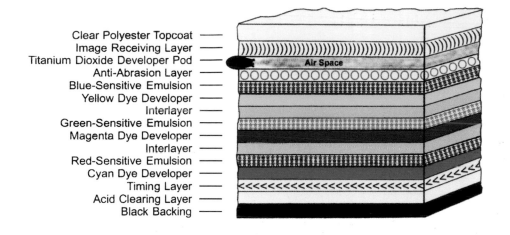

| Clear Polyester Topcoat |
| Image Receiving Layer |
| Titanium Dioxide Developer Pod |
| Anti-Abrasion Layer |
| Blue-Sensitive Emulsion |
| Yellow Dye Developer |
| Interlayer |
| Green-Sensitive Emulsion |
| Magenta Dye Developer |
| Interlayer |
| Red-Sensitive Emulsion |
| Cyan Dye Developer |
| Timing Layer |
| Acid Clearing Layer |
| Black Backing |

Air Space

Time Zero film layers. The integral film is composed of three layers of light-sensitive emulsions: blue-sensitive, green-sensitive, and red-sensitive. The unexposed silver halide grains in these layers are developed by complementary-colored dyes (yellow, magenta, and cyan respectively) to produce the final image. When a picture is taken, the titanium dioxide developer/reagent pod is broken by the camera or Daylab base rollers as the film is ejected, starting the complex development process. The reagent forms an opaque white layer, which allows the picture to be processed in the light. DIAGRAM © 2002 DIANA LEE

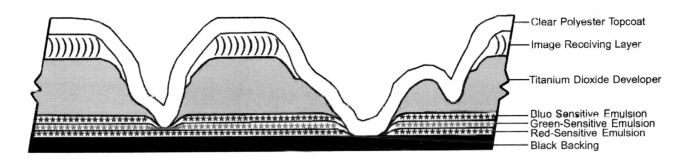

Clear Polyester Topcoat
Image Receiving Layer
Titanium Dioxide Developer
Blue-Sensitive Emulsion
Green-Sensitive Emulsion
Red-Sensitive Emulsion
Black Backing

When manipulating the film, the amount of pressure affects your result. By pressing into the white titanium dioxide developer layer, you mix white into your colors. By pressing slightly harder, you can sometimes mix in colors from the blue-, green-, and red-sensitive emulsion layers. If you end up with black marks in the image, you've reached the black backing. DIAGRAM © 2002 DIANA LEE

Smooth wooden tools impart a soft, impressionistic look to an image. Ceramic and sculpture tools work well for this. I like to begin using these tools to gently soften straight lines and give texture to skies and large light areas. Either I go back and forth across an area with the curved, broad part of the wooden tool until the image starts to move, or I use a circular motion, which easily distorts straight lines. I create patterns in the light areas of an image first, because the dark and green areas are harder to manipulate at first without getting white scratchy marks.

When you start to work on the print right away, the emulsion is very soft and pliable. It's easy to overdo it, and the effects of even slight pressure are more noticeable—and sometimes much more dramatic—than when you wait ten to fifteen minutes to begin. It's very easy to get black marks early on by pressing too hard in light areas. Many times you can fill them in by pushing the emulsion on each side toward the mark, like filling in a cavity. If this is unsuccessful, don't worry; there's always handcoloring or, if you scan your image, the cloning tool in Photoshop to fix little glitches later.

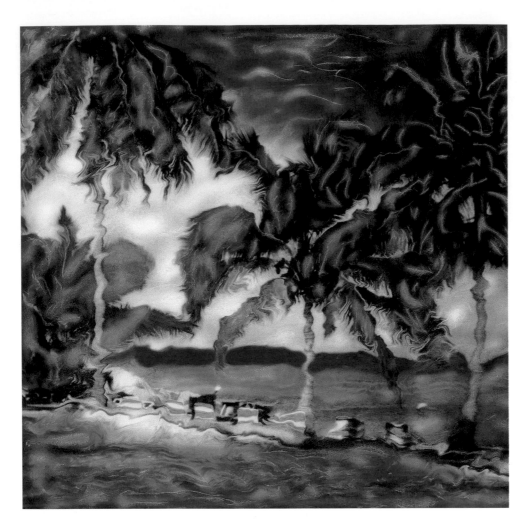

BEACH PALMS,
THAILAND. 1999
I made this SX-70 manipulation from a 35mm slide and handcolored it on the Iris print; then, after handcoloring a number of large prints, I decided to color it in Photoshop.

After manipulating the emulsion with the wooden tools, I create more detail with smaller metal tools such as burnishers, crochet hooks of different sizes, and nut picks. Griffin (Grifhold), Loew-Cornell, and others make burnishing sets with several different-sized nibs, which come in handy for working in areas of various sizes. Art supply stores are a good source for burnishers. If you're using dental tools or other metal implements, make sure they're not sharp because you don't want to puncture the mylar surface of the print. The white processing developer (titanium dioxide) underneath is caustic, so avoid getting it on your hands.

If you want black lines in light areas, it's easy to create them by pressing hard using a metal tool. You should make these lines early on, because it's easiest to get black lines while the emulsion is very soft. You can create white lines in dark areas any time before the emulsion completely hardens.

With the rounded end of a metal tool, I outline the edges of different areas I want to soften or distort, and then move the emulsion around inside those areas for the effect I want. My strokes follow the shape of the subject or area: for example, circular strokes in round objects, often exaggerating the shape or highlight. This can give the object more prominence and make it appear larger within the scene.

If I want to obliterate something, such as a parked car in the background, I make strokes completely through it, working against the natural lines. I also create white lines, dots, swirls, and scratches in the lighter or darker areas, almost like working with scratchboard in the darker areas. I often draw in white lines that I know I'll color in later (see handcoloring information on page 64), as in the image above. It's fun to put highlights in dark areas, using a soft touch; they can transform an uninteresting area of an image.

Applying various amounts of pressure and stroke lengths you can achieve different results with the same tool. Short, hard strokes from ¼ to ½ inch can give you a van Gogh–like effect. Light strokes create a softer look. You can even create colors not originally found in the image by pressing hard early on so that the red and blue dye layers are brought to the surface of the print (see film layer diagrams on page 47).

Faces and skin are tricky to manipulate. It's very easy to distort a face or make the skin blotchy. Hair, eyeglasses, hats, and clothes can be manipulated quite well, but I recommend leaving the skin alone or working very subtly, with a gentle touch.

If I want a subtle effect, I usually wait several hours. The emulsion doesn't completely harden for about twelve to twenty-four hours, and I can reheat the print to soften the emulsion. I often work on several images at once so that as they harden, I can continue working with different tools to get the effects I want. Also, what emerges on one print may give me an idea of how to handle a particular area on another print. However, if you wait too long, the print is more difficult to work with because the emulsion has begun to harden.

To really learn how the timing of development creates different effects, try exposing three images of the same subject. Keep one print untouched as a reference. Work on the second print right away, and then wait two to four hours and work on the third print, repeating as closely as possible what you did on the second print, using the same tools, and doing the same strokes with the same pressure. Then compare all three prints.

Knowing when to quit working on an image is also important. It's easy to overdo it, especially when

JACK ISKIN.
JERUSALEM 1997
This image illustrates an
effective style of photographing
a person.

GOOD TO THE LAST DROP. 2000
*Since faces are tricky to manipulate, I left
Barbara Elliott's face alone and manipulated
the rest of the image. I then handcolored with
markers on the Time Zero print.*

*The Monet Miracle kit contains an "arplaé
workstation" box with special six-edged stylus,
disposable warm packs, two "how-to" videos,
instruction book, and an adaptation kit for
using the Polaroid 600 cameras with Time
Zero film.*

learning. Time and experience are good teachers. Viewing your print from different distances or upside down as you work on it will help you see what areas still need work. In addition, set aside a finished print to review later; you'll come to it with fresh eyes, and you may see more possibilities.

You can keep the prints continuously warm (for up to six hours is best), or you can reheat the print as many times as you want and the emulsion will soften again for a while. If I'm home, I use an old hors d'oeuvres warming tray to warm prints, since I have one around for working with image and emulsion transfers. Theresa Airey uses a heating pad with a piece of glass or Plexiglas over it. In the Monet Miracle kit, the "arplaé workstation" includes a

small metal box designed to hold your SX-70 prints, the special wooden stylus, and a disposable warm pack, which lasts for twelve hours when opened. You then have a portable warm surface on which to work, the box to keep your prints warm, and the stylus; it's a great packet for traveling and fieldwork. Ken Dorr and Mario Marchiaro (of Kenario) use a Tupperware container and a thermos of boiling water to keep their prints warm while they travel and work. Or, you can heat up a terra-cotta tile (available at any local home improvement store); it will retain heat for quite a while.

You can also heat your prints while traveling by putting them on the warm hood of your car or in the sun. You can wrap them around your mug of coffee

or tea at that café where you stop to work on your images. You can run warm or hot water on them at a sink (ice and water won't hurt the prints), or put them on or near any other number of heat sources, including an iron (use a low setting). Avoid microwave ovens, as the metallized dyes can cause your image to melt or burn, making an awful smell.

If you don't have time to finish manipulating your prints, you can freeze them and then reheat them later to continue working. I find that the prints don't get quite as fluid after freezing, but it's a much better option than losing the ability to work on them altogether.

I love to go out on the road for an "SX-70 adventure." I have a small foil-lined collapsible cooler for my SX-70 camera, flash, arplaé box (or small clipboard), tools, film, and a blue ice pack. I bring the blue ice because usually I take more photos than I have time to manipulate during the day. I put the unmanipulated prints in a ziplock bag next to the blue ice, then put the prints in my freezer when I get home. Transfer artist and SX-70 photographer Tina Williams has even used the ice in a soft drink cup to keep her images cold.

When traveling a greater distance without a car, I usually just take my 35mm gear, since I know that when I get home I can use my 35mm slides with the Daylab slide printer and SX-70 base to create the manipulations. For those images I'd like to use to create SX-70 manipulations, the only thing I need to remember when I photograph is to take an additional picture with a wider composition. This is because I need to be able to crop to a square format for the Time Zero film or else lose some image area on the film.

One advantage of using a slide with the Daylab slide printer is that if I don't like how I've manipulated the SX-70 print, or I realize a different exposure would give me a better result, I can just expose another print from the same slide and manipulate it again. Sometimes, the perfectly exposed print does not necessarily grant the result I like best after manipulation. When I'm working with a Polaroid camera, I may not realize this fact until it's too late to rephotograph the subject. When manipulating the SX-70 print, the print will actually get lighter in the areas that are worked on. And sometimes a lighter exposure will give a more painterly, impressionistic result.

ENTRANCE, HUI NO'EAU, MAUI
The normal exposure (left), taken with an SX-70 camera, didn't seem as interesting as the overexposed image (right), which was more pleasing to work with and which yielded a much more painterly result.

Step-by-Step Manipulation Process

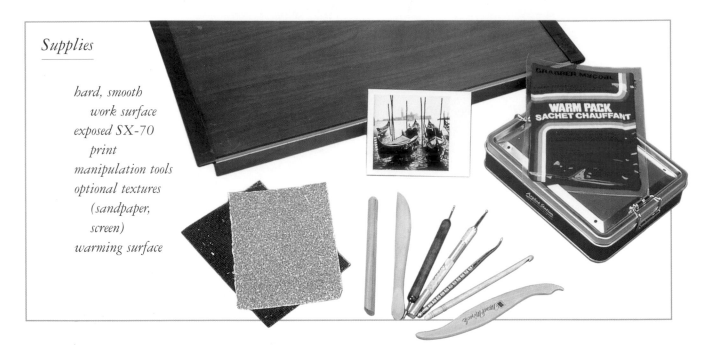

Supplies

hard, smooth
work surface
exposed SX-70
print
manipulation tools
optional textures
(sandpaper,
screen)
warming surface

1. Wait until the image is completely developed and colors are bright (approximately 5 to 15 minutes).

2. Add texture, if desired, by placing a textured surface—such as coarse sandpaper—under the print and using a wooden dowel with an angled end to rub back and forth over those areas you want textured (right).

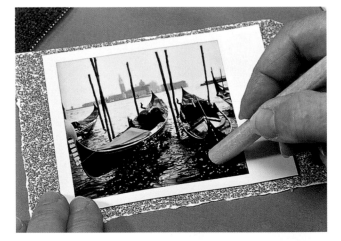

3. Remove the sandpaper and continue with the manipulation by rubbing the large, light areas of the print with a rounded wooden ceramic tool, moving back and forth or in a circular motion until the image starts to move. Keep manipulating until you achieve the desired effect.

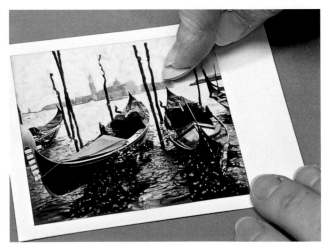

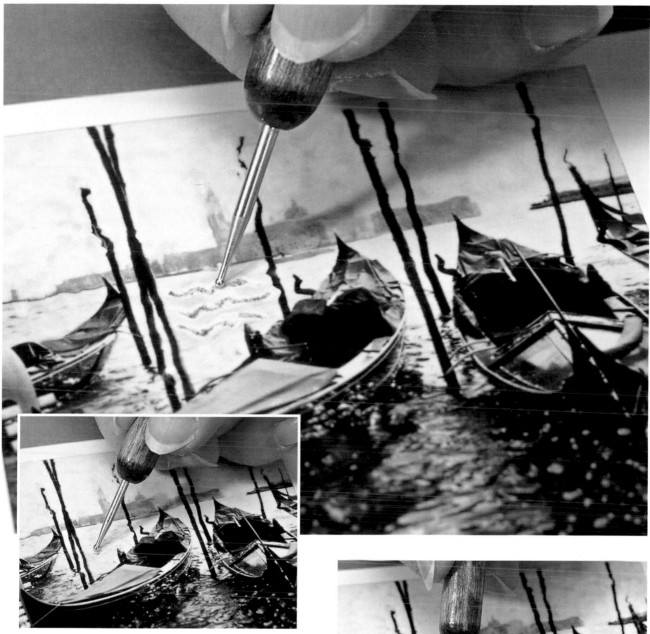

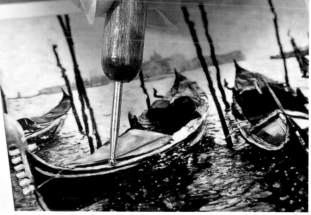

4. To create black lines, use a metal tool with a small nib or rounded end and press hard while drawing. Black lines need to be made soon after development and will show only in light areas. Dark areas will show white lines, which can be made at any time up until the emulsion has hardened. *Note:* If you're getting unwanted black marks, you're pressing too hard. Push the emulsion back into the black area from each side (detail). Don't press further on the black area. When outlining, move the light edges into the dark areas.

5. With a metal tool, outline the edges of smaller light areas, softening and wiggling the lines. Increase your pressure until you get the effect you want.

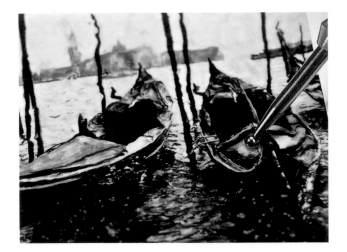

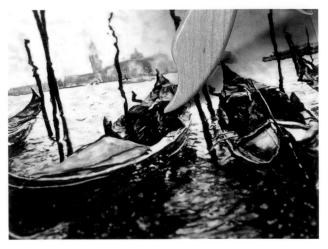

6. Move the areas within the outlined forms, crossing over the edges if you want more distortion.

7. Work in the dark areas last, adding highlights with soft strokes and white lines, or scratching out areas with harder pressure.

8. Look at the image from several different distances. Finish areas that need more work. You may need to wait until the emulsion hardens more to get subtle effects (15 minutes to 5 hours, depending on the room or print temperature and what effects you want).

If you're unable to finish manipulating the image, you can freeze it until you have more time to complete it. Just reheat it on your warming surface, and you'll have several more hours in which to work. Keep the image warm for maximum fluidity.

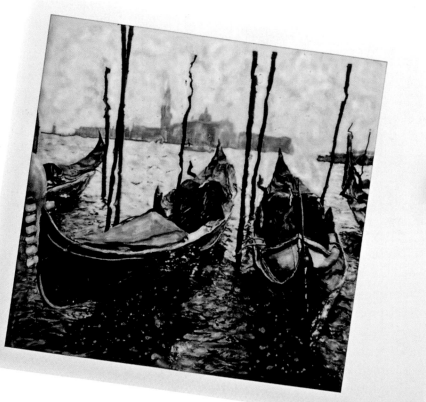

Creative Techniques

Color Filtration

In addition to color correction (see page 36), color filtration—with color filters—can be used creatively. You can use the dichroic filters on the Daylabs, or you can use filters on your SX-70 or 600 camera itself by cutting and taping color filtration gels over the lens and exposure sensor. With the non-sonar folding SX-70 models, you can use accessory holder #113 to hold filters. If you don't tape over the exposure sensor, you'll need to manually move the exposure dial toward Darken to compensate for the density of the filter.

PALMS AT SUNSET I. 2001
This version was made from a 35mm slide with no filtration added.

MAGENTA PALMS. 2001
When exposing the Palms at Sunset I *slide with the Daylab slide printer, I added 80 magenta color filtration. I then increased the saturation even more in Photoshop.*

PALMS AT SUNSET II. 2001
Different effects were created by adjusting the color channels in Levels (in Photoshop) on a separate layer.

Using Negatives Instead of Slides

Some negatives, both color and black and white, can look quite striking as manipulated SX-70 or transfer prints. If you start with a negative, you'll end up with a negative print, so forget what the positive print looks like. The best subjects have enough contrast and strong, graphic shapes to be interesting. A low-contrast negative with small unrecognizable shapes can look like mush when printed. With a color negative, not only will it be a negative image but the colors will also be reversed from the positive. I've seen some ethereal magenta, pink, and purple landscapes, since magenta is opposite green on the color wheel (see page 37).

Photograms

This technique is most easily done with an enlarger and the Daylab SX-70 base, but it must be done in the dark. While in the dark, pull out the white card and arrange objects of different shape, color, and transparency on the unexposed film. Experiment with different exposures to get the effect you like. If you make the exposure with the least light possible, you can make two exposures, moving the objects around between exposures. Try changing the color filtration on each exposure or use translucent and transparent objects for more unpredictable results.

Slide Sandwiches

Slide sandwiches cannot be made with the camera, only with the Daylab base or the enlarger. Simply place two slides together in the slide carrier. You'll need to increase your exposure, depending on how dense the slides are. You can preview the result by holding the slides up to a bright light. Whatever is darkest on one slide will block the image in that area on the other slide and be dominant. You can also use two negatives, or a slide-and-negative combination.

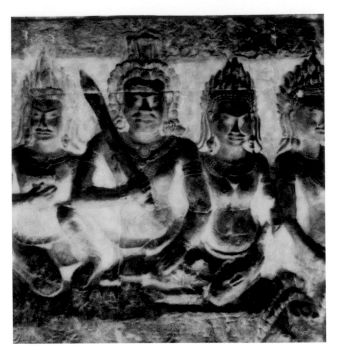

BAS RELIEF, ANGKOR WAT, CAMBODIA. 2002
This image was made using a negative instead of slide. Using black-and-white and color negatives results in a negative print, which can offer more creative possibilities. Good contrast and strong graphic shapes have the most impact.

QUAN YIN IV. 2002
To create a slide sandwich, place both slides together in the slide holder, and increase the exposure to compensate for the additional density of both slides. The darkest areas of each slide block out the lighter areas.

Double Exposures

You can make double exposures in the SX-70 and 600 cameras and with the Daylab SX-70 base or the enlarger. No matter which method you choose, you'll need to reduce the exposure by one stop, or two marks toward Darken (each mark is a ½-stop) for each exposure. For the non-sonar folding SX-70 cameras, take your first picture but hold the shutter button in while you close the camera. Open the camera again and take your second shot, releasing the shutter button normally. The picture will come out when the shutter button is released. A method for the nonfolding plastic SX-70 or 600 cameras is to open the film door before you press the shutter button on the first exposure. If the film starts to eject slightly from the camera (the front lip of the film pack might push forward) push it back into place before making the second exposure. Close the film door, and the film will eject.

When working with slides or negatives, it's easier to control the outcome of a double exposure than when working with the camera—and, you have a wider variety of subject matter from which to choose. Using the Daylab base or enlarger, after you expose the first slide (exposure reduced by one stop) and push the white card back in all the way, *don't* push the red Film Eject button. Remove the first slide, and then put the second slide in and line it up on the white card. Expose the second slide, again at one stop less the normal exposure. Push the red Film Eject button. With a double exposure, it's hard to previsualize exactly what the result will be. The lightest areas in either slide will be dominant and cover any darker values in that same area on the other slide. (This is the opposite effect of the slide sandwich.)

Double and multiple exposures and slide-sandwich effects can also be created in Photoshop by using layers, masks, and blending modes (see page 88 for more information).

By combining these two slides, I created a double exposure (right) and a slide sandwich (opposite, bottom) using the Daylab II slide printer with the SX-70 base.

QUAN YIN III. 2002
Exposing each slide separately at half the normal exposure on the same piece of film creates a double exposure. Note that the lightest areas of each image are dominant and wash out the darker colors of the other image in those same areas.

Multiple Images

By combining multiple images of the same slide, variations of the same slide, or details of a larger image, you can assemble sequences, mosaics, or mandalas with your SX-70 prints.

Removing the White Border

One of my students, Debra Amerson, decided that she didn't like the white border around her manipulated prints, so she peeled the border off, producing a unique image edge. I liked it so much that I started peeling off some of my borders.

PATRICIA (FRIEDMAN) ROSS. MANDALA. 1983
Ross used nine unmanipulated SX-70 prints to create this mandala piece.

GOLDEN MASK I.
2001
Peeling off the white border of the Time Zero print creates a unique image edge. Note how different this SX-70 manipulation is to the emulsion transfer from the same 35mm slide on page 115.

Separating the Mylar

In an SX-70 print, the image is on the transparent mylar top layer, and the backing sheet can be removed to create a different look. *Note of caution:* The white titanium dioxide developer inside the print is very caustic (alkaline). Either wear thin rubber or latex gloves or make sure you wash your hands if any developer touches your skin. If the print is new, the developer will be fluid and can be rubbed or rinsed off the print under running water to create transparent areas. If the print is older, the developer will have dried and become powdery, and is no longer caustic but neutral in its pH. You can wet it and rub off the areas you want transparent with a cotton swab or paper towel, or use a curved blade on an X-Acto knife to scrape away the unwanted areas.

You can handcolor on the back of the image with paints and permanent markers, creating a feeling of color radiating from within the subject or of the painted colors being part of the original scene. Paint the layers in reverse, starting with the foreground areas first and doing the background last. (See page 65 for more information.) Different backings can be placed on the semitransparent print. You can also sandwich images together or cut out part of an image and use it in a collage or mixed media piece. Note that if you backlight the image on mylar to give it a more transparent look, the increased light may decrease the image's longevity.

The steps that follow below are John Reuter's instructions for separating the SX-70 print and using the transparent mylar positive; they apply to SX-70 and also 600/Spectra/ Joycam prints.

1. Make your photographic image and allow the film to cure (harden) for several hours.

2. To separate the mylar front of the Time Zero print, turn your image over and carefully cut around the black negative square backing with an X-Acto knife (right), being careful not to cut all the way through to the front.

3. Slowly peel the negative away from the positive, and keep the negative for use later. (Sometimes part of the image will stick to the backing, leaving a clear area in the image.)

4. Run warm water (from the faucet) over the positive image and rub away the remnants of the titanium dioxide white deveolper on the back of the mylar with a cotton ball or swab until it's all removed (right). You are now left with a transparency. Allow it to fully dry.

5. Place the image on a light table. Use artist's maskoid (a material sold in art stores for masking white areas in watercolor painting) and paint over the areas of your image that you wish to retain. Be thorough here, and make sure every spot is covered. Let the maskoid dry thoroughly.

6. Dilute chlorine laundry bleach (1 part bleach to 4 parts water), submerge the image in the bleach, and watch carefully as the unprotected dyes are bleached away. Wash the image carefully to remove any residue of bleach remaining on the image. Let dry.

7. To restore opacity to the remaining image, paint the back of it with white acrylic paint. If you wish to alter the color, use a color other than white.

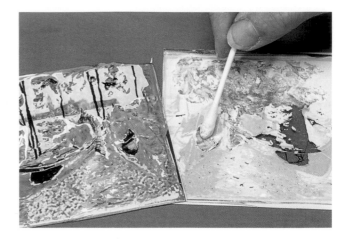

8. You can now paint the remaining clear areas or glue in collage elements with gloss acrylic gel medium.

9. When the image is complete, replace the negative that you cut off and tape it in place to seal the image.

10. When viewed from the front the image will retain the smooth surface qualities of an original image, even though new and unusual elements have been inserted. (See John Reuter's work on pages 184–185.)

Using the Negative Backing Sheet

Think twice about throwing out the white backing if you like to experiment. On the front white side of the backing sheet, you can see the lines left where you manipulated the image using pressured strokes. Joanne Warfield takes these backings, scans them into Photoshop, manipulates them further, and creates some very interesting abstract pieces. She calls them Time Zero Corrosions.

"First, I scan the negative as is, adjusting the contrast, shadow, brightness, and highlight areas in the preview mode prior to scanning. Next, I soak the negative in water for about a minute and scan it without touching the surface; then I soak it again and scan again, repeating this process. After subsequent soakings, wonderful textural erosion takes place, which creates depth and surface in the image. To my surprise, there was color within what appeared to be just black and white. You can enhance the

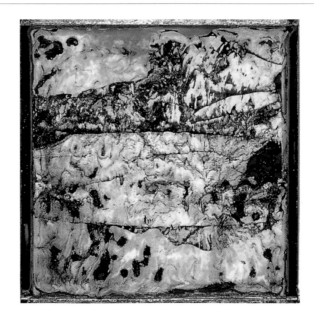

JOANNE WARFIELD. COBALT RIFT. 2001
Using the backing of a separated Time Zero print, artist Joanne Warfield scanned the backing, rinsed it, and rescanned it several times, making adjustments in the scanner to get different versions. She calls this process Time Zero Corrosion.

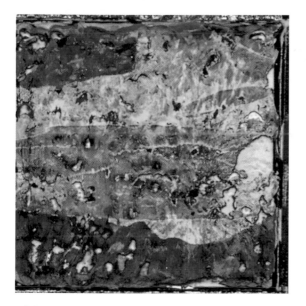

JOANNE WARFIELD. STRIA BLUE. 2001
Another Time Zero Corrosion, this is from the same Time Zero print as Cobalt Rift *opposite, but the reverse side of the mylar positive was used instead of the backing. It was also exposed to water and scanned.*

MAUREEN MONGRAIN. 2001
Copied, handcolored SX-70 manipulations encased in metal to form earrings, a pin, and a pendant.

image in Photoshop to bring out various features. I also love the abstract qualities of some of the Time Zero negatives that barely carried with them any recognizable image. Don't allow any water to leak into the scanner (see page 86). Keep a roll of paper towels close at hand for clean up. Wipe any chemical residue from the scanner when you remove the moist negative. After the last scan, clean the glass with Windex."

To further enhance these images in Photoshop, try the Posterize, Invert, Solarize, Contrast, Curves, and Color adjustments. (See pages 126–135). If you don't wish to scan the negative, you can further work with it manually. Scratch it with tools or moisten it with water, and rub with cotton swabs or a paper towel. Handcolor this abstracted image if desired.

Making Jewelry

A jeweler and photographer, Maureen Mongrain has been creating personalized designer jewelry she calls Lightboxes with SX-70 manipulations and Polaroid transfers. She makes each piece by using a Polaroid image and copying it onto a black-and-white negative. Small prints are made to fit into patinaed sterling silver Lightboxes that Mongrain constructs into pendants, earrings, and brooches. The prints are handcolored and covered with glass. She often makes custom jewelry using clients' old family photographs, creating story pieces. Using Polaroid films adds a dreamlike quality to the images. Many of the creative techniques for image and emulsion transfers found in chapter 5 can also be used with SX-70 manipulations.

Handcoloring SX-70, Color Laser, and Digital Prints

Handcoloring is very useful when you would like to add or change the colors in your Polaroid SX-70 image, or cover up a mistake. Of course, there's no need to handcolor an image with which you're ecstatically happy. However, if you do wish to work with your image further, there are several ways to approach handcoloring.

The first is to color the actual manipulated SX-70 print. The SX-70 prints are small and shiny, and require using artists' materials that adhere well to shiny surfaces. I find the best choices are permanent markers, Marshall's oil paints, acrylics, and in some cases, watercolors. You can color the surface of the print, or separate the print and color the back

AUTUMN TREE
I took this photograph with an SX-70 camera, manipulated it on the way home from teaching a workshop, and then handcolored it on each Iris print; after handcoloring a number of prints, I decided to color the image in Photoshop.

BARBARA ELLIOTT.
DANCIN' SHOES.
2000
This SX-70 manipulation was handcolored with markers on the Time Zero print.

side, so that the colors appear to come from within the print. However, if you plan to enlarge the print in some fashion—through scanning and printing digitally, getting an internegative and enlarging photographically, or just making a color copy—you may not want to color your original SX-70 print. When a print is enlarged, any little missed area or imprecision in coloring shows up a lot more than when the print is small. If you do color the print, I recommend using a magnifier light while coloring, and small pen points or brushes for detailed areas.

Another option is to color the enlarged print, which I think yields a better-looking result. Often, digital prints are printed on watercolor paper or canvas, which allows for a greater choice of coloring materials. Pastels and colored pencils work well on paper, and acrylics can be used successfully on canvas. Do not use watercolors on Iris prints or on many ink jet prints, because the printed inks will run. If you're doing a limited edition of each image, especially if you have large prints made, the main drawback of this method is that you would need to color every print in each edition. This might get repetitious, especially if you have large editions and/or large prints.

A third handcoloring option is to color the digital file of your SX-70 image in Adobe Photoshop or a digital paint program. I resisted this method for a long time, because I love the tactile aspect of handcoloring. I find it to be very meditative and enjoyable, and I didn't want my creative time tied to the computer. However, I wasn't enjoying coloring the SX-70 print itself because it was so glossy and small. And, I was concerned about any sloppy coloring showing up so glaringly when the print was enlarged. I then tried coloring each Iris print, but the thought of coloring the same images over and over in each edition was rather daunting. Finally, I tried coloring on the computer and found that I actually enjoyed it.

Whatever option you choose—or if you incorporate a little of each method—it's important to try out different artists' materials to see which ones you like to work with best. Then, practice on your reject prints until you develop a style that you like. The following sections offer more detailed information on each handcoloring method. *Note:* There's a lot of information on handcoloring, artists' materials, and color theory in my other book, *Polaroid Transfers.*

Working on the SX-70 Print

You can color the SX-70 print at any time after manipulation is complete. Since the print surface is shiny, some artists' materials—such as soft pastels or lead colored pencils—won't stick to the print without spraying the surface with a matte spray. I, personally, don't like to spray the image, because it creates a layer between the coloring tool and the print; I don't have as much control in blending colors or staying within a subject edge. Watercolors will stick to the print surface but can leave uneven layers and areas of pigment that, when enlarged, can look "blobby." You can use brushes or watercolor pencils and crayons. Of course, if you're a skilled watercolorist, you'll probably have more success than I have with watercolors.

For me, materials that are transparent, and that I can apply smoothly and evenly, work the best. Markers must be permanent—water-based markers will rub off and won't apply as evenly. Examples of good markers are the Pantone Tria markers, Zig, Sharpie pens (limited in color selection), and Prismacolor markers. The Prismacolor colors are more fugitive, meaning they will fade more quickly. Look for markers that have broad and fine tips on the same marker. Even though the markers are permanent, you can use a cotton swab to blend, lighten, or remove color completely if you do so right away after applying the color. If you need to work in a smaller area, you can make a small cotton swab with a round toothpick and a small piece of a cotton ball swirled around the end of the toothpick.

Marshall's Photo Oil paints, which are more transparent than regular oil paints, are made especially for handcoloring photographs. I like the smoothness I can get with these paints. A little dab goes a long way, so it's best to use a palette and squeeze out tiny amounts of the colors you want to use onto that. You can easily mix colors on the palette, although buying a larger set gives you more pre-mixed colors. I apply the color with a cotton swab or toothpick swab, then rub off much of the color and blend until I'm satisfied. A kneaded eraser is a good tool to remove unwanted color.

Once the oil starts to dry, blending becomes problematic with a newer layer or color, so finish one area before going on to another part of the print. One disadvantage of oil paints is that they take much longer to dry—about three days—so you can't

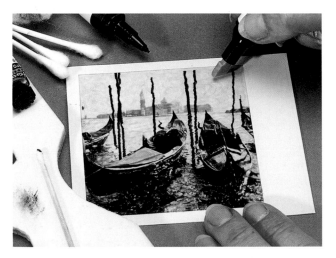

When handcoloring on the Time Zero print, use materials that you can apply smoothly and evenly, such as the permanent markers used here.

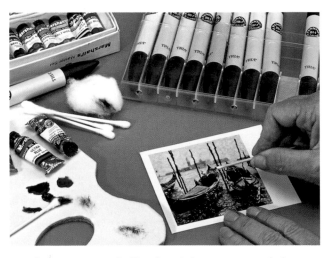

Another option, Marshall's Photo Oil paints are made for handcoloring photographs and are a good choice for Time Zero prints.

GOLDFEATHER MASK.
2001
Metallic pens are good for outlining and for drawing on your SX-70 print. Gold and silver can impart a stained glass look to an image and are my favorites for achieving this effect.

stack the prints until they're dry. Prop them up while drying, because if they lie flat, dust can collect and become embedded in the oil.

Plastic-based acrylic paints are much more opaque than oils, and should be thinned with acrylic gel medium to add transparency, unless you want to cover areas of your print. Liquitex and Golden make a thinner viscosity acrylic paint that you may not have to dilute. Acrylics are a good choice when separating the SX-70 print from its backing and coloring the back side of the print. Remember to color in reverse; that is, put the foreground colors down first and the background colors last. Keep in mind that once acrylics dry, you can't rework them.

Pearl-Ex powders are tiny mica pigment particles that can be mixed into oils, acrylics, watercolors, and many other mediums to add a metallic sheen to your colors. Since they aren't actually metallic, the colors won't tarnish. I enjoy working with Pearl-Ex for those images that can benefit from a little

sparkle. In addition, metallic pens are good for outlining and drawing on your SX-70 print. I find that the pens with the ball that you have to shake generally go on thicker but tend to dry out faster.

If you do much handcoloring of your prints, it would be useful to learn about mixing colors with pigment. This is different than mixing colors with filtration (white light) when using the Daylab's dichroic color head. The three primary pigment colors are yellow, red, and blue, from which you can mix all other colors. Complementary colors are those that are opposite one another on the color wheel, and when a color is mixed together in equal proportions with its complement, the two create a gray and muddy color. Examples of complementary colors are red and green, blue and orange, and yellow and purple. When placed next to one another, each color makes its complement appear more vibrant. Consider using a complementary color instead of gray or black for shadows.

Working on an Enlarged Color Copy or Digital Print

I find it much easier, and I can do a better job of coloring, when the print is larger and has a matte surface. For color copies, ask your copy center to use their 90 lb matte cover stock (or 60 lb, if they won't use the 90 lb—it sticks in some machines). The heavier matte paper is a much nicer quality than the regular, flimsy, and somewhat shiny paper that's normally used in color copy machines.

I find that colored pencils work best on color copies, and Prismacolor colored lead pencils glide on and blend best. If I don't like what I've done, I can completely erase it with a kneaded eraser, which is a big plus for me. Then I don't have to worry about ruining a print. Watercolors can cause the paper to buckle since it's not art paper. Pastels don't stick as well as the pencils; however, you can apply a matte

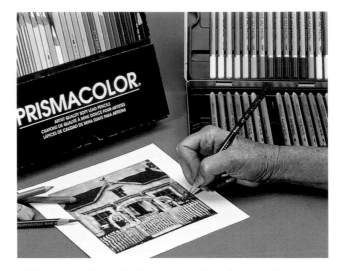

Coloring an enlarged color copy or a digital print of an SX-70 manipulation with colored pencils and pastel pencils (above) is easier than coloring the SX-70 print itself.

MENDOCINO HOUSE. 1999
I took this image with an SX-70 camera and handcolored the Iris print with Prismacolor and pastel pencils.

spray first, and use pastels and pastel pencils. I tend to stick with soft lead pencils, such as Prismacolor brand, for handcoloring color copies. Other brands will work, but soft, waxy pencils are easier to blend and go on more smoothly.

You can't remove or alter the colors from markers once you apply them. Oils are generally acidic, and can penetrate into the paper and rot the fibers unless you coat the print with Marshall's Pre-Spray. However, note that Marshall's states that its oils are acid free.

Digital prints come in many varieties, from a home inkjet print to a large Iris or Roland print on watercolor paper or canvas. (See digital printing section on pages 137–140.) If you're coloring an inkjet print output from your home computer printer, make sure the inks won't run if you're considering using watercolors. The type of paper on which you print will also be a key factor in what coloring materials would work best. Many inkjet printers allow you to print on watercolor or a thicker paper than regular inkjet paper. Epson printers produce great results on their papers, but the prints won't look good on watercolor papers—except those of their own brand—unless you create or purchase a profile for that paper and ink combination (see chapter 8 for more on different printers, inks, and profiles). Colored pencils work well on matte surfaces.

For any print on watercolor paper, soft pastels, pastel pencils, and colored pencils are my favorite mediums. With pastels, if I get too much color on the print, I can gently rub some of the color off with a cotton ball, cotton swab, or kneaded eraser. I can also blend color with cotton balls, cotton swabs, and tortillons (tight twists of paper that come in various sizes). However, note that if you rub too hard, you can accidentally take off some of the image.

I like the Conté and Schwann Stabilo Carbothello pastel pencils best because they are soft enough to blend well. For pastels, Rembrandt brand also blends well. Sennelier pastels (which are very soft) offer some great metallic and pearlescent colors.

BEACH UMBRELLAS, THAILAND. 1998
Made from a 35mm slide, the final version is an Iris print on Somerset Velvet watercolor paper. The water wasn't blue enough, so I handcolored the print with a Rembrandt soft pastel.

Working in Adobe Photoshop

For SX-70 prints, coloring in Photoshop is now my favorite method. I'm not going to give a course in Photoshop here, but rather share what I do and give some options as a starting point for your own artistic explorations.

First, I scan the manipulated SX-70 print at the highest optical resolution of the scanner at the original print size (or divide the highest resolution by two if the file size is too large for the computer). Then, I make a copy of the raw scan of the image and rename it so that I don't risk altering the original scanned file of the image. It's best to make any alterations on the largest image size you can, then downsize with duplicate files (or adjust the percentage size in the print dialog box when printing) for smaller versions after you've made all the adjustments. The image quality will suffer if you start with a very small file size and then enlarge it too much.

However, don't worry if you don't have a fancy computer setup. Dewitt Jones (pages 172–173) works with 5 to 10 MB files, prints up to 13x13-inch images on watercolor paper, and is very pleased with the results. This may be because the SX-70 manipulated images are softer and don't have as much detail as a

CARNEVALE COUPLE. 2001
*By using Photoshop commands such as Levels, Curves, and Replace Color to adjust this image,
I found that I didn't need to handcolor at all to get the desired effects.*

straight photograph; therefore, by increasing the size of the image in Photoshop, or with Genuine Fractals software after making corrections and handcoloring, the interpolation of pixels seems to work just fine. I would recommend that you color on the largest file that you can easily work on with the computer system that you have.

Bob Cornelis of Color Folio, a digital imaging studio for Roland and other digital prints in Sebastopol, California (see their website at www.colorfolio.com), showed me an excellent Photoshop workflow for versions 5.5 and above that I will pass on here. After having learned on an earlier version, I've found that this system is such a vast improvement that I highly recommend you follow at least the basic principles and fill in the details as your skill level and interest permit.

The key idea is to make any alterations to your image on layers so that your image, or background layer, remains untouched. If you don't like anything you've done, you can adjust or remove that layer. You can make each layer visible or invisible so that you can see or hide its effects. (See pages 126–135 for more.) The first layer to create is a transparent layer for cloning—cleaning up scratches, dust spots, and black marks or mistakes that you made while manipulating the image and want to cover up. Make sure the Use All Layers box in the program is checked, otherwise you won't be able to clone on a transparent layer. It's best to do any cloning repairs and handcoloring at 100 percent of the resolution size of the image with a dust-spot sized soft brush. The image will look huge on your computer monitor, especially if you are working with a very large image size.

On the cloning layer, with the cloning or rubber stamp tool, I select the area next to the unwanted spot and literally cover up the mistake. I work on one small section at a time, starting at the upper left, scrolling down slowly, and correcting as I go. Then at the bottom, I scroll over to the right (overlapping the row I just did) and go back up, continuing this until I've completed the corrections. Then, I make any contrast and color-balance adjustments on other adjustment layers (see chapter 7).

If you have Photoshop LE or Photoshop 4.0 and earlier versions, you won't be able to create cloning or adjustment layers without duplicating the background layer, which will double the file size for each background layer you duplicate. If you don't have enough RAM, you'll need to make your adjustments on the background layer and save them with your image file, or save a copy of a version so that you can go back to it and start again if you don't like what you've done. Photoshop LE is a simpler version than the full Photoshop program, and is a good program to start with if you're unfamiliar with Photoshop and feel intimidated. It comes bundled with some scanners, printers, and any size Wacom tablet.

For the actual coloring, I prefer to create a layer for each color or color group. One layer is certainly adequate to start with. However, if all the colors are on one layer, when you change the brush or layer opacity setting, which determines the strength of the colors, you change the opacity of all the colors instead of just the yellows, for example. The advantage of having more layers is that you can change the opacity of each color independently. Also, if you've colored at a 60 percent opacity setting and the colors are too strong when you make a print, you can lower the opacity setting to tone the colors down without having to recolor anything. Conversely, if you want to intensify the colors, just increase the opacity to 75 or 100 percent.

The best coloring tools to use in Photoshop are the paintbrush, which creates soft strokes of color; the airbrush, which applies gradual tones to an image, simulating traditional airbrush techniques; the pencil tool, which creates hard-edged lines; and the eraser. For each tool, you can choose the color with which you want to work, the blending mode, the opacity, and the paint fade-out rate. You can also choose a brush size and shape, its hardness, spacing, angle, and roundness, or you can create custom brushes. With a stylus tablet, you can also set the effect when varying the stylus pressure.

I keep the coloring with Photoshop fairly simple. I use the paintbrush tool because I have more control than with the airbrush tool, and because the airbrush increases the file size more than the paint-

By starting at a 60 percent opacity setting on the layer, if the color is too strong, you can lower the opacity setting without having to erase or recolor anything.

Setting the layer opacity setting at 0 percent, none of the coloring (done on the yellow part of the leaves and white outlines on the grapes in Photoshop) is visible.

brush does. With the paintbrush tool, I start with a brush opacity setting of 60 percent. Then I can vary the strength of my colors by simply adjusting the brush and layer opacity settings. I use a soft brush, unless I want a harder edge to color precisely along the border of a subject. In a small area, I choose a small brush size; in a large area, a large brush size.

You can also set the fade-out rate. The fade-out rate determines how fast the stroke fades out to become transparent. The smaller the number, the shorter the stroke before the color runs out, no matter how long a stroke you make with the mouse or stylus. I don't use a fade-out rate, but I suggest you experiment with what works best for your handcoloring style. Short strokes at a fade-out rate of 30, a hard brush, and an intense color opacity at 100 percent will yield a very different result than long strokes, no fade-out rate, a soft brush, and an opacity of 25 percent. If you're intimidated by the features of the tools, just leave the settings at default until you feel ready to try different options. By all means, refer to the manual or one of the many books on using whichever Photoshop version you have. Once you learn to use the basic features of each tool, you can have a lot of control over the effects you want to create.

With the layer opacity setting at 100 percent, colors will be the strongest.

A Wacom tablet and pen are excellent alternatives to using a mouse for cloning and handcoloring. The inexpensive Graphire 4x5 tablet offers 512 pressure levels for the pen, and the professional Intuos models have 1,024 pressure levels. You can customize

the pressure levels to brush size and softness. I have the 6x8 Intuos tablet and like it very much.

The more I work with changing color balance and specific colors with the Levels, Curves, Hue and Saturation, Selective Color, and Replace Color options, the more I realize that often I can make the changes I'd normally make with handcoloring by using these commands. Once you get comfortable using these commands, select certain colors or areas of your image with the lasso, magic wand, or marquee and experiment (on a layer, of course). It can be a lot quicker and more precise than manually handcoloring everything, especially if you can print out your own proofs.

If you aren't pleased with what you've done to your image, there are several ways to undo mistakes. I use the history palette (in Photoshop 5.5 and above, not in LE), which records every move I make. I can delete just the last stroke or cloning move, or go back to the last version I want to keep and easily trash every move that I made after that point. Make sure that you choose the layer on which the adjustments were made! If I later decide I want those

moves back, Photoshop lets me restore the image to how it looked at any point in the current work session if there's enough memory. You can also save different versions or make snapshots of your image at various stages, and create new image files from those versions. It is such a relief to know that I can try a lot of different approaches and not have to worry that I am ruining my print.

You can also add various textures and effects by using the history brush (available in version 5.5 and above, not in LE) and filters. With filters, you can even change your image into a watercolor effect or charcoal sketch, or you can distort the image in a variety of other ways. Sharpening should be the last adjustment you make before printing because the same setting will affect the look of various sizes of prints differently. The best method is to use the unsharp mask filter on a flattened version of your file (see page 135). In general, go easy on the settings, you can always apply it several times. Overdone sharpness can look unattractive and not enhance your image at all. While learning, be sure to practice techniques on duplicates of your original scans.

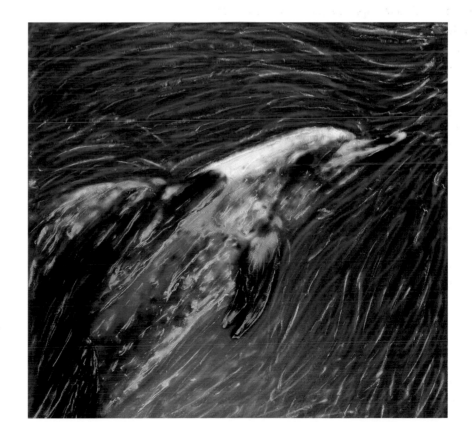

DOLPHIN DAYS. 1999
I made this SX-70 manipulation from a 35mm slide I took of Atlantic spotted dolphins using my underwater camera. Since the background was a large area of solid blue, I drew lines when manipulating the print to exaggerate the flow of the water. I added more light blue lines and the lavender in Photoshop.

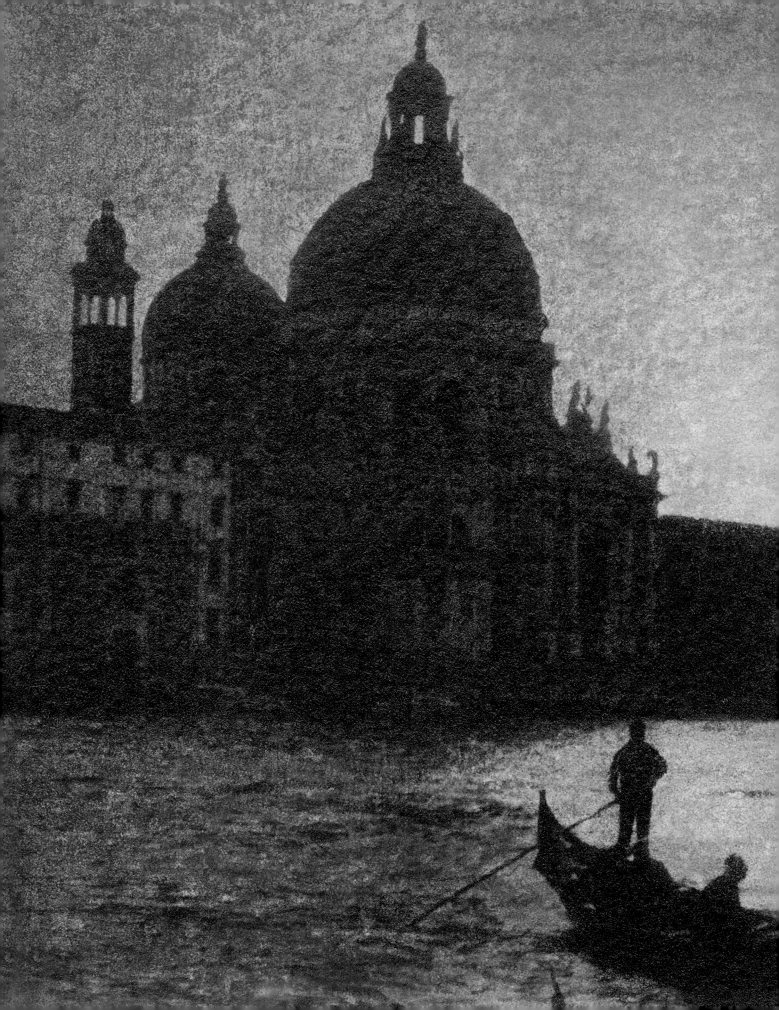

POLAROID TRANSFERS:
FURTHER EXPLORATIONS

One of the great things about Polaroid transfers is that you don't need a lot of expensive photographic equipment or a darkroom to create them. Nor do you need a photography background, since the technical basics are quite simple. To make a transfer you can use a Polaroid camera (or a Polaroid back attached to a view camera), a slide printer, or if you have a darkroom, you can projection-print with your enlarger to expose the Polaroid film. I find slide printers to be the easiest, most versatile, and affordable way to expose 35mm slides onto Polaroid film for both image and emulsion transfers, so I'll focus here on using them.

Since the publication *Polaroid Transfers: A Complete Visual Guide to Creating Image and Emulsion Transfers* (Amphoto Books, 1997), I've learned much more about the creative and technical aspects of making transfers, and new Daylab slide printer models have been introduced. I wanted to include a section in this book to update this information. If you're new to image and emulsion transfers (also called emulsion lifts), I encourage you to start with *Polaroid Transfers,* which has a very thorough beginner's section. The material presented here is supplemental to that and is not intended to be a complete introduction to image and emulsion transfers.

Creative Techniques

Many of these are techniques I've learned from other artists; some are from my students and a few more are ones I've been working with on my own. The first section describes processes that work with both image and emulsion transfers, and this is followed by techniques for image transfers only—including special instructions for using Polacolor Pro 100 Type 679 film. The last section covers methods for emulsion transfers only.

PREGNANT NUDE ON OSTRICH EGG. 1998
Emulsion transfers work well on three-dimensional surfaces, such as eggs.

Image and Emulsion Transfers

Using Black-and-White Slides or Negatives

Even though Polacolor film is color, when you use a black-and-white slide or negative, your transfer will be black and white. You can then use color filtration to add a warm or cool tone; for example, try 15 magenta + 30 yellow for sepia and 30 cyan + 30 magenta for blue. You could also add, say, 80 magenta—or any other color—to pump up a monochrome, more abstract look.

Manipulation During Image Development

Try using a burnishing tool, crochet hook, knitting needle, or closed pen to draw, rub, and manipulate parts of the negative before separating the film to get an altered look to your transfer. This is a good technique for emulsion transfers especially, because you have a full minute in which to create. Applying different pressures on the negative side at varying times during development will affect the color dye layers as they migrate, so you can create different effects. Yellow transfers first, then magenta, and lastly, cyan.

THE GLEN. 2001
Even though I used color slide film to copy this black-and-white print, and color Polaroid film to make the transfer, the resulting image is black and white because the original image was black and white.

Mandalas

By using the same image, or variations of the same image, you can make a mandala pattern from four or more exposures. If you expose some of the images backwards and then place the transfers in different arrangements, you can create mandalas that look

TRANSFER BASICS

To create an image transfer, you expose a 35mm slide (or medium-format transparency for the Daylab 120) onto peel-apart Polacolor ER film using a slide printer. The negative part of the Polaroid film is peeled apart early and rolled onto another surface, such as watercolor paper, to develop. The resulting transferred image may then be further manipulated and handcolored.

While using the same film and equipment, the emulsion transfer process yields completely different results. You expose the image onto the peel-apart film and allow it to fully develop onto the positive print. You then remove the image layer of the print (the emulsion) by putting the print in hot and then cold water; then, you can place the removed emulsion on virtually any surface. You can sculpt, stretch, and tear the transparent emulsion into different shapes and then handcolor it if desired. Each transferred image is unique due to the physical properties of the transfer process.

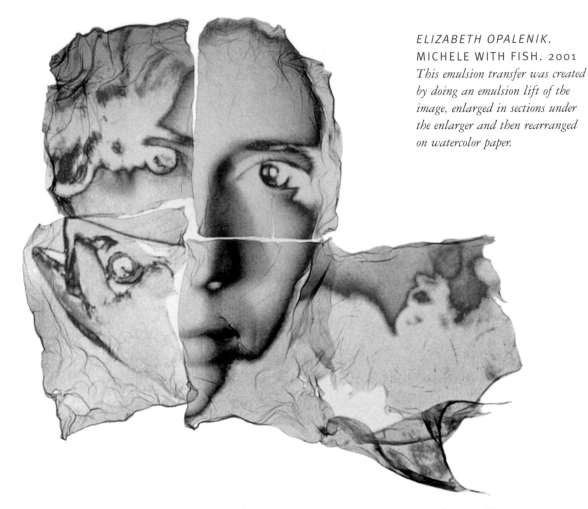

very different from one another, using just one slide (see Cynthia Johnson-Bianchetta's tulip mandala on page 171).

Mosaics

To create a mosaic effect, you can place a number of transfers next to one another; each transfer can be a different part of the same subject or each can be a different subject altogether.

You can also create a mosaic by taking one or two emulsion transfers and cutting the image(s) into sections with an X-Acto knife. I highly recommend cutting after you have the image or images on the receptor surface; trying to fish little pieces of emulsion out of the cold water tray and spread them out again is no fun, believe me. Or, you could expose one image in segments onto several pieces of Polaroid film and reassemble the image (in transfers) on the receptor surface. You can do this most easily by pro-

jection printing with an enlarger. However, you can also enlarge the image to maximum size on the Daylab 35 Plus or Daylab II, and then crop and expose different sections of the image by moving the slide holder.

Bleaching

If your transfer—or an area of it—is too dark, you can lighten your image with bleach. Start with approximately 1 teaspoon of bleach per pint of water, and put the solution in a tray; it's much easier to control the effects of bleaching when the bleach mixture is diluted.

To bleach the entire print, immerse it in the tray face down, and agitate the tray for a few seconds. Remove the print, and watch it carefully. When you like how it looks, rinse it immediately under cold running water to stop the bleaching action. If you want a stronger effect, add more

bleach. The longer you bleach, the bluer the transfer or print will become. Some handcoloring may be required to counteract the color shift, as in the image at right.

To bleach selected areas of the print, use a cotton swab or paintbrush to apply the diluted bleach solution. Or, use rubber cement, Luma Liquid Mask, or Photo Maskoid Liquid Frisket (the transparent red color lets you see what you've masked) to cover areas you want to prevent being bleached. Practice on prints you don't like first.

Staining with Coffee or Tea

Coffee and tea have been used for a long time to give a sepia look to artwork. It is the tannin in tea that stains. Be sure to brew up fresh pots of coffee or tea if you're staining many transfers; the stronger the brew, the darker the coloring. Let the coffee or tea come to room temperature before immersing your prints in it. I leave the transfer in until I like the color. You can mask off areas you don't want stained using frisket or the other masking solutions mentioned in the previous technique.

Using the "Leftovers" of Peel-Apart Film

When making an image transfer, don't throw away the "pale positive" print. (*Note:* It should be pale if you're separating the film after ten or fifteen seconds). Many times, you can use that print for an emulsion transfer to layer over an image transfer or other emulsion transfer, or in a mixed-media piece. The pale positives are more transparent and can come in handy for collage, or can be used on their own. Portraits and nudes often work well and can look like vintage sepia prints.

With the emulsion transfer, don't throw away the negative after developing the print for one minute. You can make an image transfer from that negative. I discovered this in a workshop. You must let the negative (kept warm) stay on the watercolor paper for around three minutes to get a good result. Dark images from saturated slides have more dye

GOT MILK? 2001
This image transfer was too dark, so I lightened it with a diluted bleach-and-water solution. The bleach made the image bluer, so I then colored the statue by rubbing on Pearl-Ex gold powder with a cotton swab.

NUDE IN CHAIR. 1998
I used the pale positive left over from an image transfer to make this emulsion transfer on handmade paper. I rubbed Pearl-Ex gold powder onto the transfer to add a shimmery quality.

and the image will show up better. In an emulsion transfer workshop, we're not set up with a tray of 100°F water, so I place the "ghost" image transfer (negative on watercolor paper) directly on the warming tray—instead of floating it on the water—next to its positive print that I am drying for three minutes to make the emulsion transfer. At the end of three minutes, I peel the negative and get a ghost image transfer—usually lighter, more magenta, and more textured. Some look like Pointillist paintings and can be very interesting. If you have the setup, it would be better to float the developing ghost transfer on top of a tray of 100°F water because the dyes would be less likely to dry out and create liftoff. Three minutes is about the maximum time on the warming tray, but you could leave it even longer on the warm water for a more saturated ghost.

Another technique that works with the used negative from an image or emulsion transfer is to "wet scan" it (see page 86). I love getting two or more images from one piece of Polaroid film—definitely getting my money's worth!

BUDDHA WITH LOTUS. 2000
For this piece, I made a double exposure of two 35mm slides using the Daylab slide printer, and then placed the emulsion transfer on book cover cloth.

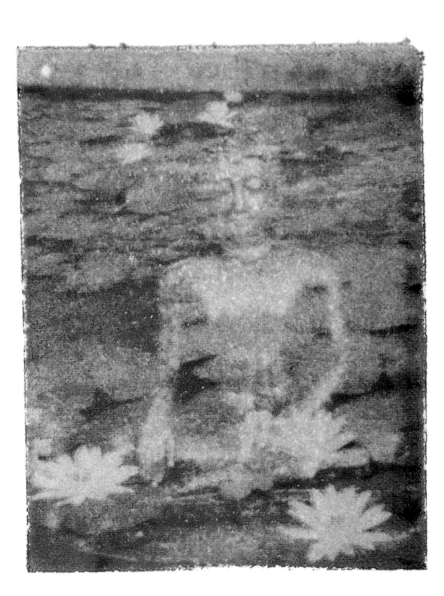

BUDDHA WITH LOTUS (GHOST).
2000
I used the Polaroid negative from the emulsion transfer double exposure (above) to make a "ghost" image transfer.

Using Other Surfaces

Papers

A variety of handmade papers and bark paper make excellent choices for image and emulsion transfers. Many wonderful papers are not acid free or considered permanent. However, I've recently come across a product called Archival Mist that neutralizes the acid that contributes to the deterioration of many papers. You spray it on whatever materials you use. Of course, it's best to start with acid-free or slightly alkaline papers, because the environment in which we live is slightly acidic.

Fabrics

In addition to transferring onto a variety of natural fabrics, cheesecloth can add an ethereal quality to image transfers, since only part of the image is there. You can use the image on the cheesecloth as one layer, with the same or another image underneath it. Joan Emm has also used cheesecloth over watercolor paper to block part of the image from transferring onto the paper (see top left image on page 80).

Sheets

Diane Fenster has created an impressive photo installation using image transfers and bed sheets. Entitled *Secrets of the Magdalen Laundries,* it was originally exhibited at Gallery Henoch in New York City in 2000 and has been traveling to other venues including the SIGGRAPH2001 Fine Art Gallery in Los Angeles. The installation consists of fifteen cotton bed sheets of various sizes, each imprinted with two 20x24 Polaroid image transfer portraits of a woman. The additional images on the sheets were created using a dye sublimation process provided by Image Transform of Des Moines, Iowa. Another component of the installation is a sound element, attained with motion-activated speakers inserted in the top hems, behind the sheets, and in some of the washtubs below the sheets.

As Diane Fenster explains: "*Secrets of the Magdalen Laundries* explores imagination in the inner life. Dreaming, reverie, and fantasy are ways of being that make the reality of circumstances more tolerable. The Magdalen Laundries convent industries in Ireland existed from the mid-19th century until the late-20th century. They institutionalized women

DIANE FENSTER. SECRETS OF THE MAGDALEN LAUNDRIES. 2000 *Gallery installation.* PHOTO ANTHONY NELSON

JOAN EMM. MOTHER AND CHILD. 2001
To create this image, Emm laid cheesecloth over a piece of watercolor paper before transferring the photo onto it, and then removed the cloth after the transfer was done. The cheesecloth prevented the image from transferring to the paper in those spots.

DAYLE DOROSHOW. BOOK COVER. 1999
Doroshow placed a 3x4 handcolored Polaroid image transfer in a polymer clay book cover.

with the reputation of being immoral—or who were indigent—and kept them imprisoned, lost to both their families and themselves. Their vitality and eros, bound by the morality of the Church, reemerges as images on the sheets that they repetitiously wash."

Polymer Clay

Polymer clay is a wonderful surface onto which to transfer. Polymer artists Dayle Doroshow and Christopher Knoppel provided my introduction to transferring onto polymer clay when they took my workshop to see if they could add Polaroid transfers to their jewelry and sculptural pieces. There are several varieties of polymer clay that can be fired in a toaster oven. The best known are Fimo and Sculpey

CHRISTOPHER KNOPPEL. PIN. 2001
This piece of wearable art is a Polaroid emulsion transfer baked onto polymer clay, with gold leaf on a polymer clay frame and a sterling silver pin back. PHOTO DON FELTON

brands. Fimo is stiffer than Sculpey and can be used for book covers, book pages, and larger pieces. You can use polymer clay for both image and emulsion transfers, and you can transfer an image onto the clay before or after firing it. If you're transferring the image before firing, the emulsion actually fuses into the polymer clay when it's fired, which is more permanent. You can flatten the clay by using a rolling pin or by sending it through a pasta maker. Or, for emulsion transfers, you can place the image onto the clay after sculpting the clay into a three-dimensional shape.

To apply an image transfer, the clay needs to be flat in order to roll the image onto it, but you can sculpt the clay after the image is dry—being careful to not damage the image. Follow the firing instructions for the clay that you use.

Mixed Media

You can handcolor your transfer and continue coloring past the borders of the transfer. Or, you can insert transfers into paintings and drawings (as Judi Bommarito did at right). Emulsion transfers are more transparent and can easily be layered over existing artwork. Image transfers need to be applied onto a porous surface, or placed onto paper and collaged into the larger piece.

Incorporating Text

There are several ways to incorporate text into transfers. If you use Photoshop 6, it's very easy to create a "type" layer on which you can add one word or paragraphs, type horizontally or vertically, distort and curve the type in many different ways, adjust transparency or opacity by degrees, add embossing, drop shadows, you name it. Very cool.

If you don't have Photoshop, don't worry. There are still a number of ways to incorporate text into your images. You can make a slide of your text by photographing it onto 35mm slide film and positioning it in the frame where you want it to appear in your image. You can also type and style the text in your computer and print it out onto film media for inkjet printers, or onto overhead projection acetates for laser

JUDI BOMMARITO. VULNERABILITY. 1998
Bommarito's mixed-media collage on watercolor paper makes use of transferred type, emulsion transfers, and oil pastels.

printers. However, at the 35mm size, the quality won't be as good as photographing onto 35mm film. With the slide of the text (with dark type and a clear background), you can make a slide sandwich: Place it with your image in the slide printer and expose both slides at the same time onto the Polaroid film.

With a slide sandwich, whatever is darkest in either slide covers anything lighter, so your type will show through. Or, if you have light type and a dark background, you can double expose the type with your image slide. In a double exposure, whatever is the lightest value in each slide will cover anything darker where the two images overlap. So, your light type will be dominant over any darker part of your image slide, and the dark background will all but disappear.

With double exposure, you can choose the positioning for the type relative to the image because you're aligning each slide separately. You can also make the type smaller or larger if you have a Daylab slide printer with adjustable bellows, or an enlarger for projection printing. If there are a lot of light areas in your image, the text may not show up well in those places. You can use the slide sandwich and double-exposure technique to combine images, as well.

Another way to incorporate text is to use pencils, markers, or permanent pens to handwrite onto the receptor surface before you lay down the transfer. Or, you can write directly on the transfer. If you don't feel up to calligraphy, you can also print text from your computer onto watercolor paper. Just make sure that if you use an inkjet printer, the ink won't run when you place your transfer on top of it.

You can also copy or print text onto acetate film transparency sheets for overhead projectors (found at any copy shop or office supply store). Then, you can use the acetate sheet to place a type layer over the transfer (or under an emulsion transfer). Or, use Linda Barrett's transfer method of ironing the acetate sheet with text onto your transfer or onto the receptor paper prior to transferring your image. (See Resources for her class contact information.)

This technique works especially well with black lettering. To transfer, the carbon side of the type must be facing down onto your transfer (or paper), so you will need to print or copy your text reversed, or flopped, at the copy store. Place some newspaper under your receptor paper, set the iron on low with no steam, and align the acetate where you want the text to be. Press down, and iron back and forth over the text for approximately thirty seconds to one minute. Grab the corner of the acetate and slowly peel it off the paper, keeping the iron pressed against the acetate as you pull it up.

LOUISE ROACH. THE HESITANT SAINT. 1999
This piece is a Polaroid emulsion transfer over collage on a steel panel with oil glaze. The artist wrote the text, adhered it to the panel with acrylic gel medium, let that dry, and sanded it with an electric palm sander. The emulsion transfer of the saint was placed over the text.

Coating the Surface of the Transfer

Wax

Covering the surface of the transfer with wax (encaustic), resin, or another coating can add more dimension to your transfers. Aubri Lane, whose work is below, has done some wonderful transfers using wax. She enjoys creating pieces that can be touched and smelled, as well as enjoyed visually.

Resin

Especially with emulsion transfers, for which a glossy look is appropriate, you can apply varying thicknesses of resin to coat or completely embed your image. Barbara Elliott has been placing emulsion transfers on stretched canvas and tiles, sometimes adding rubber stamp designs, and then pouring Ultra-Glo resin over the entire piece (below and on pages 162–163). Masterpiece Artist Canvas makes prestretched canvases in various depths with finished edges.

Acrylic Gel Medium

This medium comes in matte, luster, and gloss finishes, and can be diluted with water if you want a thinner coat. Acrylic is plastic based and is an easy way to add a finish and protect your images, especially for emulsion transfers.

Chine Collé (Paper Gluing)

Sometimes, an image can benefit by having more texture. Using a chine collé–like process, you can cover all or part of an image with thin handmade papers or acid-free silk tissue, giving more texture and dimension. You can apply other pale transferred images to the handmade paper, and adhere the layers with acid-free paste or acrylic gel medium.

AUBRI LANE. TRINITY. 1998
Lane layered gold paint, handmade paper, and melted beeswax over canvas, the Polaroid image transfer, and a vintage mat. She used a paintbrush to apply the liquid wax.

BARBARA ELLIOTT. GRID HEAD IN BOX. 2001
Elliott placed the Polaroid emulsion transfer on stretched canvas, coated it with Ultra-Glo resin, and placed it in a box covered with quilted copper fabric.

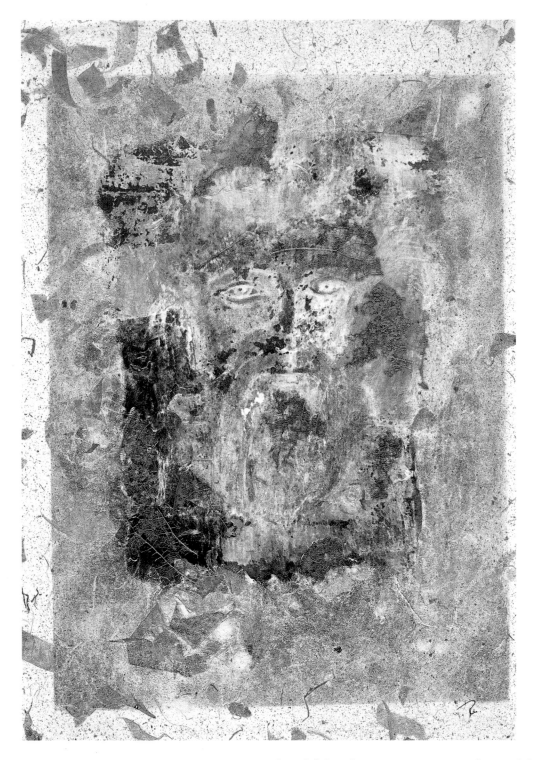

THERESA AIREY. THE APOSTLE. 2001

As Airey describes, this piece makes use of the chine collé technique: "I first made an 8x10 emulsion transfer onto watercolor paper and enhanced the image with handcoloring. Not satisfied with the results, I scanned the image and printed it on Lumijet's Museum Parchment inkjet coated paper. Still not satisfied, I used a process called chine collé to add more dimension. First, I selected a fairly transparent oriental paper with

bits of skeleton leaves. I cut out an area the size of the apostle's face, then coated the image with an acrylic matte medium thinned slightly with water. I laid the oriental paper on top of the image so that the face was visible through the torn hole. I added a few more leaf inclusions in the face area using the matte medium as glue. When I was satisfied with the results, I gave the entire image another thin coat of acrylic matte medium and let it dry."

Making Books

I started noticing beautiful handmade books in 1998 when Cynthia Johnson-Bianchetta and I began planning our annual Women's Creativity Retreats. Cynthia had been making and collecting books for several years, and we decided to include making simple books in our retreats. Then I started teaching workshops at the San Francisco Center for the Book in San Francisco.

I was amazed at the variety of methods and the potential for making books with Polaroid transfers on the cover and pages. There are so many yummy handmade papers to use. About that same time, Dayle Doroshow (see pages 80 and 160–161) came to one of my workshops with sculptural polymer clay books that she had made. You can create journals, memory books, illustrated stories and poems, gifts, portfolios—anything you want, from a simple accordion book to one with sewn signatures. And, if actually making a book doesn't appeal to you, you can buy ready-made books at art supply and gift stores and add your artwork to them. I've even made books of my transfer work with my inkjet printer and found an upholsterer to stitch them. I won't go into the how-tos of bookmaking here, but there are many beautifully illustrated how-to books on this subject—such as Shereen LaPlantz's *Cover to Cover*—or workshops where you can learn to make books.

HEATH FROST. PREY THEE MAIDEN. 2001
This book cover is a Polaroid image transfer on silk with rubber stamping, hand and machine stitching, ribbon, and beads.

ELIZABETH MURRAY.
BEHIND THE SANCTUARY DOORS. 2001
Accordion book with laser prints of SX-70 manipulation images that have been handcolored with pencils and oils.

Photoshop Manipulation

Wet Scanning the Negative

This technique is the digital version of Theresa Airey's "pulled negative" transfers. Sometimes, the negative from an image or emulsion transfer can look quite amazing. To make her pulled negative transfers, Airey takes a negative she especially likes, rinses it under hot water, and immediately copies it onto 35mm slide film on a copy stand; sometimes she solarizes the negative with a 500 watt bulb on the copy stand before copying it. From this slide, she makes transfers.

To copy the negative digitally, you need to scan the Polaroid negative when it is wet. Wet negatives give better color and definition, which requires making a wet area on your scanner glass. Use a silicone bath sealant to outline on the glass a rectangle larger than the negative to be scanned. Draw the outline with one continuous movement, making sure the corners join perfectly. You can also use several layers of electrical tape instead of silicone. Place the wet negative face down in the rectangle on the scanner glass. Make sure no water seeps through the rectangle. Leave the scanner lid up while scanning. (See chapter 10 for more information on scanning). If you see tidemarks on the scanned image, rewet the negative and add a little water to the rectangle area, then rescan. Be sure to scan in positive mode so that you end up with the negative image.

The best color paper negatives are from Polacolor ER films: Types 669, 559, 59, or 809. For black and white, Types 53, 553, and 803 and 667, 57, and 87 give the most interesting paper negatives. Davis Freeman prefers using black-and-white Type 53, which partially solarizes when room light hits the negative. Some of the image reverses, so that it's part positive and part negative (also known as the Sabattier Effect). Joanne Warfield uses Polacolor 669 and Photoshop, and has modified the Polaroid instructions to get the results she likes.

DAVIS FREEMAN.
SARA'S SHOULDER. 1997
Compare the straight black-and-white print from a Polaroid Type 53 4x5 negative (above) with the illustratype print from the solarized Polaroid Type 53 4x5 negative, enhanced in Photoshop (right). The effect of this process is striking.

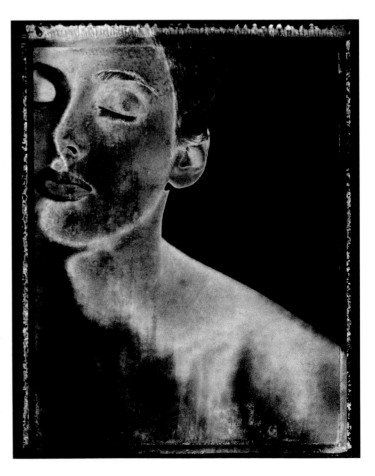

JOANNE WARFIELD.
ANTIQUE ROSES. 2001
Warfield used an unwashed wet paper negative, applying electrical tape to section off a "wet area" on the scanner. She then adjusted the image for color in Photoshop.

JOANNE WARFIELD.
EGYPTIAN SUNSET. 2001
For this, Warfield washed the negative before scanning and used the same method as above.

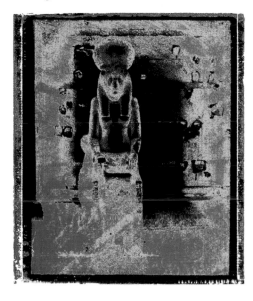

Polaroid recommends washing the negative in warm water and gently rubbing the surface to produce smoother-textured images. With washing, you lose some color, and the process becomes less messy. You can also let the negative dry and rewet it, as Joanne Warfield does. (See pages 194–195 for more on Warfield's technique.) The negative doesn't have to be a fresh one, so start saving those negatives!

Like the transfer process, no two scans will be the same. *Note of caution:* Be careful with water on the scanner. Water and electricity can be a dangerous combination. If your scanner has a focusing function, you may be able to place the paper negative and water on the scanner inside a thin glass container instead of making the wet rectangle area. I've also tried spraying the dry negative with a glossy coating of Krylon's Crystal Clear, which lends something of an appearance of wetness, but it's not as good as actual wetness from water.

Photoshop Manipulation Tools and Filters

Photoshop techniques are covered more thoroughly on pages 126–135, but I want to mention here that in addition to improving contrast and color balance, removing any glitches you don't like in your image, and handcoloring, you should check out the Photoshop Image menu. Under Adjust, try Invert to turn your positive image into a negative, and vice versa. Posterize and Equalize add interesting effects. Liquify attempts to duplicate the SX-70 manipulation technique and, when used carefully, can be quite fun.

Plus, don't forget those filters. I recommend getting a good book on Photoshop that shows what each of the filters does to an image, or you can just experiment. However, it's very easy to overdo it. For some filters you can set the amount of the filter to be applied. You can fade a filter effect by choosing Fade

in the Edit menu. In the Fade dialog box, you also have a choice of modes to further affect the look of your filter. Also, by creating a layer for the filter, you can control the strength of the filter by changing the layer opacity, and can create a layer mask to apply the filter to just part of your image.

Theresa Airey scans her transfers and SX-70 manipulations, makes adjustments in Photoshop, and then prints them onto watercolor or inkjet coated papers with her Epson 3000. She sometimes prints a light digital print as a sketch that she then paints. She warns that in order to apply water or water-based paints on an inkjet print, the piece must be printed with an archival inkjet, such as Luminos' Platinum or Silver ink sets. Some of the inkjet coated papers, such as Luminos Tapestry X and Charcoal R, will not tolerate water at all but are good for use with oil paints and oil pastels.

Double Exposures, Layering, and Collaging

While you can double expose, layer, and collage with the physical transfers, you can also scan them into Photoshop. By using a layer for each image, you can mask off the areas you don't want to come through. You can also choose the opacity and blending style of each layer, and add textures, text, and other effects (see part III for more digital information).

THERESA AIREY. TRANSIENT NUDE. 2001
Airey scanned the negative of an image transfer into Photoshop and combined it with a resized image of a nude to make this print colored with Conté pastel pencils. As she explains, "The background image was a scanned 8x10 negative image transfer, and the nude was scanned from a slide. I resized the nude to be small. After opening both images in Photoshop, I dragged the nude onto the tree image and reduced the opacity of the nude in the Layers palette until I liked the effect. I printed it onto Lumijet's Flaxen Weave inkjet coated paper and enhanced the image with Conté pastel pencils.

Image Transfers Only

AMY MELIOUS. JUNE FLOWERS. 2001
To change the shape and edges of this Polaroid transfer, Melious applied a mask to the Polaroid negative before placing it onto the receptor surface.

Masking

Just because the Polaroid film format is proportioned to a 4x5-inch format doesn't mean your images have to be that way, too. Tired of the limitations of the rectangle, Amy Melious has created a way to turn her original 35mm images into exquisite panoramic, square, and triptych transfer prints by designing paper masks for the Polaroid negative. She applies the mask to the negative after separating the negative from the positive and before placing the negative on her receptor surface. Melious stresses that it's important to press all along the edges of the image while rolling the negative onto the receptor surface with the brayer and to clean the mask edge with paper towels between each use. She uses a mask until it wears out and then makes another one.

Alternate 8x10 Image Transfer Method

Try cutting a piece of watercolor paper to *exactly* the same width as the 809 Polaroid positive sheet. Place it on the top of the Polaroid positive (and under the pod) and feed into the 8x10 processor (with the negative in its film holder) for a sharp transfer with good

color. Process for seventy-five seconds, then slowly peel the negative off the watercolor paper. No peeling apart the negative from the positive, or rolling with the brayer, is needed because the image is already being transferred by going through the processor rollers. Best results occur when you keep the film and paper warm during the processing. The main drawback to this method is that you'll have a very small watercolor border around the edge of the transfer, if that matters to you.

Altering the Image After Development

For image transfers, you can rub or scratch the emulsion with a cotton swab or X-Acto knife just after peeling the negative to create highlights or more liftoff. This is a great way to give a more painterly or abstract look to the image. Also, if I have a blotchy sky from uneven development, for example, or some other large, light area that I want to lighten or even up, I put the transfer in a tray under water and, with a paper towel, lightly rub that area with feathery strokes. Then, I blot the wet print with blotter paper, a large tissue, smooth napkin, or paper towel

to absorb the excess moisture. (*Note:* A paper towel will leave a pattern.) If you don't blot the transfer, you may get more blotchy areas from uneven drying.

Polaroid Pro 100 Type 679 Film

You can use this film—for image transfers only (not emulsion transfers)—with a few modifications to the process. The results are much more contrasty than 669, so use a transparency with a low contrast range. The film also needs more heat when being transferred than the Polacolor ER films do.

Larry Gerbrandt, a photographer from Carmel, California, discovered that using a laminator gave him predictable, reproducible results. With a Daylab slide printer, he exposed the film at one stop less than a 669 image transfer—at one increment below the 0 on the Manual Exposure Adjustment Dial toward the (-) setting—and peeled the 679 film apart after thirty seconds. After placing his Polaroid negative on watercolor paper and rolling with a brayer roller, he covered the negative with another piece of watercolor paper and put the transfer "sandwich" through a small laminator on low heat several times during the development time. He then cleared the transfer using

a bath of one part distilled water, one part white distilled vinegar, and one part hypo clearing agent; gently rubbed the yellow cast off of the print; and rinsed for up to fifteen minutes. He sent his method to Polaroid, which published it in its *Test* magazine Fall/Winter 1997 issue and put it on the company website.

I tried this method, but since I don't have a laminator, I used a dry-mount press set on 150°F for two minutes. I also used my trusty warming tray, leaving the transfer on the tray for two minutes. The results were the same. When I used his clearing bath of vinegar, hypo clearing agent, and water, the fumes were a bit overpowering, so I then compared the results to those I got using just the vinegar bath that I use for 669 transfers and then also to using just hypo clearing agent. I also experimented with different exposures and peel times, and with rubbing off the yellow coating.

I got my best results using an exposure of 1½ stops less than what I used for 669 transfers—on the Daylab, two increments below the 0 on the Manual Exposure Adjustment Dial toward the (-) setting; a peel-apart time of thirty seconds; the vinegar bath to clear; rubbing some yellow off; and rinsing for four minutes. However, I still prefer the results I get using 669 film for my image transfers.

FLOWERED MASK. 2001
This is the image transfer made with Polacolor Pro 100 Type 679 film, exposed one increment above the minus (-) on the Daylab 35, peeled apart after thirty seconds, developed on a warming tray for two minutes, and not cleared—note the yellow cast.

This version is on Polacolor 669 film. It was peeled apart after ten seconds, developed on a warming tray for two minutes, cleared in a diluted vinegar bath, and rinsed for four minutes. Note the color and contrast difference from the 679 versions.

The image, film, exposure, and developing are all the same as at left, but I cleared the image in a diluted vinegar bath, rubbed some yellow coating off, and rinsed it for four minutes. The result is much less yellow.

Here, I've scanned the 669 image transfer into the computer and colored it in Photoshop.

Emulsion Transfers Only

Other Films

For emulsion transfers only, you can use Polapan Pro 100 and the Sepia 4x5 sheet film. Polapan Pro 100 is a family of black-and-white peel-apart films with numbers that all end in "4." Sizes are the same as for Polacolor ER films—664 is a 3¼ x 4¼-inch pack film with ten exposures per pack, 554 is a 4x5-inch pack film with ten exposures per box, 54 is a 4x5-inch sheet film with twenty exposures per box, and 804 is an 8x10-inch sheet film with fifteen exposures per box. Balanced for daylight and electronic flash, the films are ISO 100 and produce a properly developed print in thirty to forty-five seconds at 75°F.

The Sepia Type 56 film is ISO 200 and only comes as a 4x5 sheet film with twenty exposures per box. You can use new or old prints from these films, as well as the Polacolor films, to make your emulsion transfers.

The emulsion transfer process with these black-and-white films is a little different than it is with the Polacolor films: (1) You must cut off the white border of the print in order for the emulsion to come loose. (2) Use boiling water rather than 160°F water. (Note: The back of the print doesn not need to be covered with vinyl adhesive paper since the backing paper doesn not dissolve on this type of film.) And finally (3), coat the receptor surface with diluted acrylic gel medium before applying the transfer, and recoat the transfer with gel medium before it dries. Otherwise, the transfer may not stay adhered to the receptor surface.

Two-Dimensional Surfaces

There are many nonporous surfaces that you can use for emulsion transfers but that cannot be used for image transfers. Sheet metal, foil, playing cards, mirrors, glass, Plexiglas, plastic, Mylar, vellum, nylon screen, sheet music, old wallpaper, fabrics, stretched and primed canvases, and canvas pads are

GONDOLA SUNSET. 2001
I used the leftover pale positive from an image transfer for this emulsion transfer on a Rosco vellumlike reflector surface. I then coated it with acrylic gel medium and backed it with silk tissue paper.

just a few ideas. (See Louise Roach's images on metal on pages 186–187.)

I've been fascinated with many of the Rosco surfaces for photographic and theater lighting. Rosco makes lighting gels, and diffusion and reflector materials, and when I first started buying sheets of amber gels for color filtration with the Vivitar slide printer, I would get the sampler packs of color correction filters for my workshops. These are wonderful surfaces, upon which I've now been putting emulsion transfers (see *Golden Mask II* page 115). The surfaces are all waterproof, so they won't ripple the way some papers and vellum do when wet.

Three-Dimensional Surfaces

For emulsion transfers, I enjoy working with three-dimensional surfaces. My favorites are stones, scraps of marble, driftwood, and eggs. Other possibilities are frosted vases and bottles, glazed ceramics, and sculptures. The surface may be a bit rough on the stone and driftwood, and if so, I sand down the rough spots, apply a few coats of acrylic gel medium to smooth the surface, and lightly sand it to eliminate brushstrokes. Otherwise, rough areas can shred your transfer when you move it around for positioning.

If the object onto which you are transferring is too big to fit in the cold water tray, you can use a deeper bin or bucket to submerge the receptor object. I find it so much easier to transfer the emulsion membrane directly onto the object without using an acetate sheet, especially if the object is curved. Since these objects won't be protected in a frame, additional coatings of acrylic gel medium or other sealant may be desired if the transfer will be touched or handled.

Goose and ostrich eggs work well. Drill holes in each end of the egg, blow out the contents, and rinse the shell in a mild bleach solution, otherwise your egg could start to smell! I use three 4x5 emulsion transfers to completely cover the surface of goose eggs, and it's a bit tricky to match all the seams. I also find that if I submerge the egg to apply the transfer, I have trouble with the egg filling with water and then ruining my carefully arranged emulsion as it drains. Instead, I've learned to pull the emulsion out of the water and quickly drape it over the egg before the emulsion has time to glob up into a ball. I smooth out any air bubbles with my fingers, starting from the center and working outward.

Barbara Elliott sometimes works with mannequins and heads made from glass and Styrofoam. Often, she'll put an 8x10 emulsion transfer of a face over the face of one of the heads, matching up the features. She submerges the head, lifts it out of the water with the emulsion in position, and then puts running water over the emulsion to smooth it out and remove air bubbles. She then stuffs the heads with a variety of fillings, such as satin or lamé cloth.

She also keeps a small jar with water handy when doing emulsion transfers and saves scraps of emulsion in it for use later when needed. To use these scraps, she empties the jar into a large tray of water to sort out the various colors of emulsion and uses an acetate sheet to lift the emulsion pieces out of the water. She then cuts strips of emulsion to use as hair or other design purposes.

ELIZABETH OPALENIK.
BIKINI LIFT. 2001
Opalenik applied emulsion transfers and "leftover" (pale positive emulsions) to a clear plastic body suit.

BARBARA ELLIOTT.
HAND JIVE. 2001
*Here, three emulsion transfers
were sandwiched between two
clear Plexiglas sheets with
white Plexiglas backing, all
separated from the emulsion
with clear acrylic washers.
It's held together with poly-
carb screws and hex nuts.*

PATTI BOSE.
DANCERS IN ANTIQUE
DRESSES. 1997
*Photographing with a long
exposure time so that the
models could change their
poses, Bose created two
20x24 emulsion transfers.
One was applied to glass,
the other to watercolor paper.
Then they were both sand-
wiched together with a ¼-inch
spacer between the layers to
create a feeling of depth.*

Ready-made prestretched and primed canvas, and primed canvas pads, are wonderful surfaces for emulsion transfers. Artists' wood panels are also a great surface for both image and emulsion transfers.

Layering and Collaging on Nonporous Surfaces

Due to the transparency of the emulsion transfers, you can use Plexiglas, glass, acetate sheets, screen, thin vellum, translucent Rosco surfaces, and a variety of other surfaces to create framed shadowboxes and sculptural pieces that have a depth of layers that enhances the regular collage techniques. To collage with opaque images, just put the emulsion transfers on opaque surfaces instead of transparent ones. Patti Bose places a transfer on watercolor paper, then places another transfer of the same image on a piece of glass, and then mounts the two images together with a ¼-inch spacer between them to create a feeling of depth. Barbara Elliott uses layers of clear Plexiglas with a white Plexiglas background to create shadows of the emulsion transfers.

New Equipment and Procedures

There have been some additions and replacements to the Daylab line of slide printers. This chapter describes all the models, including those that have been discontinued and are only available on the used market, such as the Vivitar slide printer and the Daylab Jr. The slide printers are designed for use with ordinary room light and don't require a darkroom. Included as well is information on the Polaroid 20x24 camera, which can be used to make transfers with transparencies of existing images or with still life or portrait subjects "live" in the studio.

This chapter also covers two illustrated step-by-step procedures: one for creating 4x5 image transfers with the Daylab 35 Plus using 35mm slides and Polacolor 559 film, and another for creating 8x10 emulsion transfers with the Daylab 120 using medium-format transparencies and Polacolor 809 film. With these and the step-by-step instructions for exposing Time Zero film using the Daylab 35 (on pages 30–33), and the step-by-steps in *Polaroid Transfers,* I've described how to use the most common slide printers.

GRAND CANAL. 2001
I handcolored this 4x5 Polaroid image transfer with pastel pencils directly on the transfer, then scanned it into the computer.

Slide Printer Models

To decide which model is best for you, consider how much money you can spend, how committed you are to the process, and if you know whether you want to work in the larger formats. Unless your commitment is very strong, money is no object, or you want to crop your images and work with larger formats right away, I usually recommend that beginners get an inexpensive model and learn using Polacolor 669 film. You can always trade up later to a modular system if you decide to work in the 4x5 and 8x10 formats.

Vivitar

The Vivitar slide printer, a simple fixed-focus unit with flash exposure made to expose 35mm slides onto 3¼ x 4¼-inch Polaroid 669 pack film, was very easy to use and ran on four "C" batteries. It was made from the 1970s to 1997, when it was discontinued. You can sometimes find the Vivitar in camera stores carrying used equipment, at photo swap meets, and on online auctions. The earlier model used a metal bar to open and close the Polaroid film holder on the top of the machine. I find that, with this bar, it can be more difficult to pull out the film than with the later model, which had a black plastic bar for opening the film holder. If considering a used Vivitar, I recommend getting the later model or purchasing the newer AD-90 rollers for the earlier model, which make pulling the tabs out much easier.

Daylab

Daylab Jr.

The Daylab Jr. was introduced in 1997 to replace the Vivitar slide printer. For use with 35mm slides, it offered more features than the Vivitar, such as a dichroic color head that enabled you to dial in color filtration (up to 80 color correction units of cyan,

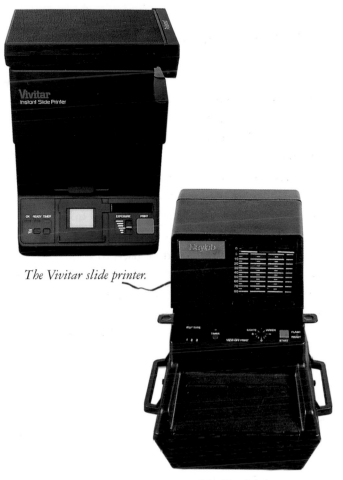

The Vivitar slide printer.

The Daylab Jr.

magenta, and yellow) without using gels, as was necessary with the Vivitar. The Daylab Jr. ran on electricity rather than batteries, with a built-in electronic flash exposure; an automatic exposure switch coupled with a timer for thirty-, sixty-, or ninety-second processing times, depending on the Polaroid film used; and an exposure-compensation dial to manually adjust the lightness of the image.

The unit had a fixed-focus lens and could only be used, for the 3¼ x 4¼-inch Polaroid peel-apart films, with the 3x4 base (included) or, for the Time Zero film, with a separate Daylab SX-70 base. The slide holder allowed for using negatives or unmounted slide strips as well as mounted 35mm slides. *Note:* When using negatives, a negative image (one that looks like the *negative*) is produced.

Daylab 35

The Daylab 35 replaced the Daylab Jr., at the end of 2000, with a sharper lens, improved electronic circuitry, and less cropping of the image than the Jr. or the Vivitar slide printer. Since the Polaroid films are a more squarish rectangle than the 35mm film format, the Vivitar and Daylab Jr. cropped the ends of the 35mm images to fill the Polaroid film area. The Daylab 35 shows 10 percent more image area, but it's also easier to get a black line down one side if you don't compose your image carefully in the viewing area.

The Daylab 35 has all the same features as the Daylab Jr.: dichroic color head, fixed-focus lens for 3¼ x 4¼-inch peel-apart Polaroid or Time Zero films, flash exposure, Automatic Exposure switch with timer, and Exposure Compensation dial. The unit is differentiated from the Jr. by the blue racing stripe around the middle of the base of the enlarging head, and by the label.

Note: In May 2001, the Daylab 35 was modified with improved brightness levels for the flash, and at that time, the setting for SX-70 on the Film Type switch was changed from 1 to 3. (See the chart on page 98 for all Daylab model settings.) However, if you purchased your Daylab 35 before May 2001, use 1 for your SX-70 setting.

Also, in the fall of 2001, the Daylab 35 was modified again to decrease the chance of getting the black line down one side of your transfer. This model, with a gray racing stripe, shows 5 percent less image area than the model with the blue racing stripe (and 5 percent more than the original Daylab 35 Jr. and Vivitar models).

Daylab II

Also for 35mm slides, the Daylab II is a modular system with a separate base for each size of peel-apart Polaroid film—3x4, 4x5, and 8x10—plus the SX-70 Daylab base. You can order it with any of the bases and film holders. You can crop and focus to each size with the adjustable bellows, which also allows for full frame images, except at the 8x10 size, which is cropped to the 8x10 proportion. With the Daylab II, you can also control the cropping to use just part of a slide.

The Automatic Exposure switch allows for three exposure settings, depending on the image size you are printing. The Daylab II also includes an Exposure Compensation Dial and a timer. The light source is different from the Daylab Jr., 35, and Daylab 35 Plus in that the Daylab II has a tungsten halogen enlarging bulb with an exposure timed in seconds—like using an enlarger and timer, rather

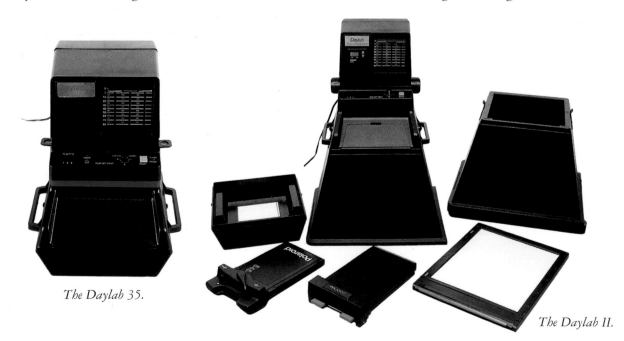

The Daylab 35.

The Daylab II.

than using a flash exposure. Tungsten is a warmer light source than flash, which is daylight balanced, and may require color balancing by dialing in 30 cyan on the dichroic color head to equal the color balance of a flash exposure. For image transfers, no warming filtration is needed to replace color lost in the peeling process, due to the warm color of the tungsten bulb. For emulsion transfers and SX-70 manipulations, no warming filtration is required, so you will need to add 30 cyan (or more) for correct color balance. For further information on color filtration, see pages 36–37.

Daylab 35 Plus

Introduced in 2000 with the Daylab 35, the Daylab 35 Plus is a modular system with a bellows for cropping and focusing like the Daylab II, and it works with the same 3x4, 4x5, 8x10, and SX-70 bases. Using flash exposure and a timer just like the Daylab Jr and 35 models, you can set the Automatic Exposure switch for three different ISO Polaroid films with the accompanying development time needed for each

The Daylab 35 Plus.

The Daylab 120.

film. There's also an Exposure Compensation dial and dichroic color head.

The 35 Plus comes with a choice of the enlarging head only (if upgrading), or any of the bases: 3x4, 4x5, or 8x10. The 4x5 has a graph lock adapter to hold either of two types of 4x5 Polaroid film holders that you can purchase separately—the 550 pack film holder for 559 4x5 pack film or the 545, 545I, or 545Pro sheet film holders for 59 4x5 sheet film. If you are using the 4x5 film holder only for transfers, I recommend the 550 pack film holder for the 559 pack film; the film is easier to load, and the film and film holder are less expensive than the sheet film and holder.

Note: In May 2001, the Daylab 35 Plus was modified with improved brightness levels for the flash, and at that time the settings for the 809 and SX-70 on the Film Type switch were reversed to 1 for 809 (most light) and 3 for SX-70 (least light). However, if you purchased your Daylab 35 Plus before May 2001, use 1 for your SX-70 setting and 3 for 809.

Daylab 120

Made for use with medium format transparencies from 6x4.5 cm to 6x7 cm, the Daylab 120 is a modular system with bellows for focusing and cropping. It uses the same 3x4, 4x5, 8x10, and SX-70 bases as the Daylab II and 35 Plus for the different sizes of Polaroid peel-apart films. It's sold as just an enlarging head or can include any of the bases—3x4, 4x5, and 8x10. The graph lock adapter on the 4x5 base works with either of the Polaroid 4x5 pack film or sheet film holders, which you can purchase separately. The Daylab 120 has all the same features as the 35 Plus—electronic flash exposure, Automatic Exposure switch with timer, Exposure Compensation dial—but no dichroic color head. You must use color gels for filtration.

Daylab EZ

A newer model from Daylab, introduced in 2002, the Daylab EZ is an affordable, electricity-powered,

SETTINGS FOR ÐAYLAB UNITS

Since the settings for the same films vary between Daylab models, the following is the chart of settings from Daylab for the Film Type switch and Manual Exposure Adjustment dial on the Daylab models. Remember, for image transfers, to add ½ stop—or one increment to the plus (+) side—to these settings, plus a warming filter of approximately 30 yellow and 15 magenta except on the Daylab II. For emulsion transfers, subtract ½ stop—or one increment to the minus (-) side—to these settings.

	FILM TYPE	FILM TYPE SWITCH	MANUAL EXPOSURE ADJUSTMENT DIAL
Daylab Jr.	669	2	0
	SX-70/Time Zero	1	-2
	664, 679	1	0
Daylab 35	669	2	0
(after 5/01)	SX-70/Time Zero	3	-2
	664, 679	3	0
Daylab 35 Plus	809 (8x10)	1	0
(after 5/01)	669, 559, 59	2	0
	SX-70/Time Zero	3	-2
	664, 679	3	0
Daylab II	669, 559, 59, 679	1	0
	SX-70 (add 30 cyan filtration)	1	-2
	809 (8x10)	2	0

easy-to-use entry-level unit much like the Vivitar. Made only for Polaroid 669 3¼ x 4¼-inch peel-apart film, it has a fixed-focus lens, flash exposure, and no filters. It loads from the side—no need to view to crop or align the image—just load the slide and push the exposure button. Great for both beginners and children, it cannot be used with Time Zero film, however.

Daylab 35 FF

Also introduced in 2002, the FF stands for "Fine Focus," which allows for using both 3x4 and 4x5 formats, and slight cropping on each side.

Daylab Copy Boy

First produced in 2002, the Copy Boy is the solution for those who don't have 35mm slides. It works with traditional photographs, postcards, drawings, and inkjet prints. Initial units work with Polaroid 3x4-inch peel-apart film, with 4x5 and SX-70 versions added later.

Daylab Pinhole Cameras

The Daylab Corporation has also come out with three pinhole cameras for Polaroid films in 3x4, 4x5, and SX-70 formats.

The Polaroid 20x24 Camera

There are only six Polaroid 20x24 cameras in the world. The camera stands five feet high and weighs 235 pounds. Producing superbly detailed, color and black-and-white 20x24-inch Polaroid prints, it was developed to accurately reproduce works of art, especially paintings and tapestries. However, it was soon used as a creative tool to make original photographs. At 20x24 rental studios in New York City, Prague, and most recently San Francisco, many well-known artists such as Chuck Close, Olivia Parker, and William Wegman have used this camera for personal and commercial expression.

A large-scale instant image is an incredible way to explore creative ideas. With the assistance of the studio manager, you can make image transfers that are truly magnificent. It's definitely an adrenaline rush to peel a negative off of a 20x24-inch print! Emulsion transfers are a little trickier because of the need for a large tray of 160°F water for removal of the emulsion. (See page 201 for 20x24 studio contact information.)

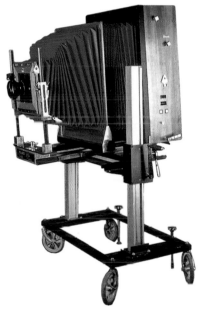

There are only six Polaroid 20x24 cameras in the world and only three available to rent: in New York, San Francisco, and Prague.

Barbara Elliott peeling a 20x24 image transfer at the Polaroid 20x24 San Francisco studio.

Image and Emulsion Transfers Using Daylabs

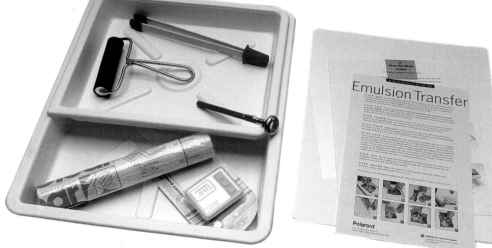

The Polaroid image and emulsion transfer kit.

The best all-around films for Polaroid image and emulsion transfers are the Polacolor ER (extended range) peel-apart films. These are 669 for 3¼ x 4¼-inch pack film, 559 for 4x5 pack film, 59 for 4x5 sheet film, and 809 for 8x10 sheet film. Balanced for both daylight and electronic flash, they have a film speed rating, or ISO, of 80 and produce a properly developed print in sixty seconds at 75°F. Pack films have ten sheets of film per pack. Note that Pro Vivid 689 does not work for either image or emulsion transfers, but you can use a few other films, which are covered in chapter 5.

You can find the basic supplies needed for image and emulsion transfers with 669 film in your kitchen, or they can be easily purchased. If you're starting from scratch, Polaroid offers an Image and Emulsion Transfer Kit that contains most of what you'll need—two photographic trays (8x10 and 11x14 inches), a four-inch brayer (soft rubber printmaking roller), a thermometer capable of reading 160°F, tongs, a clear acetate sheet, 140lb hot-press watercolor paper, self-adhesive shelf paper (like Contact paper), a timer, plus some watercolor note cards.

In addition, you'll need a squeegee, scissors, cotton swabs (Q-tips), X-Acto knife, small cloth towel, paper towels, warming tray (1950s hors d'oeuvre warming trays from thrift stores work well) or electric fry pan (again, thrift store models are great), white distilled vinegar, and, of course, a slide printer and your 35mm slides. Using distilled water is recommended by Polaroid; however, I suggest comparing results with both distilled water and your tap water. If you don't notice a significant difference, just use tap water.

Choose slides with strong graphic qualities and normal contrast. Polaroid films increase the contrast of your image, so if there's a lot, you may lose detail in the shadows and highlights. Small details may also get lost with image transfers, as the process softens the image and mutes the colors. You'll retain more detail and color with emulsion transfers.

The following step-by-step procedure uses the Daylab 35 Plus for image transfers. If you have a different slide printer, substitute the step-by-step directions for that printer found in this book or in *Polaroid Transfers*. The image-transfer steps are the same. The transfer process is simple, but if you're doing something wrong and don't know what it is, it's easy to become frustrated and waste a lot of film. Read the directions carefully, and refer to the Troubleshooting section on pages 116–119 and in *Polaroid Transfers* if you have any difficulty

Image Transfer Using the Daylab 35 Plus and 4x5 Polacolor 559 Film

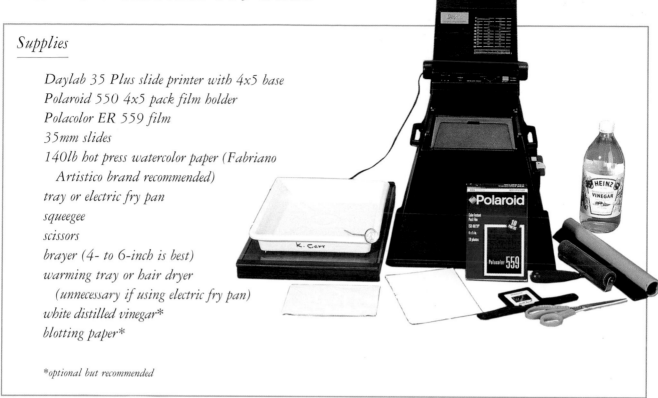

Supplies

Daylab 35 Plus slide printer with 4x5 base
Polaroid 550 4x5 pack film holder
Polacolor ER 559 film
35mm slides
140lb hot press watercolor paper (Fabriano
 Artistico brand recommended)
tray or electric fry pan
squeegee
scissors
brayer (4- to 6-inch is best)
warming tray or hair dryer
 (unnecessary if using electric fry pan)
*white distilled vinegar**
*blotting paper**

**optional but recommended*

Loading the Film and Slide

1. Attach the 550 film holder to the 4x5 base. To do this, remove the enlarger head and turn the base upside down. Slide the two metal bars as far as they will go in the "unlock" direction. Place the film holder, with the white area of the dark slide facing down, in the opening. Slide the bars to the "lock" position. If the film holder isn't secure, tighten the Phillips-head screws on the metal bars. *Note:* If you purchased the 550 holder separately, spray paint one side of the metal dark slide matte white. This will enable you to see your image to position and focus it.

2. Load the 559 pack film by opening the Polaroid film holder and putting the film pack in with the film facing down, handling film carefully by the pack edges only (above). Make sure all the white tabs are sticking out under the black safety paper.

Check to make sure the rollers are clean. If not, remove, clean, and replace them. Close film holder and latch it. Pull out safety paper. Turn base right side up with film holder opening on the right, placing enlarger head on the base so that the orientation tabs snap into the locks on each side of base.

3. Plug in the power supply from the back of the enlarger head.

4. Put a 35mm slide in the slide carrier. Place the slide upside down, with the emulsion (dull) side up and the shiny side facing down toward the Polaroid film (opposite than for exposing onto Time Zero film). The image will appear backward when viewed on the white surface of the dark slide. Make sure you position the slide horizontally—even if it's a vertical image—or you'll get a cropped square image because the film is horizontal.

To work with a negative or film strip, turn the slide carrier over and center the frame you want to print. Put the film sprockets under the two large tabs on the top horizontal side of the film holder. Using your thumbs on the bottom side of the film strip, push the film up until it buckles slightly. Be careful to avoid creasing the film by pushing up too far. Make sure the sprockets on the bottom side

of the film slide under the two short tabs. Let the film flatten.

You can also feed the end of the film strip into the tabs if your selected image is one of the last frames on the film strip. Practice with an unimportant strip of film first.

Insert the film holder into the Daylab with the negative on top.

Setting the Controls

1. Set the View-Off-Print switch to View. Make sure the dark slide in the Polaroid film holder is pushed all the way in first to prevent the film from being exposed. The viewing light will come on. Open the previewing door on the front of the Daylab to see your image projected onto the white surface of the dark slide. *Note:* It's easier to see the image if no room light is shining on it. Turn off the light, or use a dark cloth to cover your head and the preview door. Also, if you have difficulty focusing, a magnifying glass might be helpful.

2. Align the slide or negative in the viewing area, moving the slide carrier in the opposite direction you want, since it's a reversed/mirror image. Crop the image by turning the knobs located on each side of the enlarger head. Raise the enlarger head to increase the size for tighter cropping, and lower it to reduce.

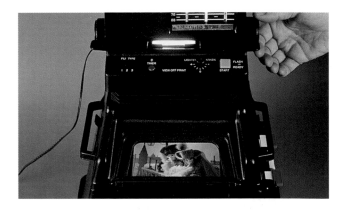

3. Focus the image by turning the same knobs slowly in the reverse direction. *Note:* Since the cropping and focus functions are combined into one adjusting knob, while in the focus mode the image will continue to get smaller while raising the enlarger head, and vice versa.

Once you've enlarged the image, you can select any area of it to print by moving the carrier. You'll see slightly more image than will be on the resulting print, so don't crop too tightly.

4. Set the Manual Exposure Adjustment dial. For image transfers, turn one increment above 0 in the plus (+) direction. For emulsion transfers, turn one increment below 0 in the minus (-) direction. If you want your result to be lighter because your slide is dark, or you don't want the meter to render your white snow a dirty gray, increase the exposure by moving the dial toward the plus (+) mark. Note that each line on the dial is equivalent to ½ stop, allowing you to add or subtract up to 2½ stops. If you want the transfer to be darker, move the dial toward the minus (-) mark.

If you need more exposure than the maximum plus (+) setting will allow, move the Automatic Exposure switch (the ISO setting) to 1 (for 8x10s). You can also make multiple exposures of the same image. Each subsequent exposure doubles the amount of light of your first exposure. Just make sure the Flash Ready light is on before pressing the Start button each time.

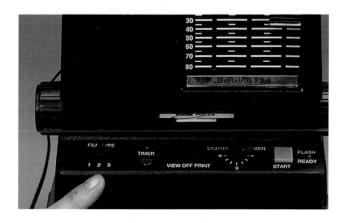

5. Set the Automatic Exposure switch to 2 for Polaroid ISO 80 peel-apart films.

6. Choose color filtration, if desired. Use the three built-in color filtration controls—cyan, magenta, and yellow. Combinations of any two will create a wide variety of colors. For image transfers, I recommend using 10M to 15M and 20Y to 30Y to replace color lost by peeling apart the film early.

Exposing the Film

1. Close the previewing door. *Note of caution:* Leaving the door open while exposing the film will fog and ruin the print.

2. Set the View-Off-Print switch to Print. Don't leave your slide under the viewing lamp longer than necessary because heat from the lamp can damage your slide. There's a safety shutoff that will turn off the view light after two minutes. To turn the lamp on again, set the switch to Off and then back to View.

3. Wait for the green Flash Ready light to come on.

4. Pull out the dark slide until you can see the blue line on its underside. The first time you do this, mark two dots on the white surface to make it easier to tell how far to pull out the dark slide in the future. If you pull the dark slide completely out, just put it back in.

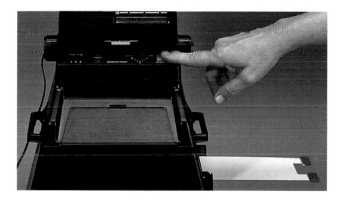

5. Press the Start button with a feather-light touch. If you press too hard, you could move the bellows (there's no bellows lock) and blur your exposure.

6. Immediately push the dark slide all the way into the printer after the flash goes off. If you don't see the flash, you didn't push the Start button hard enough and didn't expose the film. Get in the habit of pushing the dark slide in right away. If you forget and open the preview door or turn the view light on, you will fog the top piece of film.

Making the Transfer

1. Pull the white tab on the film firmly and at moderate speed straight out—not up or down or to the side (top image). Turn the slide printer so that the tab is directly in front of you. Two new tabs appear: a larger tab with arrows below another white tab. For now, do not pull either one.

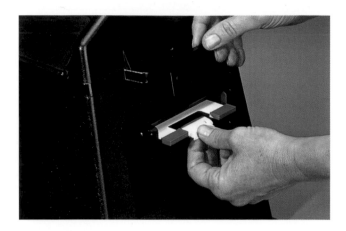

2. Prepare the watercolor paper by tearing or cutting it into approximately 5x7-inch pieces. (If you tear one 22x28-inch sheet in half, then in half again, and then in half again, you end up with sixteen pieces that are the right size.) Dip the paper in a tray of water approximately 100°F until it's limp—about 15 to 30 seconds. *Note:* The hotter the water, the less soaking time needed.

Remove the paper and drain it by holding one corner until it stops dripping. Place the paper on a hard, smooth surface and squeegee it until all excess water is removed. *Note:* Too much squeegeeing can roughen the paper. If you want finer detail in your transfer, instead of dipping, spritz it with a sprayer and squeegee it.

If your tap water is hard, try using distilled or bottled water to see if your transfers improve. The pH of the water should be around 7 for best results.

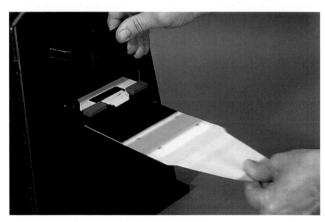

3. Pull the larger tab with the arrows straight out at moderate speed and with no hesitation. (If you hesitate midway through, you'll get a red line through the film where you stopped.) This pulls the film through the internal rollers, dispersing the chemicals evenly over the surface of the film to begin the development process. From this point, you have 10 to 15 seconds before you peel apart the film.

Handle the film on the edges only. If you hold it where the film is developing, your finger pressure can make white ovals on your transfer.

Note of caution: Never pull two white tabs in a row—always a white tab, then an arrows tab. Otherwise, you'll line up two pieces of film to go through the rollers and neither will turn out. The developer will squish and you'll have to clean the rollers.

4. During the 10 to 15 seconds before peeling, cut off the end of the film opposite the pod or tab end (bottom image). This is where excess chemicals have collected. These chemicals are a caustic gel, so cut the end over the trash and avoid touching it. (You can also cut off the end after you separate the film.) *Note:* If you don't cut off this end, a brown stain will appear on that end of your transfer.

Also cut off the tab end above the pods and below where the tab is joined. This makes it easier to peel apart the film.

5. About 10 to 15 seconds after pulling the Polaroid film through the rollers, separate the film quickly, starting at the tab end. Place the *negative* piece face down and centered on the damp watercolor paper. Use your hand to press it onto the paper. Don't wait too long to place the negative or the dyes may start to dry out. *Note:* The longer you wait to separate the film, the more dye will have transferred to the positive print, leaving less to transfer to the watercolor paper; this will cause your transfer to look washed out. However, if you peel before 10 seconds have passed, the dyes may not have had time to begin their migration and you could fog the film.

6. Roll the brayer back and forth over the negative approximately six times. To avoid sliding the negative across the paper, make gentle contact first. Begin in the center of the negative, rolling out to each end. Increase to heavy pressure.

Note: If you roll the negative too lightly, the emulsion won't make full contact with the textured paper, and you'll get white specks in your transfer. Too much pressure, however, can distort the darker areas. If you see emulsion squirting out, you're applying too much pressure.

7. Let the transfer develop for 1 to 2 minutes, floating the paper (with the negative on top) in a tray

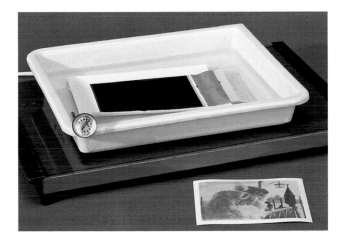

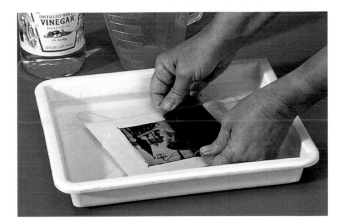

of water warmed to approximately 100°F (below, left). Keep the negative warm during development to prevent the image from lifting off when you peel the negative later. To keep the temperature constant, use a warming tray under the water tray, or use an electric fry pan and mark the setting for 100°F.

Moist heat is best; however, you can put the negative and paper directly on the warming tray, or you can preheat your work surface by placing a plastic-sealed heating pad under a sheet of acrylic or thick beveled safety glass. Or, use a hair dryer at a medium setting to blow evenly over the back of the negative from about a six-inch distance. Be careful not to get the negative too hot. If the temperature is too high (or too low), you can increase the possibility of liftoff (when part of the dye in the dark areas of the transfer lifts off while you're peeling the negative off the receptor surface, leaving a turquoise area).

8. Remove the paper and negative from the water and place on a hard surface. Peel off the negative very slowly by folding it back over itself little by little (above). This results in the least liftoff. To completely avoid liftoff, peel the negative under water or in a vinegar bath (see page 106 for vinegar bath information). If you want liftoff, peel more quickly.

When you get near the end of the peeling process, the film edge can flip up and scrape the emulsion on your transfer. To prevent this, place a finger on an unpeeled corner of the film to anchor it until you peel the negative completely free of the watercolor paper.

9. If desired, you can manipulate the transfer with a Q-tip or wet paper towel to create highlights or even out blotchy areas in light parts of the image. Create more liftoff in dark areas by scratching with an X-Acto knife or rubbing with a Q-tip.

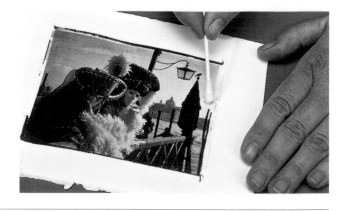

Brightening (Optional)

This optional but recommended step brightens and clarifies whites and colors. After the transfer has partially or completely dried, soak it in a solution of 1 part white distilled vinegar to 4 or 5 parts water that's room temperature (approximately 68°F). Agitate for up to 30 seconds by rocking the tray (to avoid bubbling of the emulsion).

Note: If bubbles begin to appear on your image, either add more water to the bath, lower its temperature, take the transfer out sooner, or make sure the next transfer is drier before putting it in the bath. Also try Fabriano Artistico brand paper if you're having this problem.

After agitating, rinse the transfer for 3 to 5 minutes under a gentle stream of water that's room temperature. You can also change the water in a tray 8 times to clear the residue vinegar—the old "fill and dump" photographer's trick; 2 fill-and-dumps equal 1 minute of washing. *Note of caution:* Do not stack the transfers in water because the emulsions are delicate and can be damaged by rubbing against other prints.

Drying the Transfer

Air-dry the transfer on a drying screen; a clean nylon window screen laid flat with air circulating underneath, or a sweater drying rack, works well. Or, hang the transfers on a line with clothespins after blotting with blotter paper or tissue.

If your print is wet from peeling under water or rinsing after the vinegar bath, blot the print with blotter paper; smooth, lint-free Photo Wipes; or tissue to avoid uneven drying. If you need to dry a transfer quickly after blotting, use a hair dryer, warming tray, or toaster oven on low heat. *Note:* The transfer may buckle if dried too quickly. You can flatten prints in a dry-mount press set on low (180°F), or by ironing them on the reverse side at a low setting and/or placing them under weights.

Handcoloring the Image Transfer (Optional)

After the print is dry and flat, you can handcolor it with watercolors, pastels, pastel pencils, colored pencils, acrylics, pen and ink, markers, and oils. You can also scan it and color it in Adobe Photoshop.

Spraying with Protective Lacquer (Recommended)

McDonald's Pro-tecta-cote comes in various surfaces, from glossy to matte. I prefer #951 Retouch in case I want to add more handcoloring after spraying. Krylon offers several sprays, as well. *Note of caution:* After coloring with soft pastels, spray first with a workable fixative, such as Lascaux, Latour, Sennelier, and Krylon, or even Aquanet unscented hair spray. Then spray with the McDonald's or Krylon UV spray. This is because the UV sprays will ruin the look of the pastels when sprayed directly on them.

Making a Polaroid Print with the Daylab 120 and 8x10 Polacolor 809 Film

The Daylab 120 operates just like the other Daylab modular systems with two differences: (1) The Automatic Exposure Switch needs to be set to 3 for 8x10s. On the Daylab II the setting is 2 for 8x10s, and on the Daylab 35 Plus the setting is 1 for 8x10s. Just make sure you follow the manuals or these directions; and (2) there's no dichroic color head, so if you want to use color filtration, you'll need to use gels.

Note that I've shortened several of the descriptions about aligning and focusing the image, and setting the controls, because I covered them in detail in the previous procedures.

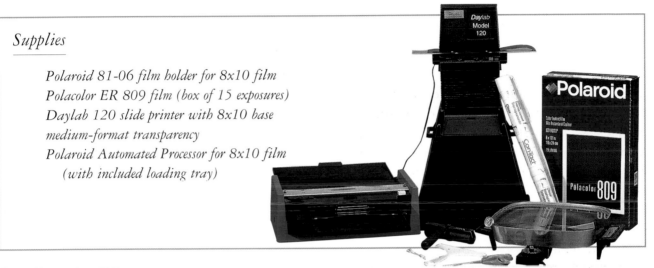

Supplies

Polaroid 81-06 film holder for 8x10 film
Polacolor ER 809 film (box of 15 exposures)
Daylab 120 slide printer with 8x10 base medium-format transparency
Polaroid Automated Processor for 8x10 film (with included loading tray)

Loading the Film

1. Place the negative film holder on a flat surface with the white area of the dark slide facing up. Push the two blue buttons on the holder and open it like a book. The orange tongue will be on the top right side (see picture below). Make sure the felt strips are clean. Rub a finger back and forth along the strips to remove dust, or wipe with the sticky side of masking tape.

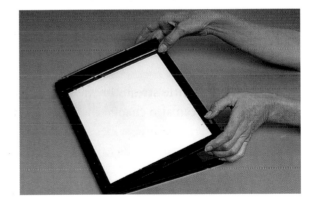

2. Place the negative film sheet (in its paper envelope) on the right side of the open holder. Center it between the blue lines above the orange tongue. Make sure that the three arrows at the bottom of the envelope are facing up but pointing downward. Slide the film and paper envelope down from the top so that the orange tongue on the film holder catches on the underside fold of the envelope and you can't push down any farther from the top.

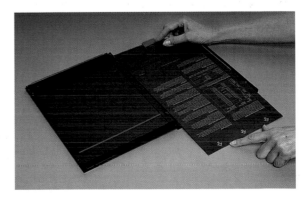

Note of caution: Don't pull the paper envelope out from the bottom or you'll expose the negative. The arrows on the bottom should be showing, and the envelope edge should be sticking out about 7/8 inch below the holder. In addition, protect the film and film holder from strong light.

3. Close the film holder, pressing the cover down firmly and making sure that both blue buttons are latched. Place the holder on its side, and from the bottom end with the arrows, pull out the paper envelope slowly and carefully, leaving the film in the holder (top). The film should stick out about 1/8 inch on the bottom.

4. Slide the film holder into the bottom of the Daylab 8x10 base, making sure that the white surface is up and the negative tab is sticking out.

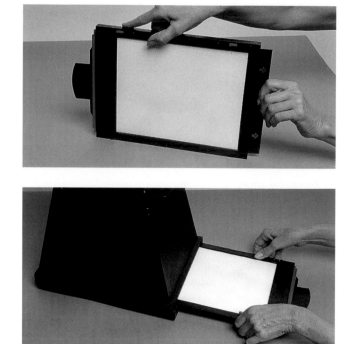

Setting the Daylab 120 Controls

1. Turn the enlarging head upside down, and remove the protective lens cap.

2. Set the Automatic Exposure switch on 3, because 8x10 needs more exposure. Select any filtration desired with gels. Turn the Manual Exposure Adjustment dial to one increment below the 0 in the minus (-) direction for emulsion transfers, or one increment above the 0 in the plus (+) direction for image transfers. Turn the View-Off-Print switch to View. Open the previewing door.

Aligning and Focusing the Slide

When using a mounted slide, place it on the middle of the Plexiglas slide-film holder (remove the paper covering on the Plexiglas first). When using a roll of unmounted slides, place the roll on the slide-film holder and the appropriate template for 6x6 or 6x7 over the roll and the holder. Magnets in the holder and template will align the two pieces. *Note:* Make sure the narrow edge is in front.

Align the image in the viewing area by moving the holder. Crop the image by turning the knobs on

each side of the enlarger head. Raise the enlarger head to increase image size, and lower it to reduce.

Focus the image by turning the knobs in the opposite direction than for cropping. Turn the View-Off-Print switch to Print, and close the previewing door. (*Note:* Leaving the door open while exposing the film will fog and ruin the print.) Wait for the green Flash Ready light to come on.

Exposing the Film

1. Pull out the dark slide until you can see the blue line on both edges. To make it easier to see when to stop pulling, make dots on the white area adjacent to the blue lines. Make the exposure by pushing the Start button with a feather-light touch.

When pushing the dark slide back in after making the exposure, make sure that the blue handle doesn't catch on the negative tab underneath and bend it. To prevent this, hold the tab down a little bit while pushing in the dark slide.

2. Remove the negative film holder by holding the release lever at the bottom right front of the

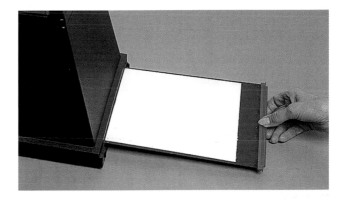

base with your left hand. Put the fingers of your right hand (palm up) under the negative tab, grasp the entire negative film holder, and pull it out of the base. Be careful not to pull just the dark slide.

Using the Polaroid Processor

1. To set up the Polaroid processor, fold open the top so that the white button is visible at the right front. Check that the rollers are clean (refer to the owners manual for the cleaning procedure).

2. Insert the loading tray into the processor as far as it will go (right). Make sure that the flat narrow end is toward you. It will click into place.

3. Load the positive film sheet into the processor tray by sliding the sheet, pod end first and pod side face up, into the processor tray under the silver plate until you feel resistance. (*Note of caution:* Don't touch the sheet surface or press on the pod area.)

The edges will lie within the recessed area of the tray, flush with outer end. You can pull the positive sheet back with the two card pieces at the corners. *Note:* Load the positive just before you are ready to process the film; a positive sheet lying face up for an extended period can collect dust.

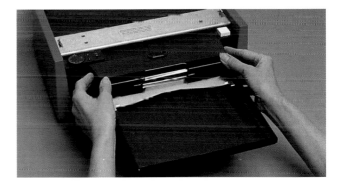

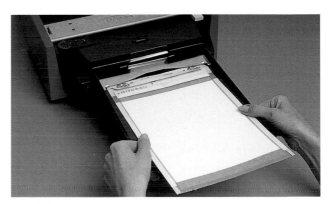

4. Place the negative film holder on top of the positive film sheet, over the silver plate. Make sure the white surface of the dark slide is facing down toward the positive. Check that the tab end is toward the processor; the yellow arrow should face up. The negative tab should be straight, not bent or folded. Insert the film holder into the processor loading tray by pressing down while pushing it in, over the silver plate. Push as far as it will go.

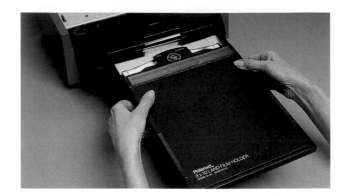

Processing the Film

1. Push the white button on the processor, holding it down for 1 second; when you hear a clunk, the film has had enough time to go through. The positive and negative sheets will join in the processor, be fed through the processing rollers, and be deposited in the processing compartment.

2. Lift the processing compartment lid from the back. Take out the film by the tab end, holding the paper and not touching the film itself (right).

3. For emulsion transfers, let the film process for 60 to 90 seconds. The timing depends on the room temperature (refer to the directions on the black negative envelope); you'll achieve the best results with a room temperature of from 70°F to 80°F. Then, grasp a corner of the positive near the tab end and pull the film apart quickly and smoothly. Peel apart down one side and then across the bottom where the chemicals are to avoid the paper masking over the chemicals coming loose and making a mess (bottom).

4. For image transfers, peel apart film quickly in one continuous motion after 15 seconds. Pull film apart the same way as for emulsion transfers—grasping a corner of the positive near the tab end and pulling down one side and across the bottom. It's much easier to separate the 8x10 film this

way—too many problems can arise when separating the tabs. Avoid touching the excess chemicals.

(*Optional step:* After separating the film, cut off the nontab end of the negative. Do this directly over the trash to dispose of the excess chemicals.)

Proceed as with smaller image transfers. *Note:* If you're having trouble with liftoff, peel the negative off the receptor surface very slowly while it is sub-

merged in a tray of room-temperature water or the vinegar bath, especially with dry transfers. If peeled in the vinegar bath, rinse the positive for 3 to 5 minutes in running water, or do 8 fill-and-dumps.

Then, blot the transfer with blotting paper or smooth, lintless Photo Wipes to remove excess water. This avoids the mottling in light areas that's caused by uneven drying.

Removing the Empty Film Holder and Loading Tray

To remove the empty film holder, push down on the ridged areas on each side of the holder and pull it out. Don't try to lift up the film holder or remove the loading tray with the film holder in it. Load another negative to continue making transfers.Once the printing session is finished, remove the loading tray. Depress the tray at the raised oval in the center, near the processor end, and pull the tray straight out.

Making an 8x10 Emulsion Transfer

Making an 8x10 emulsion transfer is actually easier and more fun than working in the smaller sizes, at least for me. Since the emulsion is larger, I have more control over manipulating the image, and finessing all the little creases and shapes. I often use a wet cotton swab to shape and wrinkle the emulsion for even further finessing. A fingernail or thumbnail works well for tearing the edges. But the process is the same, no matter what size film you work with.

The emulsion membrane can be manipulated most easily when the side that was attached to the paper substrate (the paper backing of the print) is the side that goes onto your receptor surface. There is a gel layer between the paper substrate and the emulsion that used to stay on the paper substrate when the emulsion was removed. Unfortunately, due to a Polacolor film change (sometime in 2000) to make the film more environmentally friendly, the gel now stays on the emulsion most of the time. It's usually necessary to remove this gel before placing the emulsion on the receptor surface. The easiest way to do this is to flip the emulsion membrane over in the cold water tray, put an acetate sheet under the membrane, and lift them up out of the water together. Then, brush off the gel with your fingers (it's harmless).

Supplies

warming tray or hair dryer
vinyl adhesive (Contact) shelf paper
scissors
electric fry pan
thermometer able to read 160°F
timer
tongs
tray of room-temperature water
clear acetate sheet (large enough to support
 entire emulsion)
paper (or other receptor surface)
spritzer
brayer (6- to 8-inch is best)

You have three choices on how to proceed at this point. First, you can use an acetate sheet to transfer the emulsion to your receptor surface, since the emulsion is already on the acetate (see 5a). You would also use the acetate if your receptor surface can't be submerged without being damaged, or your receptor surface won't fit into the tray (or bin or bucket). The emulsion can be manipulated on the on

acetate sheet or on the receptor surface. If you're going to manipulate on the receptor surface, you want the side that was attached to the paper substrate to be facing out on the acetate so that the emulsion will move around easily when placed on the receptor surface. This is how it is if you've just removed the gel.

Rewet the emulsion by quickly dipping it and the acetate into the water, and wet your receptor surface (or spritz it with water if it can't get too wet). It is much easier to manipulate the emulsion if it is wet; if it is too dry, the emulsion membrane will tear easily. After wetting, place the acetate down on the receptor surface—with the emulsion in between the acetate and the surface—and carefully remove the acetate.

Second, you can manipulate the emulsion on the acetate sheet (5b), so you would want the easily manipulated side to be facing the acetate—you'll need to flip it over after removing the gel. This means your image will be backward when you place it on the receptor surface. If this matters to you, expose the image reversed by placing your slide in the slide printer the opposite way (with the shiny, or viewing, side facing away from the Polaroid film). If your receptor surface is rough, or can't be dampened much, this method is the best choice.

The third way is the simplest for me (5c). After removing the gel, you return the emulsion to the cool water, flip it over, simply put your receptor surface underneath the floating emulsion, and lift them out of the water together, then manipulate.

Preparing the Print for Separation

1. After you've made it, let your positive Polacolor print dry for 8 to 24 hours, or use a hair dryer or warming tray to dry it for 3 to 5 minutes. The positive print surface should not be tacky. *Note of caution:* As long as the prints are tacky, don't stack or touch them, because you can damage the emulsion.

2. If you wish, you can first cut off the white borders or cut the print into any shape. The white borders will become a light pink or blue during development, depending on the film type, and this can add another level of interest to the transfer. Then, cover the back of the positive print with vinyl adhesive Contact paper. Cut the Contact paper slightly larger than the print, remove the paper backing, and apply the sticky side to the back of the print (above, right). This seal prevents the back coating from dissolving in the water when you soak the print. *Tip:* The vinyl adhesive roll without the paper backing doesn't stick well for this type of use.

3. Heat a tray of water to 160°F, and fill another tray with water that's room temperature. (An electric frying pan is ideal for keeping the water at 160°F, but you can also continuously reheat water with a

kettle—pouring it in at a temperature of 200°F). *Note:* If you're having difficulty or your water is very hard, try distilled water and see if it makes a difference. The pH level of your water should be near 7. I use well water with no problem, however.

Immerse the positive print (with the adhesive paper backing) face up in the hot water for 3 minutes until the emulsion starts blistering or lifting (opposite, top). If you're using a kettle and pouring the water into a tray, use water that's 170°F to 180°F as 4 minutes is required because the water cools. The water should be deep enough so that the print remains completely immersed. If the print rises, push an edge under the surface with tongs. Don't touch the emulsion in the image area as it's

delicate and will tear. If the print continues to rise, gently agitate the tray or pan, or hold it on two edges with the tongs and the thermometer until the print stays submerged. *Note:* Any parts of the print that aren't submerged for the entire time won't loosen in the cold water and may tear.

Using tongs and holding the print by its edges, remove the print from the hot water and place it in the tray of room-temperature water. Do not put your fingers into 160°F water.

Separating and Manipulating the Emulsion

1. To separate the emulsion from the paper backing of the print, start at the edges of the print and gently push the emulsion toward the center with your index finger until the emulsion is completely free from the backing. It will separate as a single delicate and fragile membrane. (You can also loosen the top of the print and pull it down like a bed sheet, and the membrane will be reversed.) Leave the emulsion membrane floating in the water and discard the paper backing.

2. If a gel-like substance remains on the back of the emulsion, flip the emulsion over (it's already flipped if you pulled the membrane down like a bed sheet), and place a piece of acetate (or another receptor surface) under the image (right).

3. With your thumbs, push two corners of the emulsion down on top of the acetate. Slip your index fingers under the acetate, and holding the acetate and the emulsion, lift them out of the water together (bottom).

4. Rub the gel off gently with your finger (it isn't harmful) into the trash. Then, follow either step 5a, 5b, or 5c. *Note:* If you want to stretch the emulsion, let it sit in the cold water for about 10 minutes; the longer the emulsion sits in the cold water, the larger, thinner, and more stretchable it becomes—and the easier to tear!

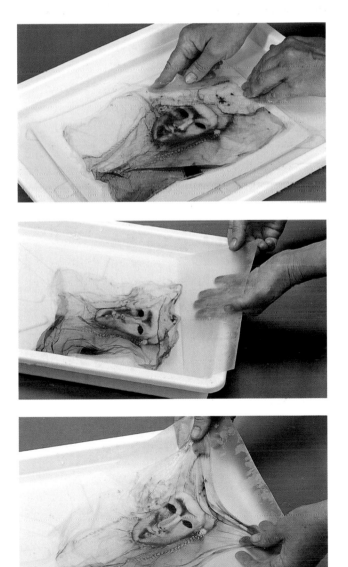

5a. Here, you use the acetate sheet (with your emulsion already on it) to transfer the emulsion to the receptor surface for manipulating (top, right). Prepare the receptor surface by dampening it with a spritzer, if this won't damage it; the emulsion will transfer more easily if the receptor is dampened or wet. Turn over the acetate so that the emulsion is on the underside, and place the acetate (emulsion side down) onto the receptor surface. Press the acetate with your fingers or the brayer so that the emulsion adheres to the receptor surface. Slowly peel the acetate from one corner, using your fingers or a Q-tip to hold the edge of the emulsion down on the receptor surface if it starts to lift (bottom).

5b. For this method, you manipulate the emulsion on the acetate and then transfer it to the receptor surface. After removing the gel, put the emulsion and the acetate back in the water. Flip the emulsion over so that the gel (moveable) side faces the acetate. With your thumbs, push two corners of the emulsion down on top of the acetate. Slip your index fingers under the acetate, and holding the acetate and the emulsion, lift them out of the water together.

If you want to remove the wrinkles in the emulsion, hold the top two corners of both the acetate and the emulsion and dunk them together in the water several times always holding two corners. When done, lift the emulsion and acetate out of the water, letting any excess water drain off. After manipulating the emulsion, place the acetate—with the emulsion side down—onto the receptor surface, press, and peel off the acetate carefully.

5c. The final option is to arrange the emulsion directly on the watercolor paper or other receptor surface. After removing the gel, put the emulsion and the acetate back in the water. Place the watercolor paper or other surface under the floating emulsion in the water tray. With your thumbs, push two corners of the emulsion down on top of the watercolor paper. Lift them out of the water together.

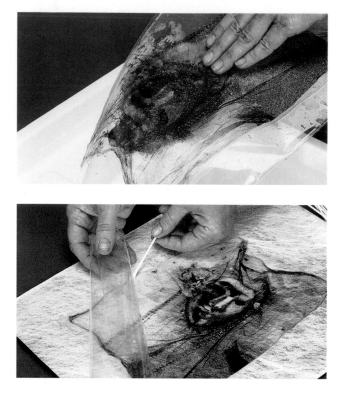

Holding the top two corners, dunk the paper and emulsion in and out of the water several times to remove the wrinkles in the emulsion. Lift the emulsion and the watercolor paper out of the water, letting any excess water drain off.

6. At this point, you can manipulate the emulsion until you are satisfied with the image. To stretch the emulsion, place your fingers in the center of it and pull gently in opposite directions all along the width (below). Move to different areas and stretch so that the stress point keeps changing. To wrinkle, scrunch, fold, or sculpt the emulsion, use your fin-

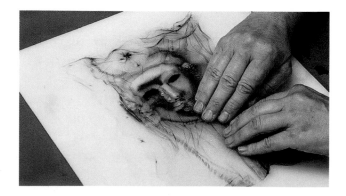

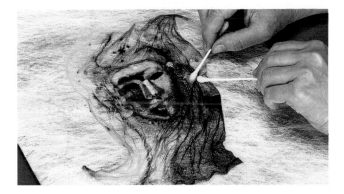

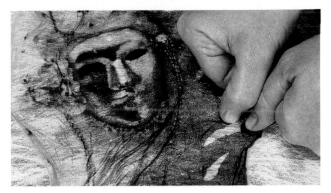

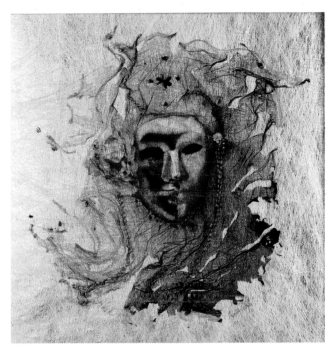

gers, cotton swabs, or a soft paintbrush (above). To tear, use fingernails, cotton swabs, or an X-Acto knife, or pull it with your fingers (top, right).

If the emulsion starts to dry out at any time during this process, splash it with cold water; otherwise, it can tear if it becomes too dry.

7. Lightly roll the image with a *wet* brayer, moving from the center out to each side of the image. This flattens all folds and ridges, and eliminates air bubbles and excess water. Use only the weight of the brayer; applying too much pressure will stretch out your carefully manipulated image. *Note of caution:* If the roller isn't wet or you don't start in the center and move outward, the emulsion might adhere to the brayer and wrap around it.

If applying the emulsion onto a three-dimensional surface that prohibits the use of a brayer, use wet fingers or running water. Start from the center, and smooth out any air bubbles and extra moisture.

8. Air-dry the emulsion transfer on a screen or hang it on a line, fastened with clothespins. *Note of caution:* If you dry the transfer too quickly—for example, with a hair dryer—it will curl and ripple. Usually, you can flatten the transfer later, but if the surface is too curly the emulsion might crack and flake off.

When the emulsion transfer is dry, flatten it in a dry mount press if you have one, set on low (180°F), and then place the transfer under a weight. You can also iron the back side of the transfer on a low setting before placing it under the weight.

9. If desired, handcolor the emulsion transfer with watercolors, pastels, pencils, or acrylics. Emulsion

GOLDEN MASK II. 2001
For this Polaroid emulsion transfer, I used Rosco spun silver reflector material as the receptor surface to add a textured metallic background to the mask, which I tore and shaped.

transfers are slicker than image transfers, and after you finish any coloring with soft pastels you'll need to spray the transfer with a workable fixative so that the pastels won't rub off.

10. Emulsion transfers are fragile, and it's a good idea to protect them with a protective spray. Don't use McDonald's Pro-tecta-cote or Krylon UV Clear sprays after coloring with soft pastels without first using a workable fixative—the pastels will be changed in an unflattering way. If the piece is to be handled or will remain in a moist area, sealers might be needed.

Troubleshooting

Although the image and emulsion transfer processes are fairly easy, problems can arise. I cover most of the common difficulties in *Polaroid Transfers,* so I won't repeat those here. However, I've discovered even more problems that can occur in the years since writing that book. I've also become pickier about my results as I've gained more "control" over the processes. Sometimes on a bad day, I can't make even one good transfer, so don't feel bad if you get results you're not thrilled with. Save those prints for practicing some wild technique that you wouldn't dream of trying otherwise. Following, I describe film-related issues first, then image transfer-related problems, and finally emulsion transfer-related problems.

Film-Related Problems

White Half-Circle or Shape in Center of Pod End
Called a U-break, a white half-circle or shape on the positive and negative in the center of the pod end of the image has several causes. The most common is that you haven't pulled out the arrows tab quickly enough, and the developer doesn't spread evenly. Another cause is

This transfer has several problems: The white shape at the left side is a u-break, which often looks like a white half-circle. The texture lines throughout the image are a result of either the paper being too wet or of not using warm water during development. The area on the right was caused by pulling the film out and separating it too slowly.

The black bars along the bottom and sides indicate that the slide was not properly aligned on the white card in the Daylab slide printer. If the black edge is curved, as on the right side here, the white card wasn't pulled out all the way when you made the exposure. In addition, this image has a missing corner (upper left), caused by not pulling one or both of the tabs out straight.

developer that's too dry; outdated or poorly stored film can cause the developer to miss this U-shaped area. Extreme humidity can also sometimes cause a U-break.

Partially Black Image or Black Bars on Top, Bottom, or Sides of Print

This is the result of aligning your slide incorrectly on the white card in the Daylab slide printer. If you don't match the top and bottom edges of the slide image to the top and bottom edges of the white card, you'll get a black line or bar where the slide image isn't touching the edge of the card.

Image Is Black on Right with Curved Edge

When using the Daylab slide printer, you didn't pull the white card out all the way, so only the area that was uncovered was exposed.

Light Blue Areas in the Positive Print and the Transfer

The film is fogged. Several factors can cause this. The film holder was opened while film was in the holder. This usually exposes only the top piece of film, so the rest of the pack should be fine. Or, you forgot to push the white card in after exposing the film in a Daylab slide printer and either turned the View light on, opened the previewing door, or removed the enlarging head. Again, only the top piece of film will be fogged.

Or, you're using a Daylab slide printer near a window or skylight with bright light hitting it. Daylabs are meant to be used in normal room light and are not completely light tight when used in daylight. Moving the Daylab away from the window or bright area, or closing the window blind or shade, is the best solution. You can also put a dark cloth or towel over the Daylab.

It's also possible that the film has been exposed to heat, either in transit or by being stored near a heater or warming tray. If it was fogged by heat before you purchased it, return it to your dealer for new film. Store your film in a cool dry environment. Refrigerate sealed packages if possible to extend the life of the film.

And finally, there may be a light leak in the Daylab base, the bellows, or the unit. If you're getting fogged film in normal room light, test your equipment with a different pack of film and try to locate the source of the light leak. Call Daylab to repair or replace your unit.

Image Transfer–Related Problems

Brown Pattern of Goo Over Image

The film is expired or has been stored improperly so that it has become outdated before its expiration date. Try to use Polaroid film before it expires, or within six months of the expiration date. However, I've had great transfers from Polacolor 669 and 559 film that was two years past expiration. Just try it and see. The brown pattern is more obvious on image transfers and sometimes doesn't even show up on the positive print, so use that box of film for emulsion transfers. I've had success removing the goo from image transfers right away with a cotton swab or paper towel. Blotting the image will remove a lot of the goo, as well.

Black Gritty Specks

This is often caused by rolling too hard over your transfer, especially using a hard rubber brayer or— *quelle horreur!*—an acrylic roller. Get a soft rubber roller and don't roll so hard. I like the six-inch size roller for more even pressure. *Note:* If you end up with white specks in your image, you're not rolling hard enough.

Bubbling

Bubbling can be caused by several factors. Little bubbles can be caused by pulling the arrows tab out too quickly. Or, if your image transfer is very wet and you put it on a hot surface, such as a warming tray, the heat can cause bubbling. Also, if your image transfer is very wet and you put it in a vinegar bath, the vinegar can get into the soft emulsion and cause bubbling. In addition, if your vinegar bath is too strong or too warm, it can cause bubbling; dilute it with more water and make sure the bath temperature is approximately 68°F.

Recently, when I've used a popular French hot-press paper, I've noticed a lot of bubbling. If this happens, try using a different brand of paper, such as Fabriano Artistico. Note that any of these factors in combination is even more likely to cause bubbling.

A pattern of brown developer goo over the image transfer indicates that the film is expired, or has been stored improperly and so aged prematurely. The darker the pattern, the older the film.

Black specks are often the result of rolling too hard with a brayer or using a hard rubber or acrylic brayer.

Bubbling can be caused in several ways, mostly by heat or incorrect vinegar baths. This print has also been fogged, hence the bluish color.

The mottled sky below was caused by uneven drying. The diagonal line on the upper right corner is the result of hesitating when separating the positive and negative instead of making one continuous peel.

Mottled Uneven Areas

Mottling, especially in light parts of the image transfer, can be caused by uneven development and/or uneven drying of the transfer, or can be the result of not using a flat hard surface to work on.

The former can happen when the transfer is floating on the warm water and part of the negative is submerged and gets more heat or water. Also, part of the watercolor paper might have been wetter—and more dye transfers to the wetter areas; this can be caused by uneven squeegeeing. Sometimes, if you pull apart the negative and positive parts of the film slowly, more dye transfers to the positive end and that corresponding part of the transfer will be lighter.

The latter cause—uneven drying—can happen when the transfer is very wet, because as it dries, it dries unevenly. The first areas to dry form indented pockets and the surrounding viscous emulsion runs into the pockets, creating darker puddles of emulsion.

The solution to mottling and uneven drying is to wet the transfer and blot it with blotting paper, smooth tissue, or a Photo Wipe. This will pick up most of the excess darker emulsion and will also lighten the print slightly. You can remove small areas of excess emulsion by additional blotting, or rubbing with a cotton swab or wet paper towel.

DIGITAL APPLICATIONS

Several years ago I came to the point where I wanted to make larger and more archival prints of my transfers and SX-70 manipulations, and that's where digital printing comes in. I receive a lot of requests to discuss various digital printing options in my workshops. The technological breakthroughs on home inkjet printers with archival inks and papers makes digital printing available to anyone, without having to invest thousands of dollars in high-end professional equipment.

Although this section could fill several volumes, I am only focusing on the basic technique of creating a fine digital print from your SX-70 manipulation or Polaroid transfer on a home computer, and/or having a professional digital studio work with you to produce large Iris, Roland, Epson, or other types of prints. If you're interested in pursuing work with scanning, Photoshop, and digital printers, there are plenty of books that cover the specific information not found here (see Bibliography for recommendations). Every six months there are technological changes in equipment, software, and supplies, so I'd wait until you're ready to actually use the equipment or software before you go out and buy anything.

Scanning and Photoshop Adjustments

Before you can make a digital print you need to scan your Polaroid SX-70 manipulation or transfer. You can do this yourself if you have a scanner, or you can take your original art or transparencies to a service bureau or digital studio to have them scanned. This chapter will cover the specific information you need to make a good scan, as well as some of the options you have in Adobe Photoshop for making further adjustments to improve or change your image.

I worked part-time at the digital fine-art printer Skylark Images, so I've learned how professionals approach scanning, Photoshop adjustments, color management, and print output. I've also discussed with other photographers what size digital file is really necessary for working with altered Polaroid prints, since the images usually are softer and don't contain as much detail or "information" as, for example, a 4x5 view-camera photographic print.

DOORWAY, TA PROHM, ANGKOR WAT. 2000
Partial liftoff occurred on the door, and I scraped the rest of the black with a cotton swab. I then handcolored with pastel pencils.

Scanning

Artist Dewitt Jones got tired of working with large files for his SX-70 manipulations because it takes longer for changes to be applied to the file. He now does 13x13-inch prints on watercolor paper with a 10 megabyte file and loves the quality! My files from Skylark Images are about 80 megabytes for the same size print. I'll present both views, with a recommendation that you start with the scanner, computer, and printer you already have until you decide at what level you want to involve yourself, or whether you want to have a digital studio scan and print professional-quality images for you.

You can get wonderful prints that you can mat and frame even if you don't have a professional setup. If you already have high-end equipment, then you'll be able to work with large files that have high resolution, get more accurate color, and thereby have more control over your final result. I'm only presenting the most basic scanning process. If you decide to pursue digital printing seriously, there are many books and courses on scanning and Photoshop.

Types of Scanners

There are three types of scanners: flatbed, film, and drum. Flatbed scanners are used for reflective, flat art (such as photographs, prints, and paintings) and the scanner captures the light as it reflects off the original. Film scanners capture light as it passes through a transparency or a negative. You can also get transparency adapters for some flatbed scanners. The larger the transparency, the better the results with a transparency adapter. To create comparable results with 35mm slides, a film scanner is best.

Drum scanners can scan film or reflective art, but the art must be able to be mounted on a cylinder. Drum scanners have the optimum resolution but are very expensive, which puts them in the professional category. If you work with a good digital studio, they'll probably have a drum scanner. If you're working with a lot of images, scanning costs can add up when you're paying someone else to scan. For the small studio, I've found that a mid-range flatbed scanner, such as the Epson Expression 1680 with the LaserSoft Silverfast software works quite well for the quality I desire. Less expensive scanners can also give acceptable quality—check reviews online at PC Connection (www.pcconnection.com) for scanners in your price range before purchasing.

A good scan is crucial for making a good digital print. You'll get the best quality if you scan from your original Polaroid art rather than from a transparency or 35mm slide reproduction of your work. Be sure to dust off your artwork before scanning to save yourself hours of cloning away dust spots and hairs. If your piece is too large for the scanning area on your scanner, having it photographed with a 4x5 camera with a digital back will still yield a first-generation scan. Joanne Warfield has found that the slide adapter to the Nikon 990 3.4 megapixel digital camera works well (much better than a flatbed scanner with a transparency lid) as an interim scanner for 35mm film. The camera becomes the scanner and the image is downloaded directly to the computer.

If you can't or don't want to provide the original art, a 4x5 transparency of your original art is the next best option for quality. However, I've seen very fine output with a film scanner from a 35mm slide of artwork, if the slide is well exposed, sharp, and evenly lit (with no glare from a glass frame). A few simple adjustments in Photoshop can do wonders. Work at the best quality level you can, and go from there.

Calibrating Your Monitor

At this time, CRT flat screen (not LED flat panel) monitors are the most accurate for matching the image on your screen to your print. The larger the monitor, the better. Before purchasing a monitor, check reviews and articles for recommendations.

Before you make a scan or print anything, it's important to calibrate your monitor so that when

you're viewing your image on the monitor screen, it will look as close as possible to the print you will be making. How the image looks on your screen will be affected by the color of the room walls, the light source, the monitor screen color and texture, how old the monitor is, and a variety of other factors. Try to have as neutral an environment as possible in which to work, with a gray background on your monitor screen and dim room light. Match as closely as possible the light intensity of the room, or viewing light, to the light intensity of the monitor.

With Macintosh computers, go into the Control Panel to Monitors, set the colors to Millions, and follow the step-by-step calibration guide. The calibration will then be loaded into the ColorSync Profiles for your printer in the System Folder. Since the monitor phosphors burn out over time, it's a good idea to calibrate once a month to correct for these changes. There are other, more precise software programs for calibrating your monitor, such as ColorBlind's affordable Prove it! or ColorVision's Spyder. (Also see Color Management on page 141.)

Scan Quality

There are several factors that affect the quality of a scan: bit depth, dynamic range, software algorithms, and resolution. The bit depth refers to how much color information the scanner can capture. Higher quality graphics scanners are 36 to 48 bits, or 12 to 16 bits per each RGB color channel (the red, green, and blue additive colors that the monitor uses), but may only save out 8 bits per channel. Some operations in Photoshop can only be done in 8 bits. Each 8-bit channel has 256 shades of that color, and when all three colors are combined over 16.7 million possible colors can be created.

The dynamic range measures how much information the scanner can get from the film, which makes a difference with dark shadow detail. Scanner software is also important. The Silverfast software is often bundled with a scanner and can be superior to the scanner-brand software. Upgrading to the most recent software release can also improve the quality of your scans.

Scanning Resolution

Resolution is something you can choose for a scan and a print, and refers to the size and number of dots of ink per inch—or "dpi"—when printing, or the number of pixels per inch—or "ppi"—if you're looking at a computer screen (monitor). A pixel (short for picture element) is the smallest unit of measurement in a digital file. There are 72 pixels per inch on a Macintosh monitor screen (96 ppi for PCs), so a higher ppi than 72 ppi is pointless for web and online use. The terms ppi and dpi are interchangeable; it depends on whether you're referring to a monitor or paper. The higher the dpi used in the original scan, the more detail you'll get—as well as subtler color transitions and better final print quality. Higher dpi does, however, result in a larger file size.

Optical resolution refers to how much detail the scanner can capture from the artwork itself, and it should be used rather than *interpolated* resolution. Interpolation uses information measured by the scanner to create more pixels, resulting in a larger file. The optical resolution of many scanners is often in its model name; for example, my Epson 1680 has its highest optical resolution of 1600 dpi, but will interpolate to 3200 dpi. If you need to interpolate to get a larger output-image size, you'll get a much better result doing it later in Photoshop, or by using interpolation software such as Genuine Fractals, which expands the image without pixelization.

Input and Output Sizes

Resolution refers to both scanning resolution and printing resolution. Bob Cornelis of Color Folio digital studio recommends scanning at your scanner's highest optical resolution at the original artwork size—input size—rather than choosing the output size and the resolution you want at that output size.

For example, if you have a 1600 dpi optical scanner with an original SX-70 print at 3x3 inches and choose an arbitrary 7x7-inch output size at 300 dpi resolution, the scanner calculates a resolution that may be interpolated—rather than an optical resolution—in order to give you that result. This

can adversely affect the quality of your scan. Also, some scanners won't let you fill in the output size. It would be better to scan at a 1600 dpi resolution at 3x3 inches and not assign an output size. If you're concerned that the resulting file might be too large to work with, choose one of your scanner's smaller optical resolutions. Many scanners don't give you information about what other resolution settings are optical, however. Usually dividing by two will give other optical resolutions, so in this example you could scan at 800 dpi instead of 1600 dpi. This would help if you were scanning an 8x10 Polaroid transfer because the resulting file would be quite large, around 590MG, at 1600 dpi.

The easiest way to figure out how a 1600 dpi resolution at your original input size would translate to the output size and resolution you want is to open an image file in Photoshop, go to Image, then Image Size, and plug in the numbers. Try 1600, 800, and 400 dpi and look at the resulting file sizes to get an idea of how image size, resolution, and file size relate to one another. Don't save these settings unless you actually want to change the image.

The resolution at which you need to scan will depend on what you're going to do with the image. For web, e-mail, or online purposes, you only need a small file at 72 ppi. Speed of downloading is important, so a large file is a disadvantage because it will load slowly. If you're scanning a 3x3-inch SX-70 print and you want the image to be the same size online, you can scan at 100 dpi resolution at 3x3 inches and adjust to 72 dpi in Photoshop. Printing requires greater resolution.

Printing Resolution and Interpolation

When printing, for most purposes a 300 dpi printing resolution is a good choice, 150 dpi at the very minimum. If the resolution is too low, your image will print looking blurry and jagged. You've probably noticed this if you print a 72 dpi online image. For 1440 and 2880 dpi inkjet printers, a range of 240 to 360 dpi is fine. Iris and Roland printers use 300 dpi files. If someone else is printing for you, discuss how you should scan for their printing system.

You can always interpolate, or resample, the image in Photoshop to make the image larger, although if you enlarge too much, you may lose image quality. There are too many variables to state how much larger you can interpolate an image. A lot depends on the image itself—how much detail it has, how sharp that detail is, how good the scan is, what the viewing distance of the print will be, and, of course, your subjective response. If possible, you should have at least one third of the information in the scan—that is, a 5x5-inch output size image at 300 dpi could be resampled to a 15x15-inch print at 300 dpi. Having half or more of the information is even better. Photoshop fills in the remaining pixels.

The most precise of the resampling methods is Bicubic, so select this when you're changing the image size without changing the resolution. I asked Bob Cornelis what the difference in quality was using Photoshop resampling versus Genuine Fractals, and his tests indicate that for lower-resolution scans, Genuine Fractals did a better job of resampling, and with higher resolution scans, he noticed no difference. I would start with Photoshop, and if you're not happy with the results, either don't enlarge so much, try Genuine Fractals, or get a better scan of your original art.

Other Adjustments

Although you can make other adjustments with the scanning software, such as to contrast and color, only do this if your scanner gives you accurate previews. Instead, make those adjustments in Photoshop, where you can undo something you don't like. However, when scanning wet negatives, artist Joanne Warfield finds that she gets better results by adjusting the scanner software and making several scans at different adjustments to be sure that one or more will be useful. Most scanner software offers auto-adjust features such as auto contrast, color balance, and sharpening. These features can blow out your highlights, and remove shadow detail and color that you may want. It's best to turn these features off if you can, and make these corrections yourself in Photoshop. It's unwise to sharpen at the scanning stage..

Working with Adobe Photoshop

There are two levels of Adobe Photoshop: Photoshop LE (or Limited Edition), which has fewer features, and the regular Photoshop, geared for professional use. I've been using the regular Photoshop, but recently installed Photoshop LE to acquaint myself with it. I was surprised at how much is included in it. Much of what I suggest in this section can be done in Photoshop LE, which comes bundled with some scanners, printers, and the Wacom tablets. However, one of the big advantages of Photoshop versions 5.5 and above is being able to make adjustments to your image on layers without doubling your file size with each layer. If you have LE, you can start with it and upgrade later, but if you're purchasing the software, I'd recommend getting the regular Photoshop.

File Format Types

Once you've scanned your image, you'll be opening it in Photoshop. When you save the image, you'll need to choose a file format to save it. Keep it in the native Photoshop format until you need to put it on the web, export it to a page layout or other software program, or send it to a printer that requires a different file format. Then, duplicate the image so that you also keep the Photoshop file, and flatten the duplicate, otherwise you'll lose the layer information when saving to another format. An advantage of a Photoshop file format version is that you can keep any layers you've created so that in the future if you want to change something in the image, you can.

When you're putting something on the web or in an e-mail, jpeg (joint photographic experts group) is the best file type to use for photographic images. It's a "lossy" compression format that reduces the images into much smaller files by throwing away data (that you won't be able to get back). You can choose quality levels from low to maximum, and a standard or optimized baseline. Optimizing eliminates any unnecessary pixels for the web to give you

a faster-loading image online with the same quality. The progressive setting loads even more quickly, with several passes. Don't use jpeg to save files for printing—you'll lose detail, especially if the jpeg format has been applied to an image more than once.

When you need to save your image in a non-native Photoshop format, choose tiff (tagged image file format). It's a raster (bitmapped) file format, and almost every application can open or import tiff files. LZW compression is a "lossless" compression method that is not supposed to lose any data in the compression. Bob Cornelis recommends not to use any compression, even LZW. There are other file formats, but for our purposes you won't need them.

RAM (Memory)

Working with large files in Photoshop requires a lot of RAM, or memory. If you plan to work on your own digital image files, one of the best investments you can make is to put the maximum amount of RAM into your computer that it will hold. Or, if your computer isn't really suitable for working with digital image files, make sure that when you purchase a new computer, you get the maximum amount of RAM possible. This is because you need at least five times the amount of memory available for the file size on which you're working to perform the commands; that is, for a 50 megabyte file you'll need 250 megabytes alone for Photoshop, not to mention the memory required for your operating system and other software memory requirements.

File Storage

Unless you have a very large hard drive, you'll need some other form of storage for your images after scanning a number of them. A second hard drive (internal or external) is an excellent option; archiving images on CDs or DVDs, or copying the digital files onto zip or jaz disks are other possibilities.

Photoshop Workflow: Using Layers

After you've scanned your artwork at the highest optical resolution of your scanner at the input size (or at the largest file size that you can comfortably work with using a smaller optical resolution), and have saved your raw scan into Photoshop as a native photoshop file, there are a variety of ways to proceed. It helps to work in low-level room light with no glare on the monitor screen and to have a print-viewing light that is color balanced for daylight. This is because tungsten is a warmer light source than daylight, and your prints may look greenish in daylight if you adjust the image for tungsten viewing only. I find that the Photoshop workflow presented below (and also mentioned in chapter 4 on handcoloring a digital file) is the most helpful that I have encountered so far. Work with it both to the best of your abilities and to what your computer setup allows.

It is unwise to alter the raw scan, because you may do some things, especially while you are learning, that you won't be able to undo later. It's much better to work on layers with a copy of the raw scan as the background layer and to archive the actual raw scan. It's also best to make changes to the entire image first before selective changes to just part of the image.

Cropping the Image

Starting with the copy of your raw scan, first see if you need to remove any imprecise edges or black lines from misalignment in the slide printer or scanner. Use the Crop tool for this. It's wise to wait until you print to crop the actual image area—this keeps your options open in case you want to use different cropping later. To square up an SX-70 manipulation (because one dimension is longer than the other), you can crop the top or bottom, or uncheck the Constrain Proportions box in the Image Size command and set the width and height to be the same. The image will readjust slightly without any of it being lost.

Cleaning Up with Cloning

The first layer to create is for cleaning up any dust marks, scratches, or glitches in your manipulated image that you'd like to eliminate. When using Photoshop 5.5 or above, make sure the Use All Layers box is checked so that the cloning tool will sample the background layer when using a transparent layer. If you make other layers first, you'll need to move the cloning layer next to the background layer and make the other layers invisible when cloning. Otherwise, you won't be able to clone effectively. If you're using LE or earlier versions of Photoshop, you don't have this layer option for cloning, and you'll need to clone on a duplicate of the background layer, which will double your file size (transparent and adjustment layers only add the pixels you create).

Make any cloning repairs at 100 percent of the resolution size of the image with a dust spot sized soft brush. The image will look huge on your monitor at 100 percent, especially if you're working with a large image size. On the cloning layer, with the cloning or rubber stamp tool, I select the area next to the unwanted spot and literally cover up the mistake, working on one small section at a time.

If I don't like what I've done, the history palette (not available on Photoshop LE or 5.0 and below) lets me trash any moves or unwanted states. If you decide to use the Dust and Scratches filter instead of cloning, be aware that it softens the image in order to make the dust and scratches less noticeable.

I really like using a Wacom tablet and pen for cloning, handcoloring, and any other precision work on my digital images because it gives me more control than the mouse. I've tried the inexpensive Wacom 4x5-inch Graphire tablet with 512 pressure levels with the pen, and the professional 6x8 Special Edition Intuos tablet with 1024 pressure levels. I prefer the 6x8 Intuos, but the 4x5 Graphire is more than adequate. The feel of working with a pencil seems much more like creating art than does using the cumbersome mouse. Plus, Pen Tools (more filters), Adobe Photoshop LE, and Corel Painter Classic come bundled with any Wacom tablet.

Setting the Highlight, Shadow, and Midtone Values

The next layer to create is an adjustment layer for tonal values, or contrast. Photoshop LE, 5.0, and earlier versions don't have these adjustment layers. Use an adjustment layer if you can, otherwise you can save a copy of the image file before adjusting, then save your adjustment settings with the image file in a folder.

If you're a *Photoshop for Dummies* candidate, Variations and Brightness/Contrast are the easiest ways to adjust contrast. These adjustment commands aren't as flexible and precise as those that follow, but if you know nothing about Photoshop or adjusting contrast and color, you can begin here.

Using the Variations command is an easy way to see which changes will improve the image. The Variations command, under Image and then Adjust, lets you visually adjust the contrast, color balance, and saturation of your image by comparing it to variations of the original image. Choose the Shadows, Highlights, and then Midtones buttons to adjust the dark, light, and middle value areas of the image for brightness as well as for color balance. Click the thumbnail you like best in each setting and that version becomes your Current Pick.

You can also adjust the saturation (the three thumbnails to the right of the screen above), which changes the hue to a deeper or paler version. Every time you click a thumbnail version of the image, it blends with your previous choice and becomes your new Current Pick. The Current Pick is compared

to your original at the very top. You can cancel at any point and start again if you don't like what you've done. When you get a version you like, save it as an adjustment file before closing Variations. Adjustment files save the adjustments and can be applied to another file of the same image to recreate what you've done. You can also use the Save As, Save A Copy, or Duplicate commands to save different versions of your image.

The other very basic adjustment command is Brightness/ Contrast, which adjusts all pixel values in the image at once, so you have no separate control over highlight, midtone, and shadow adjustments. I don't recommend using this command, and I don't know any professional who does because you can irreversibly ruin your image file unless the adjustment is applied on a layer (then you can manipulate or discard it without affecting the original scan).

These screens show my Rosebud 3x3 SX-70 manipulation with the Levels histogram. There are several recommended ways to set the highlight and shadow values, the simplest of which is to use the Levels sliders. The Levels histogram is a useful tool for adjusting contrast in the highlight, shadow, and midtone values, as well as for adjusting color balance by choosing a color in the Channel bar.

When you open the Levels dialog box, a histogram of the image is displayed (the smaller box on the right of the screens). This graphs the number of pixels at each brightness level in an image and gives you a picture of the tonal range of the image, or the key type. A high-key image has detail concentrated in the highlights, and a low-key image has detail concentrated in the shadows. If there's space between the ends of the histogram and the triangular input sliders below it, moving the sliders to the first group of pixels on both ends of the histogram increases the tonal range of the image. This remaps the lightest value to white (or 255) and the darkest value to black (or 0), and increases contrast. The Auto Levels command does this for you

and works best for an image with an average distribution of pixel values.

I prefer to have more control by adjusting the tonal values myself. Be sure to have the Preview box checked so that you can see how the image changes as you move the sliders. If you don't like the changes, play around with the sliders and see what looks good to you.

Midtone values only need to be set when you want to change the brightness values of the middle range of tones with minimal effect to the shadows and highlights. After setting the highlights and shadows, move the gray slider under the middle of the histogram to the left to lighten the midtones or to the right to darken them. You can also enter values directly into the Input Levels text boxes, using the center box for midtones. If you don't like what you've done, clicking on Cancel stops the changes from being applied to your image. (Compare the two Levels boxes and screens; note how the contrast changes when the three sliders are adjusted: Highlights are brighter and there's more detail in the shadow areas.)

Color Balance and Saturation

Once the tonal correction is done, it's easier to accurately diagnose any color cast, or over- or undersaturation of colors. If you're not skilled in color correction, refer to the color wheel and color correction information on pages 36–37 for a better understanding of what happens when you start changing the color balance. The simplest method of correcting color balance is by using the Color Balance command, which allows you to adjust the highlights, midtones, and shadows independently. Once again, I would use an adjustment layer, or if you can't, save

a copy of your image file before applying Color Balance. Every time you make adjustments on the background layer, it degrades the image quality. So, if you adjust and then don't like what you did and adjust again, you're losing quality.

You can also use the Levels or Curves commands to correct or shift the color balance. Choose red, green, or blue instead of RGB in the Channel bar at the top of the dialog box. Moving the input triangle sliders in Levels, increases or decreases the chosen color. For more precise color correction, Curves offers the most control by setting as many

Many professionals use the Curves function to adjust not only the shadow, highlight, and midtone values but also color balance. Curves gives you the ability to adjust not just three variables (of shadow, midtone, and highlight) but any point along the 0 to 255 scale, while keeping up to fifteen other values constant. Rick Miller from Color Folio suggests making the Curves grid match the Zone System, with ten gradations going from black to white rather than four. This is done with Option and Click in the Curves field. It helps me put what I'm adjusting into a familiar context from my black-and-white printing days. To lighten the image, pull the graph line up from the middle, and to darken, pull down. To lighten a particular value, put the cursor on that area of the image (the cursor turns into an eyedropper). Click to see where that value is on the graph line, then adjust that point.

The screen above shows the Curves grid with ten gradations and no adjustment in the RGB channel (for contrast). The one at top right shows adjusted green (green is selected with Channel); the eyedropper selects the color value shown by

the circle on the 0 to 255 gradient scale. The line has been adjusted to lighten that value. The final screen above shows the green channel adjusted even more.

fixed points as you need on the diagonal line. You can also affect some radical changes by making extreme adjustments with color adjustment controls (see examples on page 134).

The Hue/Saturation command allows you to adjust the hue (or color), saturation, and lightness of the individual color components in an image. Adjusting the hue involves moving around the color wheel through different colors. Adjusting the saturation (or purity) of a color uses a color wheel that has a white center, with the colors being more saturated as you move to the edge of the wheel. You can

adjust all colors at once or individually. The Colorize option on the dialog box is interesting to explore. You can add color to a grayscale image converted to RGB, or apply it to an RGB image to reduce its color value to one hue.

Selective Corrections

After you've made the global corrections to the entire image, you can correct specific parts of your image by selecting just those areas. There are a variety of selection tools—such as Marquee, Lasso, Polygon Lasso,

Magnetic Lasso—or you can target color areas with the Magic Wand tool or the Color Range command. Once you select an area, you can apply additional color, adjust contrast or density, or apply blurs, sharpening, or a number of other filters to adjust the area(s) selected. You can also create more layers and color different parts of the image.

Layer Masks

Layer masks are an excellent way to make corrections to specific areas of the image. By selecting an area and then choosing New Adjustment Layer and the type of layer you want—Levels, Curves, Color Balance, etc.—you will automatically create a layer mask with everything but the selected area masked out with black. You can also use a paintbrush to make a mask. If you use black as the foreground color in a layer mask, whatever area you paint with black will block the adjustment from happening in that area. You can also use white as the foreground color, which will allow any adjustments to pass through the area painted in white. The opacity slider can be set for further control so that the adjustment can be blocked or passed through at any percentage of opacity you choose.

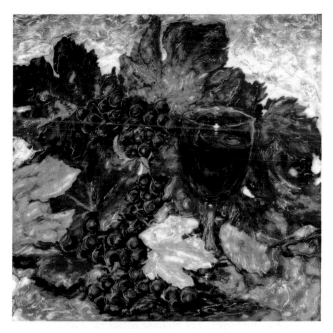

GRAPES AND WINE. 2001
For this 3x3 SX-70 manipulation, I used the Lasso to outline the wine glass, then made an adjustment layer in Curves to lighten the wine so that the highlights would show without making the entire image too light.

TROPICAL BOUQUET I with Layer Mask
For this 3x3 SX-70 manipulation, I used the Lasso to outline the background, then made adjustment layer masks in the blue Channel in Curves (to remove the yellow) and in the RGB Channel (to lighten the background).

Photoshop Filters, Effects, and Sharpening

Using Photoshop filters and other effects is completely optional and also easy to overdo. However, there are a few that can enhance the look of your image, depending on what you want. Some Photoshop books show examples of what each filter does, but the best way to learn about the filters is to try a number of them on a small image file (1 to 2 megabytes), save each version, and compare. It's quite fun to see what can be done, and there are ways to fade the effect of the filter if it's too intense. You can use the Fade command under Edit (not available in LE) or change the opacity setting on the layer. The Find Edges filter (under Stylize) can turn your image into a line drawing with color washes similar to Glow Edges but with black lines.

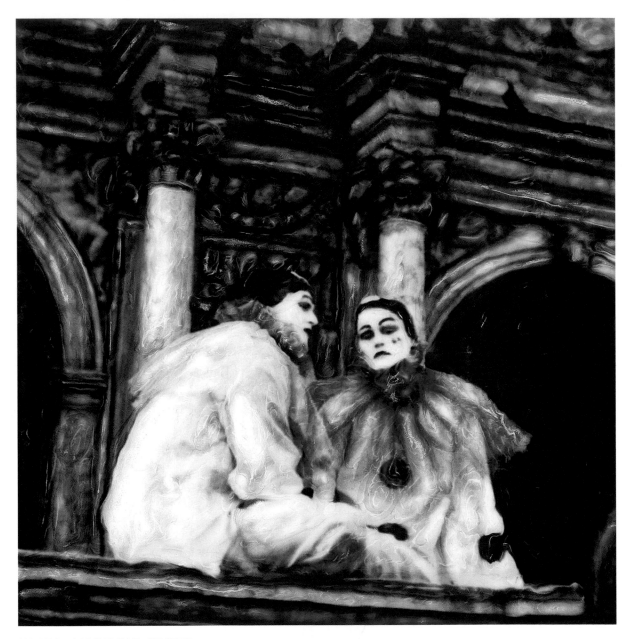

MIMES, CARNEVALE, VENICE. 2001
This SX-70 manipulation was photographed on 35mm slide film and exposed onto Time Zero film with the Daylab slide printer, then scanned and enhanced in Photoshop.

Here's the Radial Blur Photoshop filter applied to the same image.

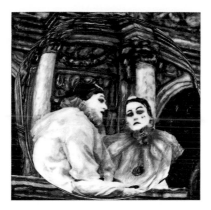

The results with the Spherize filter.

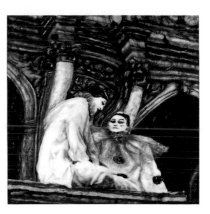

With Twirl filter.

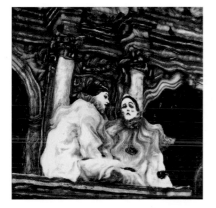

With Zigzag filter.

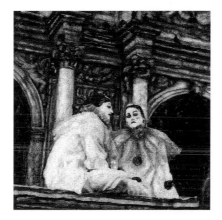

With Craquelure filter.

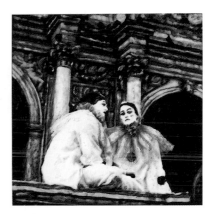

With Sumi-e filter.

With Glow Edges filter.

Other than filters, there are some effects that warrant exploration. The Invert command reverses the image from a positive to a negative. It was originally designed for scanning negatives and being able to work on the positive image. Some images are very striking when inverted, and then, combining other commands such as Posterize can add even more interesting effects. (See Joanne Warfield's work on pages 61, 87, and 194–195.) Often in my workshops, I suggest that participants try using color or black-and-white negatives in the slide printer instead of slides. Some of my favorite transfers were made with negatives, which is doing the same thing as using the Invert command.

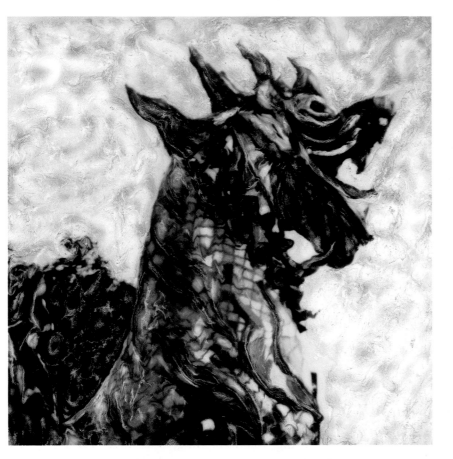

DRAGON, THAILAND. 2001
Photographed on 35mm slide film and exposed onto Time Zero film with the Daylab slide printer, this SX-70 manipulation was scanned into the computer and enhanced in Photoshop.

Here, a new Invert layer was added, and all but the Posterize, Invert, and Background layers are invisible. Making adjustments on layers lets you make them visible or invisible, allowing for many versions from one digital file.

This version was colored in Photoshop on a separate layer.

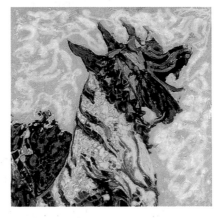

Here, Hue/Saturation and Curves adjustment layers, plus the colored layer, create a completely different effect.

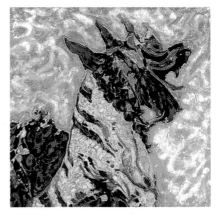

Here, a Posterize layer was added to the Hue/Saturation, Curves, and colored layers.

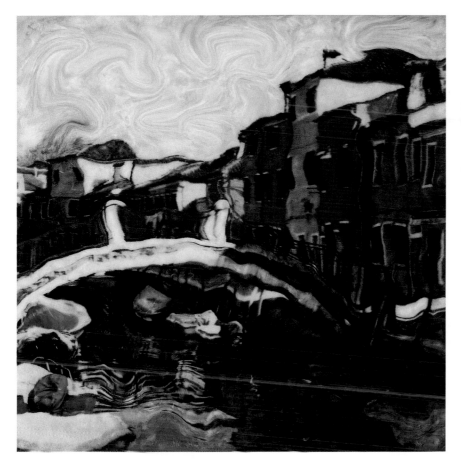

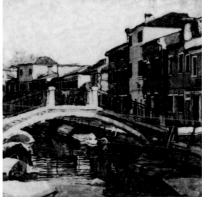

BRIDGE, BURANO. 2001
The SX-70 manipulation above was photographed on 35mm slide film and exposed onto Time Zero film with the Daylab slide printer, then scanned into the computer and colored and enhanced in Photoshop using layer masks to help with contrast. Compare with the version at left in which the Liquify filter was applied to a layer.

The Liquify command (not in LE) attempts to give the same fluid ability to manipulate the image as attained by smooshing the Time Zero film in an SX-70 manipulation. There are a variety of controls that change how the image liquifies. Definitely do this on a layer (see above).

There are additional plug-in filters that you can purchase for Photoshop, including Kai's Power Tools (KP) from Corel and a whole set of edges and other effects from AutoFx.com (see Resources). Diane Dias and Mitchell Shenker from Armadillo Artworks add distinctive edges to their digitized SX-70 manipulations in Photoshop using the Airbrush and Smudge tools. (See their images on pages 156–157.)

Sharpening

Sharpening is best done as the last step, just before printing. This is because different amounts of sharpening are needed for screen or web uses versus printing, and for varying resolution and print sizes.

If layers have been used, a copy of the image file should be flattened and sized before sharpening. the image file should be flattened before sharpening. Otherwise, the cloning layer won't be sharpened. For most uses, Unsharp Mask is the best sharpening filter to use. It corrects the blurring introduced during photographing, scanning, resampling, or printing. It also locates pixels that differ from surrounding pixels and increases contrast by the amount that you specify.

You can also specify a value for Radius and Threshold. Radius determines the number of pixels surrounding the edge pixels that also get sharpened. A lower value sharpens only the edge pixels. Threshold value refers to how different the sharpened pixels must be before they're considered edge pixels and are sharpened by the filter. Use the default settings until you're up to experimenting with setting these values. I mostly increase the percentage, use the Preview button, and apply the filter again if I don't see enough change in my image.

Output Options

Once you've scanned and corrected your digital image file in the native Photoshop format, you're ready to make prints. Nowadays there's such a broad range of options for output to printers. You can print on an inexpensive consumer inkjet printer at home, or choose from a variety of inkjet printers geared for photo quality. You can use the inks and paper made for your printer, or with the use of color management profiles, you can explore using other ink and medium combinations. There are also digital studios and service bureaus that use professional equipment, such as the Iris or Roland printers to print large images on watercolor paper, canvas, and other surfaces, and digital enlargers that use photographic paper. This chapter gives an overview of various printer types and guidelines on how to choose the right printer for what you want to do. Also covered is an introduction to color management, profiles, and various inksets and papers.

TREES, BOBOLI GARDEN. 2001
I made this 4x5 Polaroid image transfer from a 35mm slide taken in Florence and exposed with the Daylab II onto 559 film. I then scanned it into the computer, enhanced it in Photoshop, and output a giclée print of it on an Epson 2000P printer.

Printers

Consumer Inkjet

The least expensive option for printing your image file is a low-end inkjet printer. One of the main drawbacks of consumer inkjet printing has been that the inks only last a few months to a couple of years at most in display light before noticeable fading. Also, the inks run on any contact with water. These problems are being addressed with new inks and papers that last from ten to sixty-plus years before fading. The longest-lasting are often labeled as "archival." Epson's DuraBrite inks, for the four-color C Series, bring longer-lasting inks and better-quality images on plain paper to the office market.

Epson has been the leader in photographic-quality inkjet printers for years. Their Photo line of printers uses six colors instead of four, adding a light cyan and a light magenta to the standard cyan, magenta, yellow, and black (CMYK) four-color inkset, which improves the print quality. Recently, Hewlett Packard (HP) has come out with Photo-Smart consumer printers that offer some serious competition in quality and longevity.

Epson inks print best on Epson papers and give a beautiful result. However, if you feel adventurous, you can explore options such as using other papers with Epson inks, using third-party inks and papers with any Epson printer, or quad-tone black-and-white printing (substituting four black inks instead of the CMYK color inks). Profiles need to be used for each particular ink and paper combination for best results (see page 141 for information on profiles and color management).

The latest Epson models have a built-in microchip in the ink cartridges that prevents the use of third-party inks. However, CIS (Continuous Ink Supply, www.NoMoreCarts.com) and others have developed a custom-designed micro-chip that will always read 100 percent full, no matter how much ink is used. Ink in the CIS cartridges is automatically replaced by ink in large reservoir bottles kept beside the printer, so you can print forever with the same set of cartridges as long as you keep ink in the reservoir bottles. No permanent modification of the printer is required. Any ink compatible with Epson printers will work with their continuous ink-feed system. Continuous ink-feed supplies dramatically bring down the cost of inks.

Epson 2000P

In 2000, the release of the Epson 2000P ushered in a new era of home digital printing with the introduction of water-resistant pigmented inks that claim to be archival, lasting 200 years before noticeable fading in display light (under glass). The technology, called MicroCrystal Encapsulation uses tiny .1 micron-sized ink particles with a specially formulated resin polymer. The 2000P uses Epson's standard micro piezo

The Epson 2000P is the first consumer printer to use water-resistent pigmented inks for long-lasting giclée prints up to 44 inches and roll-type media. PHOTO JOHN A. TEAGUE

inkjet technology at a resolution of 1440 x 720 dpi. New paper stock—including heavy archival matte, watercolor, luster, and semigloss surfaces—are made for use with the 2000P.

In line with the other Epson Photo models (excluding the Epson 3000), the simplicity of controls and ease of use to get excellent prints right out

of the box makes the 2000P my recommended choice if you want to start printing your own archival digital prints. The standard paper sizes are from letter to 13x19 inches (Super B) plus user-definable sizes and panoramic up to 13x44 inches, including roll-type media. I have the 2000P and love it. The heavyweight archival matte paper is excellent for fine-art printing, and if I want more texture, the Epson watercolor paper is okay.

One drawback with the Epson pigment is that when viewed under different light sources, the colors change more significantly than with other inks. This is called metamerism and is caused because the pigmented inks sit on top of the paper's surface rather than being absorbed into it as with dye-based inks and, therefore, have different spectral reflective curves in different light. (The Epson 2000P print driver seems to be profiled for tungsten illumination.) Be sure to look at a print in daylight (or a 5000°K view light) and tungsten light before finalizing your digital file. A print that looks great in tungsten light may look green in daylight. Decide where the print is most likely to be viewed and correct to that light source. On Inkjetart.com, I found a Photoshop Curves correction when making prints for reflected daylight and fluorescent illumination. Add magenta (or remove green) by using an input of 195 and an output of 187 in the green channel.

Black-and-white images can appear flat on the 2000P, so increase the contrast more than you regularly would to compensate. With the appropriate profiles, a variety of other papers can be used with the Epson inks, including some nice watercolor papers. Third-party pigmented inks and papers can also be used in the Epson 2000P, as well as in other Epson printers. Additional maintenance is required to clean out debris and ink pads due to the flaking of papers not designed for Epson printers.

Epson 3000

Up until the introduction of the 2000P, the Epson 3000 was the printer of choice at the consumer level if you were serious about making your own digital prints, and it is still favored by many artists because

The Epson 3000 has long been a favorite for its flexibility in using third-party inks and media. PHOTO JOHN A. TEAGUE

of its flexibility. It comes with four ink cartridges, but larger quantity bottles can also be used, which makes it easier to use third-party ink/paper combinations, including inks made for Iris printers. The maximum paper size is 17x22 inches, and it is made to use dye-based inks at a 1440 dpi resolution. Some pigmented inks can clog the tiny ink nozzles if used. Artists Theresa Airey, Joanne Warfield, and Wendell Minshew have worked extensively with the Epson 3000 and third-party ink/paper combinations.

Wide-Format

In recent years, the piezo printhead technology has revolutionized the possibilities for inkjet printing from the desktop to wide-format printers. Wide-format printers are those that print 24 inches or wider and, other than Iris printers (nonpiezo), usually use roll media, including different surfaces of papers, canvas, backlit films, and synthetic materials. The best-known wide-format printers made for fine-art purposes include the Iris, ColorSpan, Roland, Epson, and Hewlett Packard DesignJet models. Encad and some other wide-format printers are used for making signs, posters, and banners and are not generally used for most fine-art printing because of the visible dot pattern.

If you're planning to purchase a wide-format printer, Epson makes a line of the most affordable and popular models for both dye-based and pig-

The Epson 10000 wide-format printer can use both dye and pigmented inks, and prints up to 44 inches wide on roll-type media.

PHOTO EPSON AMERICA; REPRINTED WITH PERMISSION OF EPSON AMERICA

ment-based inks: the 24-inch wide Stylus Pro 7000 (dye-based inks) and the 7500 (pigment-based inks); the 44-inch wide 9000 (dye-based inks) and 9500 (pigment-based inks); and the newer, faster 44-inch-wide 10000 with upgraded features (available for both types of ink). Epson ink and media costs can be higher than other brands, so over time you may end up spending more than what you saved on the printer cost unless you use third-party inks and media. However, at the time of this writing, there are no other comparable 24-inch fine-art inkjet printers on the market.

I've heard excellent reports about 36-inch and bigger HP DesignJet models, especially 2500 and 2800, and the newer 54-inch 5000ps and 5000ps UV for pigment inks. They're more expensive than Epson printers, and feature ease of use, high-quality results, a wide range of archival media, and much faster print speeds than Epson or Roland printers.

Before purchasing a wide-format printer, it's best to research information, evaluations, and reviews of the different models and brands and decide what features are important to you—size, speed, color gamut, permanence of inks and media, ease of use, and cost, for example. Each make and model of printer has its advantages and disadvantages, and no one printer can do everything well. To learn from the experience of others, there are online Epson user

notice boards and list serves you can subscribe to on www.yahoo.com and at www.leben.com. Also see www.wide-format-printers.org and www.BigPicture.net, which lists wide-format printers under $10,000, and in the $10,000 to $20,000 range.

If you'd rather have a digital studio make high-quality digital (also called *giclée*) prints for you, the Iris printer (and now the improved Ixia) has set the standard of excellence for giclée printing for over a decade. The name giclée comes from a French term meaning "to spray forcefully." Recently, other printers have begun to offer comparable quality, such as the ColorSpan GicléePrintMaker FA, a drum printer like the Iris, and less expensive but still excellent quality Roland Hi-Fi JET printers; the ColorSpan Series XII roll-fed models; Epson wide-format models 9000, 95000, and 10000; the IT I-Jet; or the HP 5000ps and 5000ps UV (pigmented inks). See what services are offered in your area. Of course, the expertise of the studio personnel and their ability to understand your vision of what you want the print to look like are very important factors in choosing a digital studio, as well as the equipment, inks, and media used. Many digital studios now provide clients with profiles for digital images so that you can scan your images and also print the image files on your desktop printer.

Iris Printers

The Iris print has been considered the highest-quality fine-art giclée print since 1990, and the only real choice until recently. The Iris printer, capable of printing ten million colors, was originally designed for prepress proofing because the colors were so vivid and accurate. The inks were fugitive, however, and didn't last. Then in 1990, Graham Nash (of Crosby, Stills & Nash) and R. Mac Holbert modified the printer hardware and software to be able to use artist papers to create fine-art prints and Nash Editions was born. Since then, developments in ink technology have improved the life span of some ink and paper combinations to over sixty years in display light before noticeable fading (according to tests done by Wilhelm Research Institute, see www.wilhelm-research.com).

Skylark Images digital studio (www.skylarkimages.com) in Santa Rosa, California, offers Iris printing and a variety of other services and wide-format printers. PHOTO JOHN A. TEAGUE

The Roland Hi-Fi JET printer. PHOTO JOHN A. TEAGUE

The Iris 3047 drum printer. PHOTO JOHN A. TEAGUE

Watercolor paper or canvas up to 36x47 inches is mounted on a drum and as the drum rotates at high speed, individual droplets of color spray on the surface at a rate of four to five million droplets per second. In 1999, Iris stopped making the Gprinter, and IT (Improved Technologies) now makes the new and improved Ixia model.

Roland Printers

Another increasingly popular option is a Roland print. The Roland line of Hi-Fi JET inkjet printers produces both six- and eight-ink prints up to 64 inches wide. Both dye and pigment inksets are available. The pigment inks have been some of the first offered and have a large color gamut when used with certain watercolor papers and canvas. The prints are rated to last well over 100 years before noticeable fading.

ColorSpan DisplayMaker Printers

The ColorSpan printers have a thermal rather than a piezo print head and can print at speeds much faster than the Roland or Epson printers. This is important if you run a digital studio, because to print at 1440 dpi for maximum quality can take hours for a large print. The ColorSpan DisplayMaker Series XII can print up to 72 inches wide with four to twelve color dye or pigment inks.

Digital Enlargers

If you want to print on photographic paper, a digital enlarger is the high end of color photographic reproduction and truly continuous tone. The digital enlarger exposes regular photographic paper using laser technology, resulting in color prints up to 50x50 inches with greater resolution, color accuracy, and repeatability than traditional photographic prints. The Lightjet 5000 by Cymbolic Sciences and the Durst Lambda are both excellent. For lower cost and smaller output, the Chromira is a good choice. Many digital studios can proof your image on a smaller Fujix printer and send the digital file to a lab that offers digital enlarger services.

Color Management

If you're a beginner and using one consumer inkjet printer with the paper and inks designed for it, don't worry about color management. Photoshop and your printer software will take care of it for you. Other than calibrating your monitor (absolutely necessary), there are a few simple adjustments that you can make in your printer setup dialog box to tweak the colors in ColorSync (for Mac) or in ICM (for Windows). When you want to have your digital file printed by someone else on a different printer, or you want to use other papers and inks, you'll need to learn about color management and profiles. Otherwise, the original image, the image on your monitor, and the printed image won't match.

Color management is a method of getting predictable color from one device to another. Each device in your workflow—the scanner, monitor, and printer—reproduces color differently and operates within a specific color space, or gamut (range) of colors. Color management systems were developed to solve this variability by measuring each device with a language agreed upon by the ICC (International Color Consortium, a group of color management professionals and vendors). It's necessary to calibrate all of your devices—scanner, monitor, and printer to bring them to a known industrial standard. A profile is then created that represents the difference between your scanner, for example, and the target value to which you're calibrating. The Epson 1680 Artists' package (flatbed scanner) that I have comes with Monaco EZ Color, an easy-to-use calibration application that creates device profiles using a reflective IT8 target. ColorBlind's IC Colormatic is an excellent software calibrator and also easy to use.

The ICC has defined standards for how profiles should be made (ICC profiles) for use across different equipment, paper, and ink combinations. This makes it possible to get the same or similar result that you see on your monitor when printing an image on a variety of printers and papers. Most manufacturers provide the ink/paper profiles for their products, and digital studios will often provide you with the profiles used on your images. The profile you're using can be assigned to the digital image file, and that profile is then "tagged" or embedded in the file. When someone else views and prints that file, they can convert the profile if necessary to get the same result. Otherwise, there'd be no consistency.

You'll need to choose what color space to use for your output. Monitor colors are in RGB and printer colors are in CMYK, although Epson and other consumer printers convert RGB to CMYK when printing. If producing images for the web, "sRGB" would be the color space to choose to most closely match the colors available on a Windows monitor. For inkjet printing, leave the color space in "Adobe RGB 1998" (a bigger color gamut than sRGB).

Color management can be confusing to grasp, especially at the beginning. There are a number of magazine and online articles about color management, plus excellent descriptions in the manuals for Photoshop 5.5 and above. Books such as *Real World Photoshop 6* can be helpful. Also consult websites that offer information (such as inkjetmall.com) or that sell color management systems, and user groups with archives by topic (see Resources). At the beginning, I recommend purchasing professionally made profiles, either standard or custom made, rather than purchasing a system to make the profiles yourself. You may still need to tweak the profiles you purchase in order to get the results you want.

The easiest way to get good prints is to use your printer's standard inks and papers. However, if you want a different result—greater choice of papers, longer-lasting inks, printing in quad-tone black-and-white—there's an exciting world out there. Luckily, information is available in books, magazines, and online about what papers, inks, and printers work well together. Theresa Airey's book *Creative Digital Printmaking* (Amphoto Books, 2001) is an excellent source of specific information. Some of the following has been distilled from her book.

Inks and Print Media

Inks

Dye-Based Inks

To date, the inks with the best color gamut (the range of colors that a color system can display or print) are dye based and the least archival. Dye-based inks are transparent and water soluble, and they chemically bond to the paper. They shouldn't be used with coated inkjet papers because the dye will adversely affect print longevity.

Popular dye-based inks for Epson printers are made by Luminos (Lumijet series), Lyson, Cone Editions, Xtremegamut, and MIS (actually MIS inks are hybrids—half dye and half pigment). The dye-based inks that come in the printers (OEM—Original Equipment Manufacturer) aren't archival; however, there are archival dye-based inks, such as Lumijet's Platinum and Silver sets, and Lyson's archival inkset. These archival sets were made to go onto coated inkjet papers and are lightfast from 35 to 150 years, depending on the paper. Lumijet was the first to match a dye-based archival ink with a suitable paper to give the print permanence. Platinum inks on Tapestry X last 150 years, whereas Silver inks on Tapestry X last about 35 to 65 years.

Pigment-Based Inks

Pigment inks are opaque, provide better light stability, and have a smaller color gamut than dye-based inks. The pigment particles attach to the paper fiber and are water resistant. The particles can clog the tiny nozzles of most inkjet printers unless the printer is designed to use pigment inks. Such printers include the newer Epson 2000P, 5500, 7500, 9500, and 10000. Examples of pigment inks for the Epson are the Epson Archival, Generation, Indelible Inks, and Ultra-FLO RE9500 formula inks. The RE9500 can be used without profiles with the regular drivers or RIP sold by Epson, as long as Epson recommended media are also used and the settings are correct for the media type.

Some inks have an acidic pH and aren't compatible with the Epson inks. When using Luminos, Lyson, or Cone Editions inks, you'll need to use a cleaning cartridge when changing inks, otherwise a sludge or particles can form that can damage your printer. Generation, MIS Archival, and Quad-Tone inks are pH-compatible with Epson inks. I would still recommend cleaning each time you change inks—you'll get better results and the printer will last longer.

Quad-Tone Black-and-White Inks

If you want to print your images in black and white, the PiezographyBW printing system from Cone Editions combines a special hextone carbon pigment inkset and a new printer driver. Prints with full tonal range and exceptional sharpness can be created and are sometimes called digital platinum prints. Quad-tone inksets are also made by MIS, Luminos (Lumijet Monochrome in neutral and sepia), Lyson, and others. Artist Wendell Minshew uses the MIS quad-tone inkset and is very pleased with its look and nonfade performance.

Media

Coated Inkjet Media

There are two types of media used for inkjet printing—coated inkjet media and artist papers. Coated inkjet print media are acid free, pH-balanced artist papers that are coated to produce better color and dot dispersion when used with inkjet printers. Recommended choices are Concorde Rag and Waterford DI (projected image stability with pigment inks in excess of 150 years by Wilhelm

Research Institute); Hahnemuhle's papers; Lyson Media; Lumijet Preservation and Standard Print Media (with these inks—Lumijet, Lyson, or in the 2000P Epson, pigment inks); and Somerset Photo Enhanced (recommended for pigment inks only).

Somerset Photo Enhanced will last longer with pigmented inks or the quad-tone inks, but will fade very quickly (in approximately 6 years) with the other archival inksets, such as Lumijet's or Lyson's. A variety of newer papers, such as Hawk Mountain and Cone Editions, have come on the market and many have not been tested for print longevity. Unless you're using two-sided coated papers, print only on the front side because the back of coated paper doesn't receive the ink properly; it's usually an off-white, while the coated side is white.

Also, many of the coated inkjet papers were not developed to be compatible with pigment—or partially pigmented—inks, such as the MIS archival inks. Puddling or a dot pattern may result. Generation inks are compatible with many coated and uncoated media, including their own Generation Photographic and Fine Art Media, Hawk Mountain, Hahnemuhle, Somerset Photo Enhanced, Epson matte and glossy papers, and some Lumijet and Lyson papers. Research recommended ink/media/printer combinations before buying to avoid frustration.

Coated canvas and other synthetic fabrics and papers, as well as backlit film media are available for some inkjet printers. Usually, images printed on canvas with the same inks used on some papers don't last as long before noticeable fading. Tarajet, Ultra-Stable, and Bulldog make coated canvas, although Bulldog's is made primarily for wide-format Iris, ColorSpan, and Encad printers.

Artist Papers

Artist papers are made for printmaking, drawing, painting, collage, and decorative uses. Watercolor papers come in three surfaces: hot press (the smoothest), cold press (with some texture), and rough (with the most texture). Not all artist papers are good for printing with inkjet printers. Absorbency, weight, color, compatibility with the inks, neutral pH, and texture are some of the factors to consider. A few of the most popular artist papers that last the longest are Somerset Velvet and Arches hot press and cold press (both the regular warm white and the newer bright white).

Some paper and ink combinations last longer than others. Lumijet has matched their dye-based inks with their archival coated inkjet papers for varying degrees of permanence. The Platinum inks are translucent and last the longest of their inks, from 65 to 75 years when matched with Lumijet's coated Preservation Papers (Charcoal X and Tapestry X have been rated at 120 years or more by Henry Wilhelm) and artist papers such as Somerset Velvet and Arches hot and cold press papers. The Lumijet papers are also compatible with the Lyson dye-based inks and will last as long as with the Platinum inks.

At this time, there are papers—such as Concord Rag, Arches Hot Press, Legion Waterford DI, and Lumijet Tapestry X and Charcoal R—with a print life of 100 to 150 years if matched with the correct archival inks. More are being tested. With technological advances, soon there'll be a variety of archival prints lasting up to 200 years with an expanded color gamut.

Using Third-Party Inks and Media

To get started using third-party inks and media, spend some time reviewing the information and resources at websites such as www.inkjetmall.com, various ink and media manufacturer sites, profile and color management sites, Epson user group notice boards and list serves, and again, Theresa Airey's book *Creative Digital Printmaking*. Airey also offers specific suggestions on how to tweak the paper and color space settings in the Epson 3000 (applicable to other Epson printers, as well) to get better results with non-Epson inks and papers. You'll probably need to work with profiles for the specific ink and paper combinations you choose. Cone Editions, ProfileCity.com, and others make standard and custom profiles that you can purchase (and will probably need to tweak to your satisfaction) if they aren't provided by the manufacturer.

Presentation and Marketing

Once your transfers or SX-70 manipulations are final prints, there are a number of different directions you can go with your images. You can exhibit your prints as fine artwork in venues such as galleries, art fairs, shops, and restaurants. If you're a commercial photographer, you can apply what you've learned to assignment work, stock, portraits, and weddings. Licensing your images to companies that produce posters for decor markets and greeting cards for mass markets is another option. And, you can place your images on the web in online galleries or art marketing sites, and you can create your own website. Or, you can simply enjoy your creations and make cards and prints as gifts.

MENDOCINO WATER TOWER. 2001
This SX-70 manipulation was photographed with an SX-70 camera, scanned, and enhanced in Photoshop using Hue/Saturation and coloring layers.

Fine and Decorative Art

Polaroid manipulations and transfers are excellent for fine art exhibitions and as decorative art for the home or corporate environment. You can use original pieces or digital prints. An advantage to using digital prints is that you can make them in any size and quantity you want of the exact same piece, unlike original pieces of art of which no two are alike. In addition, the digital prints can be more archival than the originals, depending on what printer, ink, and media you choose.

Limited Edition Prints

When making digital prints, the question arises as to whether to create limited editions of your prints, and if so, how many prints should be in each edition. There are several ways to approach editioning prints. In my experience, the edition size depends on the intended market. A gallery may want a small edition of under fifty that are higher priced, whereas if you're selling at art fairs or have an art website marketing your work to a larger audience, an edition of 200 or more would be more in line with projected sales.

Some artists make an edition for each size of the image printed, while others have one edition that includes any size made of the print. Still others edition the large-print sizes of an image and have an open edition of smaller prints. Whatever approach you decide to take, I think it's extremely important to state what your editioning means on the Certificate of Authenticity that's required by law to accompany Iris prints or on an information sheet that you print up for your digital images. If you sell a print in an edition of forty-five, the buyer thinks that there will only be forty-five of that image in the world. In my opinion, it's misleading, if not unethical, not to inform that person if you're selling hundreds of that same image, unnumbered in a smaller size. Editioning prints is a controversial subject with many opinions on the best way to make editions.

ESTERO, POINT REYES. 1999
I made this 8x10 Polaroid image transfer from a 35mm slide that I exposed on 809 film with a Daylab II, and then hand-colored and scanned. The final work was a 8x10-inch Iris print on watercolor paper that was number 17 of a limited edition of 100 prints.

When printing on paper, the traditional way to sign and number the editioned prints is to write in pencil the title and edition number on the left under the image, and sign your name on the right side—all on the paper, not on the mat. The mat can easily be removed, along with your information. With canvas, many artists use a pen and write directly on the image. I also use a label that I have made for the back side of the mat, giving information about the digital printing process, paper, inkset, and title of the image. I fill in the edition number when I apply the label to the mat. I always include the Certificate of Authenticity if it's an Iris print.

Once you start editioning prints, you'll need to keep track of what you've printed and sold. I use a database program and also note the date sold, price, and buyer (or gallery) information. Some artists use a "tier" pricing method, where, for example, the first ten of an edition of forty are one price, the next ten are a higher price, and so on so that the last ten are much more expensive than the first ten. If you make

LOUISE ROACH. ATHENA'S PEAR. 1998
This is a Polaroid emulsion transfer over collage on a steel panel with oil glaze. Roach decided to make her own frames because she couldn't find ready-made frames that had a heavy enough feeling for her steel panels. She used wood that she and her husband routed, joined, and painted. She then added crackle finish, plaster, sanding, acrylic glazes, and dark furniture wax. Each of her frames is different.

small editions, are well known, or are represented by a gallery, you may want to consider this method; it increases the value of your work, especially in the secondary art market. Many artists have one price for each size of their prints and raise their prices every year or two.

Matting and Framing

Matting and framing your artwork is the most common method of display, and it protects the print. With archival prints, it's important to use acid-free mat board, which won't yellow and discolor your print. You can cut the mats yourself, find someone who cuts mats in quantity, or order precut or custom mats from a mail order company such as Light Impressions. Orille Enterprises in Sacramento cuts mats for me (see Resources).

If you plan to cut a lot of mats, there are several inexpensive mat cutters that are simple to use, such as the Alto Model 4501 or the Logan 700 SGM. For mounting the print, I like to use clear archival mounting corners available from Lineco (University Products) and Light Impressions. For large prints, I also hinge the artwork at the top in two places with archival Filmoplast P-90 tape. With these methods, if you want to change the mat, the print can easily be removed without damage because it is not adhered to the backing, as it is with dry mount tissue or spray mounts. Many photography or art supply stores and mail order catalogs carry these items (see Resources).

You can get very creative with matting. Instead of overmatting, with the matboard covering all or most of your paper up to the image, you can have the image "float" so that the deckled edges of the paper show. If the paper doesn't have deckled edges, you can create them with several tools. Fiskars makes rotary trimmers and scissors with a variety of interchangeable edges, and Design A Card/Art Deckle makes a ruler and templates that create deckled edges when tearing the paper. By using handmade paper behind the print, and even making deckled edges close to the print itself, you can greatly enhance an image.

For matted prints on paper, I use picture framing glass that I buy in bulk for the standard sizes I use. For added protection against fading from ultraviolet rays found in sunlight and fluorescent lighting, use UV-inhibiting glass or Plexiglas. For images printed on canvas or for three-dimensional work, glass isn't usually used, so make sure the print has been sprayed with a protective coating—ideally, a spray that also has ultraviolet protection, such as McDonald's Pro-tecta-cote by Sureguard (which comes in various surface finishes from matte to gloss), Krylon UV Resistant Clear Acrylic Coating, or Golden Polymer Varnish with UVLS.

You can purchase metal sectional and wood frames in a variety of styles and colors, or choose from a number of designer frames. Nielson makes excellent sectional frames with contemporary designs. To accent the unique quality of her work, Louise Roach, makes her own frames (above and pages 186–187).

Longevity

Historically, color photographic prints have never lasted as long as black-and-white prints or artwork made with pigment colors because the photographic dyes are not as light stable as pigments or silver gelatin. At best, up to sixty years in display light before noticeable fading was the most offered for a very few photographic papers, such as Fuji Crystal Archive paper and Ilfobrome Classic (Cibachrome). Polaroid transfers, SX-70 prints, and other color prints need to be kept out of direct and even indirect sunlight to prevent fading. I even saw a Cibachrome print that had faded to faint pastels after three months of sun exposure near a window. However, I've had Polaroid transfers hanging in my studio for ten years with no noticeable fading (with no direct or indirect sunlight falling on the prints).

Now, with the new pigment inks, in combination with certain artist papers and archival inkjet papers, we can finally expect that our manipulated Polaroid images can last for well over 100 years when we scan the images and make digital prints. There are still precautions that you need to take, however. Avoid exposing artwork to sunlight or UV rays. Atmospheric pollutants can decrease longevity by interacting with the paper and ink chemistry. Moisture, changes in temperature and humidity, cigarette smoke, paint fumes, dust, and more can also all affect print longevity. The best protection is to prevent the conditions that can damage your artwork.

Shows, Galleries, and Art Fairs

To get started exhibiting your work, there are juried and nonjuried group shows that you can enter to gain experience and start building a resumé. Join your local art center and look for Call-for-Entries notices in art-related publications such as *Artweek.* Local restaurants, frame shops, wineries, and even hair salons and opticians often use their walls as rotating galleries.

At some point, you'll need to decide what market you want to focus on: galleries, usually with smaller editions, a more select clientele, and higher

PANE DOLCI, BURANO. 2001
SX-70 manipulation.

prices (*note:* galleries often take half the retail price as commission); or art fairs and print markets, where a higher volume of prints are sold at lower prices.

With art fairs, you need to be willing to create a booth and move it around, selling your work on weekends. I know artists who sell very well in this venue and then have repeat sales to their customers from their websites. I think it's hard to sell art from a website to someone who hasn't seen your work in person, so exposure of your work in shows is important for future sales, even if nothing sells during the show itself.

In choosing galleries or print distributors, look around and find the ones who carry the kind of work that fits with yours. If you do representational landscapes, an abstract gallery would not be a good choice. Since Polaroid art is considered "crossover" art, you're not limited to just photographic galleries. Ask about the submission policy of the gallery or distributor, and put together a professional packet to submit. And, don't be disappointed if you get rejected. Rejections are part and parcel of being an artist, and it happens to us all. Often, it's more about the gallery owner's taste than the desirability of your work. To market your art well requires a lot of hard work and persistence.

Commercial Applications

Licensing Your Images

Another option for getting your artwork into the marketplace is to work with a company that licenses your images to appear on their products. One of my first students in 1993, Amy Melious, has been quite successful with greeting card and poster companies, as well as corporate art buyers. She started by making her own image transfer note cards using color copies, and placing them in stores herself. A card rep liked her cards and began distributing them for her. Then a card company saw the cards and asked to license the images for greeting cards. Then a poster company saw the cards and has kept her busy creating images for them ever since.

She offers this advice: "If someone is choosing to look into licensing images, I feel an important first step is to buy books on marketing photography and another book that contains examples of legal forms. They are an important tool for learning the language of negotiations as well as the differences between the various types of use rights. I was a member of California Lawyers for the Arts for a while in San Francisco. They offer workshops for working artists in subjects such as copyright and licensing, and they sell some good books on these subjects. Agents can often handle many of the details of contracts and negotiations, but I still feel it's important to understand everything you sign to protect yourself, the integrity of your work, and the company representing you.

"Unless a company specifies what it prefers for submissions, I think good laser copies (or inkjet prints) are a very acceptable form of presentation in today's market. I think many artists are intimidated by the idea of having to put together a formal presentation, but in fact, I think those on the receiving end like to handle something they can play with and pass around that isn't too precious or valuable, because those packets can be a liability for them. I usually offer to let them keep on file whatever I send, in fact, because sometimes they won't be ready for it for months or even years."

In addition, it's important to look at magazines such as *Decor* (for the framing industry) to get a sense of where your style of work might fit in. Then, approach those poster companies. Or, look at greeting card lines to get an idea of which publishers to contact. Sometimes, while you're exhibiting your work, creative directors might see your images and call you. When attending openings and art fairs, ask artists who are doing what you'd like to do if they have any suggestions for you, but be sensitive and don't take up much of their time. They are there to sell their work.

ELIZABETH MURRAY. IRIS PATH OF LIGHT. 1992
*Murray photographed this scene with an SX-70 camera
in Monet's garden at Giverny. She then handpainted on
the original Polaroid with photographic oils and, after
scanning and outputting, on the enlarged print with oil
pastels, oils, inks, and pencils.*

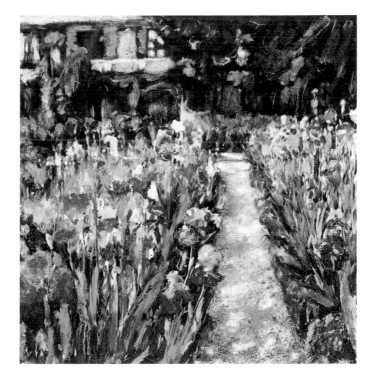

AMY MELIOUS. VINEYARD. 2001
*A mask was applied to the Polaroid negative to create
a panoramic format, and the image transfer was then
handcolored with pastel chalks.*

Corporate Art

Corporations purchase large amounts of art for their offices, cruise lines, hotels, and other buildings that have empty wall space. Some corporations have their own art buyers, others use agencies. Large prints are in demand, although some corporations also purchase original art. Some corporate offices work with local arts council organizations so that their walls become a rotating art gallery, with openings every six months. If this isn't being done in your area, see what the possibilities are to get a program started.

KENARIO. TABLE FOR TWO. 2000
Kenario has many corporate clients for their SX-70 manipulations.

Portraiture, Commercial Assignments, and Stock Sales

Polaroid artwork has been successfully used in a variety of commercial applications, from advertising; editorial illustrations; book, album, and magazine covers; and annual reports to portraiture and weddings. Alternative approaches to photography are popular these days. However, I would be careful about selling publication rights to your artwork too cheaply, such as for royalty-free photography CDs. That undercuts you and other photographers. If you have a unique image, don't sell it for $1 and make it commonplace. Photographers Michael Going, Ernesto Rodriguez, Davis Freeman, Anna Tomczak, and Kenario have all been very successful with their manipulated Polaroid work for advertising and editorial clients (see their work in the Gallery section).

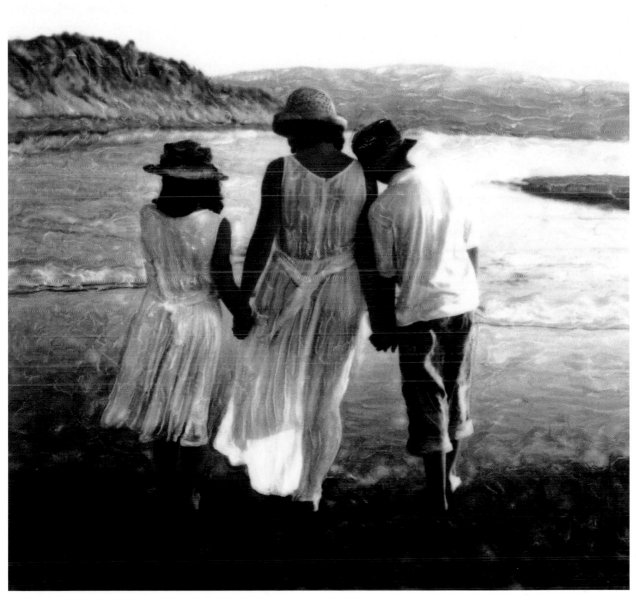

CATHERINE PETERS. WALK WITH ME. 1998
This manipulation was photographed with an SX-70 camera for a portrait commission.

Online Marketing and Websites

The Internet, especially the World Wide Web, has radically changed how accessible artwork can be to audiences anywhere in the world. Online galleries have sprung up everywhere, and many artists have their own websites. In addition, art marketing sites can market your work for a fee or commission, and some sites even print the editions for you and keep a higher percentage of the retail price. For example, if they print, you get 20 percent of the sale price; if you send them the prints, you get 50 percent. With many people having e-mail, it's easy to send jpeg files of your images to someone interested in seeing more of your work. Online discussion groups about Polaroid processes, digital printers, and fine art are a great resource and can help build a network of information and support for you as an artist.

Online Galleries and Discussion Groups

A good way to find online galleries is to go to a good search engine and look for websites that come up in the category you want, such as "SX-70 Manipulations" or "Polaroid Transfers." Some galleries have rotating group shows, others feature certain artists, and with some, you can have your own ongoing page. Some sites charge for this service while others are free. My favorite resource for Polaroid art forms is Marek Uliasz' wonderful site at www.frii.com/~uliasz/photoart/polaroid/. He has put together a very thorough site with information, galleries, and links to books, artists, and a Polaroid transfer discussion forum that you can join. Another discussion board I went to when I was on AOL was in the Photography section under "Polaroid." The Usenet alt.photography group and the Yahoo groups are other alternative-processes club possibilities to explore.

Corporations such as Polaroid, Daylab, and Calumet have artist galleries on their websites that you can become part of by contacting them. Usually there's a link to e-mail them with your information.

Your Own Website

It's becoming easier and easier to have your own website. Some web servers, such as AOL, allow you to have a web page or small website as part of their monthly service. Others charge a small monthly fee to host a website up to a certain size. If you want your own domain name, you need to register the name you choose with a company such as Network Solutions and pay a registration fee and then an annual fee to keep the domain name. Your server can use your domain name as an alias for you to receive e-mail through your domain name, if you wish.

You can create a simple website yourself with one of several web design programs such as Adobe Go Live or Dreamweaver, or you can hire someone with experience to work with you to create a professional and complex site. My partner Phil created my first website in 1997 with the simple but now obsolete program Adobe Pagemill.

It's important to use small, optimized jpeg files that will load quickly, otherwise viewers will move on if your site takes too long to load. Use images at a 72 dpi resolution with the jpeg file saved at low or medium-low quality. Also, choose the Progressive format option unless your image is very small. Progressive means that your file is visible within a web browser faster and is then refined by subsequent passes as more file information is downloaded. It will automatically optimize your image. If your image is very small, then choose Baseline (Optimized).

If you have Image Ready, a web graphics program that comes with Photoshop 5.5 and above, you can optimize the images there and also easily create a web gallery. You have a choice of layouts, and can create thumbnails that open to a larger image size when clicked on. By adding type, an e-mail link, and

possibly a background, you can create several gallery pages of images on your website without having to be a web designer.

No matter how simple or sophisticated your site is, the most important thing is to get viewers to see it. You want to get listed in all of the search engines for all of the keywords that relate to your website. One way is to add those words into the HTML code of your default home page. Other ways are to submit your site to the search engines or hire a company that specializes in getting sites listed on search engines to do that for you. You can also network with other related sites by asking them to add a link to your site in exchange for you linking to their site. I like this method, because it benefits us all to have a mutually cooperative system of supporting each other as artists and suppliers.

Art Marketing Sites

Some art marketing companies have expanded to include websites that market a variety of artists; other art marketing companies are Internet based only. A well-known example is www.art.com. Artist Ernesto Rodriguez (here and pages 188–189) has a series of images on www.sagemore.com. Usually, the site selects a group of images from an artist and the artist gets a percentage of sales income—less if the company has the work printed. This can be an excellent way to get started, increase your exposure, or have a particular series marketed—but be sure that the company is reputable. It's wise to talk with a few of the artists they represent to learn whether the artists are paid on time and if the company fulfills their part of the contract.

It's impossible for one artist to cover all of these arenas. Marketing your art can be a full-time job. Most of us just do what we can, but if you're really serious about marketing your work, contact an art consultant or rep that can work with you. Choose a market niche that you enjoy and that fits your artwork, rather than spreading yourself too thin. Oftentimes, if you're working with a poster or art-print company, they may want only certain styles or

ERNESTO RODRIGUEZ. CARLOTTA. 1998
SX-70 manipulation photographed with an SX-70 camera, scanned, edited in Photoshop, colored in Adobe Painter, and output as an 11x11-inch Iris print on watercolor paper.

subject matter, and may even direct what you need to do for them. For some artists, it's a dilemma whether to commercialize and make what will sell or make art that emerges in their own creative process. Examine your feelings about this and proceed in a way that allows you to grow as an artist.

Whatever your choices, remember to enjoy what you're doing and keep experimenting. My hope is that you'll find new excitement about your photography and art, and about the myriad directions in which using Polaroid films creatively can take you. Use this book as a reference: Master the basic techniques, then look through the book again for ideas and directions that interest you. New techniques with Polaroid film keep being discovered, often by accident. So remember, there is no one correct method to create with Polaroid films—experiment and find the way that works best for what you want to express. The digital revolution is opening up vast new possibilities for us to create, print, and market our Polaroid art. What an exciting time in which to create!

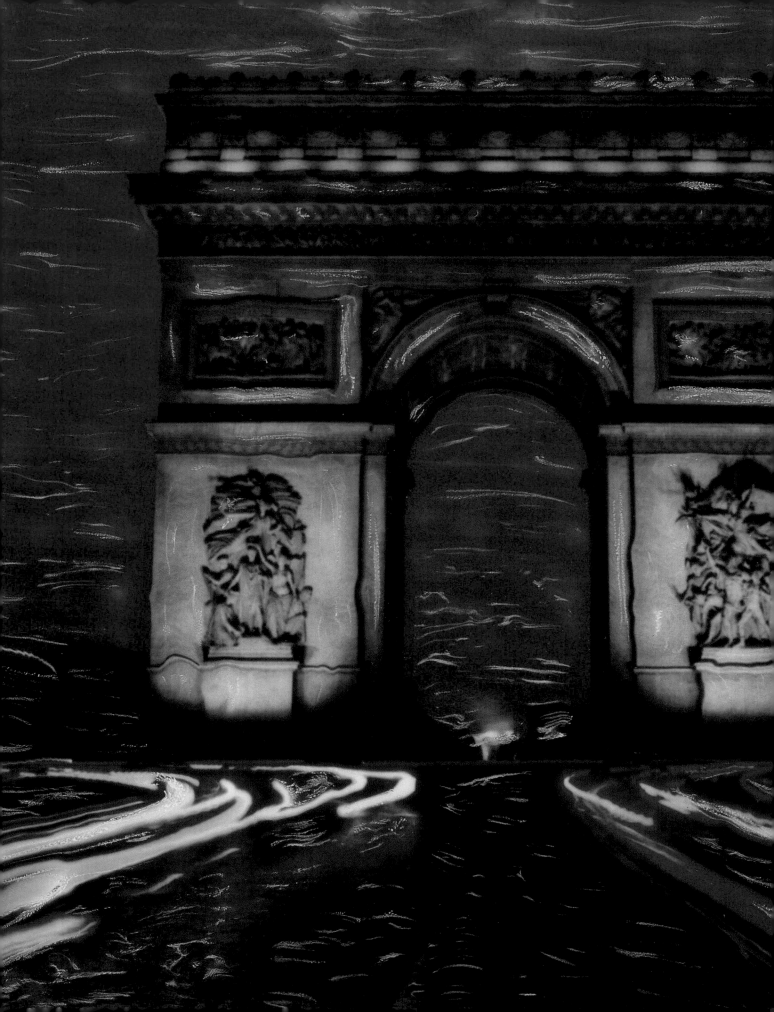

GALLERY

The artists included here represent a wide variety of styles, techniques, and subject matter. Some are well known and well published, some exhibit principally in fine art venues, while others have used their work innovatively within the commercial arena. One is a housewife who had no artistic experience before taking one of my workshops and, a year and a half later, has produced a body of remarkably creative and imaginative work. Contact information for all the artists is listed in the Resources section. When selecting their images, I chose works that could hopefully encourage your explorations with these alternative uses of Polaroid films. Many of the pieces illustrate beautifully the techniques and concepts put forward in the text of this book but also go that one step farther—beyond technical manipulation and into the realm of pure inspiration.

Armadillo Artworks:
Mitchell Shenker and Diane Dias

Armadillo Artworks is the creative collaboration between husband-and-wife artists Mitchell Shenker and Diane Dias. Shenker, a longtime photographer, and Dias, an artist and graphic designer, bring their distinctive talents, experience, and passionate creativity to their images. With a deep love for color and the magnificent way light creates form, Shenker and Dias take their inspiration from Impressionism, the very spirit of light, and the playfulness of painting as a child.

Each work of art begins first as an SX-70 Polaroid image. By carefully resculpting the developing emulsion while still soft, they reinterpret and transform the image into one that dissolves the boundaries between photography and painting. Their enhancement of the colors and textures captures each image's vital essence and heightens the sense of realism. As if using paint on a canvas, they blend these effects of color, light, and texture into a unique, impressionistic style of their own.

Using a digital stylus as a paintbrush, they further refine the image in Adobe Photoshop. They enhance colors and contrast using the image adjustment palettes, and then selectively add brushlike strokes using the stylus to give the image a painterly feel. Soft, undulating edges are added to each final image. Using the airbrush and smudge tools, they paint each border with the stylus to create a unique, hand-rendered look: "Our goals are simple—to create art from that which inspires us, perform a little magic, and capture those serendipitous moments in time that give us great delight."

PSYCHO PEAR. 2001
SX-70 manipulation, enhanced in Photoshop.

SOUTH BEACH. 2001
SX-70 manipulation, enhanced in Photoshop.

JAVA JUICE. 2001
SX-70 manipulation, enhanced in Photoshop.

Tony De Bone

SHAIVA SADHU SMOKING THE CHILLUM. 1997
Hancolored 20x24 Polaroid image transfer.

For many years, Tony De Bone has photographed people who adorn themselves, and who can be considered out of the mainstream or on the margins of society. Three series have emerged from those images (*Drag, Sadhu,* and *Fetish*), which were shot in India, New York, San Francisco, and Honolulu. Having made friends and acquaintances from those various communities through photography, he became fascinated by their lifestyles and welcomed the privilege to photograph them at various venues and events. He found them camera-friendly and evocative subjects to photograph, and he has attempted to do this with respect, with impartiality, and without judgment, while reflecting captured moments of their world and portraying a glimpse of an extended reality for all of us.

De Bone has exhibited in solo and group shows both in the United States and internationally, winning numerous awards including a Gaudì Medal Award and a purchase prize in the III International Biennial of Photography in Spain. He also lectures on his work and Polaroid transfers. Museum and private collections own his work, and his images have appeared in books and magazines such as *Contemporary Nudes 3* (Spanish edition), *Photo Metro,* and *La Fotografia Actual*.

"As an artist, I have always been intrigued by the process of art, and therefore, my fascination with Polaroid image transfers. This process has been central to my art for the past ten years. I have worked in four Polaroid formats (3x4, 4x5, 8x10, and 20x24). My interest in large-format images has led me to produce five portfolios with the 20x24 camera in the

Polaroid 20x24 studios in New York and San Francisco. I was attracted to the Polaroid image-transfer process because of the imperfections, irregularities, and uncertainties that sometimes appear in the images. The process provides numerous opportunities to experiment with various art materials while reworking and color-enhancing the images, and incorporating in them an additional step beyond printing that adds to the depth of the images. The resulting image transfers often appear to be a combination of a photograph, a drawing, and a painting.

"My work is dedicated to all those people who graciously permitted me to photograph them, some of whom have become my friends [and others who] stood still only long enough for a snapshot and quickly disappeared into the crowd."

FAUX MARILYN. 1997
Hancolored, handpainted 8x10 Polaroid image transfer. PERMANENT COLLECTION MUSEO SALVADOR VILLASECA DE REUS, CATALUNYA, SPAIN

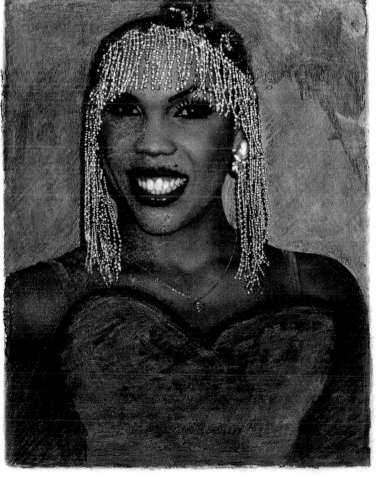

MISS JASMINE. 1997
Handcolored, handpainted 8x10 Polaroid image transfer.

Dayle Doroshow

Dayle Doroshow is a mixed-media/polymer clay artist and owner of design studio Zingaro, *stamp of distinction.* She trained in traditional ceramics at the Riverside Bell Tower Pottery program and the Columbia University Extension program in New York City, and sold her pottery in Greenwich Village shops. Her jewelry, home decor, ethnic spirit dolls, and handcrafted books can be seen at galleries and art shows across the United States. She also teaches classes in bookmaking with polymer clays, from tiny matchbox books to elaborate three-dimensional sculptural books:

"I have always been intrigued and excited by the mystery of ancient cultures. Dreams of archaeological ruins and travels to far away places have influenced my artwork from the time of my studies in traditional ceramics in New York City. Upon dis-covering polymer clay in 1994, I have enjoyed creating artwork with a pioneering medium while still reflecting my passion for the magic of past civilizations and their artisans. The many facets and possibilities of the clay allow me to create modern day artifacts inspired by far-off places and by places that exist in my imagination.

"A class in Polaroid transfer and emulsion lift techniques sparked a curiosity about integrating the two mediums. I want to explore the possibilities of sculptural work combined with the beauty of photographic imagery wrapped onto, into, and around these sculptures. Using neutral- and metallic-colored clays in combination with various surface treatments of the clay, I lay the emulsion onto the clay. These surface effects include metallic powders, gold and silver leaf, and imprinting the clay with designs and paint.

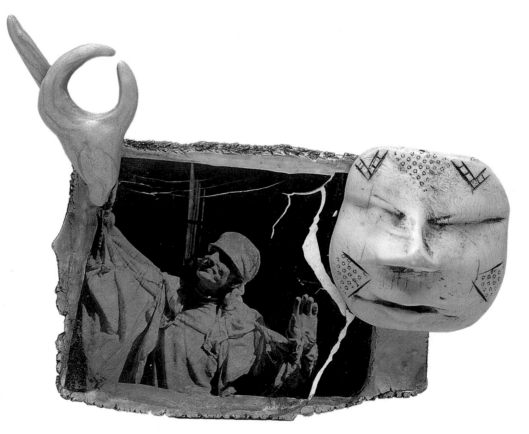

MASKED THOUGHTS #2. 2001
Polaroid emulsion transfer on gold Pearl-Ex powder, applied to polymer clay. PHOTO DON FELTON

MASKED THOUGHTS #1. 2001
*Polaroid emulsion transfer on silver
leaf, applied to ivory polymer clay.*
PHOTO DON FELTON

VENETIAN DREAMS. 2001
*Polaroid emulsion transfer on gold
metallic clay.* PHOTO DON FELTON

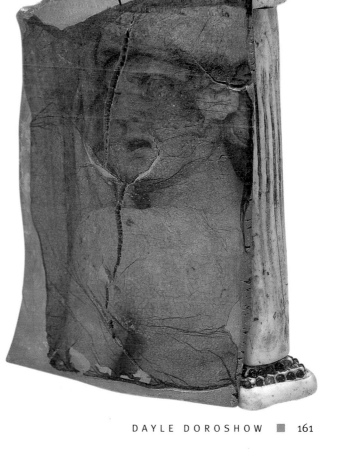

"I have experimented with applying the emulsion to both cured and uncured polymer clay. For applying the emulsion to uncured clay, care should be taken to get all excess water and air bubbles off of the emulsion transfer before baking. The different brands of clay cure (bake) at different temperatures, so it is always wise to read the manufacturers' directions on the package. I use the FIMO brand of polymer clay which bakes at 265°F for thirty to forty minutes.

"While I don't consider myself a fine art photographer, the images I do create inspire me to transform this two-dimensional art into a living three-dimensional piece that is able to be viewed from all sides, picked up and handled, and experienced in a different way than we usually experience photographic works."

ANCESTRAL MEMORY. 2001
*4x5 emulsion transfer on Pearl-Ex powder, applied to
polymer clay.* PHOTO DON FELTON

Barbara Elliott

Barbara Elliot experiments freely with different receptor surfaces for the emulsion lift process. Glass head forms become the surfaces for the beauty school head shots. To remove the air bubbles under the emulsion, she runs water very carefully over the emulsion after it has been set in place over the head form. The water helps the emulsion lie flat over the contours of the face. She also likes to layer different pieces of Plexiglas with emulsion lifts to create three-dimensional effects.

Another favorite technique is to place an emulsion lift onto a prestreched canvas and pour resin over the entire surface, creating a windowlike effect. Various galleries and shops carry her work, and she has exhibited and sold her work in juried shows.

She says she became an artist and photographer in May, 2000, when she attended a Women's Creativity Retreat with Kathleen Carr and Cynthia Johnson-Bianchetta to further her exploration of the Polaroid image- and emulsion-transfer processes:

"It was there that I was transformed from a somewhat normal person, who had no art-making experience whatsoever—but who possessed a wild imagination and love of the absurd—into an obsessed slide-taking, image-making, emulsion-lifting maniac. My favorite subjects include mannequins with bald heads or decidedly not-pretty faces, beauty school hairdo heads, dolls with disfigurements, and an acupuncture practice model named ACU MAN. My favorite 'gift of the universe' memory is that of walking down Octavia Street in San Francisco and seeing a ham hock stuffed inside a red fuzzy sock, as naturally as you please. I am always on the lookout for sights such as these and consider myself blessed when one occurs, especially if I have my camera in tow."

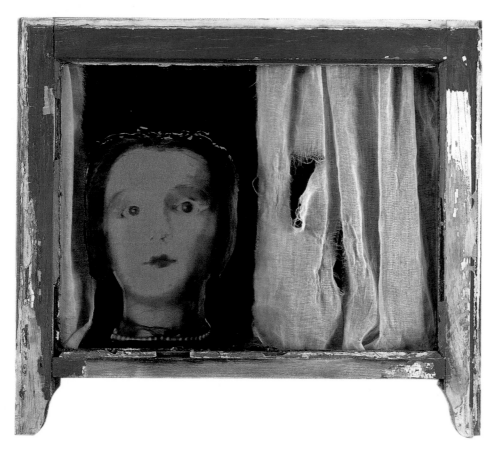

ROMANCE ON SHORT NOTICE. June 2001
8x10 Polaroid emulsion transfer on window glass. Thin vellum paper was cut out to just cover the back of the image.

RED SATIN ON MY MIND. 2000

8x10 Polaroid emulsion transfer on glass head stuffed with satin. The head was put in a large bucket of water with emulsion over it and lifted carefully out of the water. Then it was put under running water to force any air bubbles out and smooth out the emulsion.

COMING INTO HER OWN. March 2001

Four Polaroid emulsion transfers on glass in a shadow box. Each emulsion face was cut away from the rest of the photo with an X-Acto knife.

WONDERLAND REDUX II. July 2001

8x10 Polaroid emulsion transfers on Plexiglas triptych. Each emulsion is sandwiched between two sheeets of Plexiglas and backed with white Plexiglas separated from the image by clear acrylic washers. Each piece of the triptych is held together by polycarb screws and hex nuts.

Joan Emm

RED CAFÉ, ITALIA. 1997
20x20-inch giclée print of a 3x3 Polaroid 600 Platinum manipulation on stretched canvas.

Born in Chicago in 1949, Joan Emm originally wanted to be a nun and live in Africa. She studied art and psychology at the University of Illinois, Champaign-Urbana, in the '60s, and "Well, things changed," she remarks.

In the '70s she moved to California to study photography. Three years of workshops in Santa Fe, Los Angeles, San Francisco, and "West Coast School" at Brooks Institute in California helped her to refine a sense of style. A week-long workshop with Joyce Tenneson provided encouragement about her initial Polaroid "experiments."

She apprenticed to master photographer David Peters and opened her own portrait studio in 1990 in Mill Valley, California. In 1992, she learned to do SX-70 manipulations, and in 1995 she introduced her artist/partner Ric Morrisonn to this creative technique: "It was our second date. That day at the beach we used a Polaroid OneStep camera and a bobby pin. We nicknamed our instant art 'smooshes.'"

A year later, Emm and Morrisonn had created a portfolio of over 500 Time Zero manipulations, including an extensive array of motorcycle images. They silk-screened their favorite SX-70 motorcycle images onto T- shirts, loaded up the used ambulance they had purchased, and drove them to Sturgis, North Dakota, for the largest motorcycle gathering in the world. The success of the sales there eventually led to the giclée images that Emm now sells as 20x20 limited-edition prints in art galleries.

DOOR WITH RED ROSES. 1998
20x20-inch giclée print of a 3x3 SX-70 Time Zero manipulation on stretched canvas.

AWAKENING (WOMAN IN BLACK
DRESS WITH VEIL). 1997
*20x20-inch giclée print of a 3x3 SX-70
Time Zero manipulation on stretched canvas.*

Since their move to the redwood forest in Mendocino in 1995, Emm has been exhibiting her work and teaching photography to professional photographers in California and Italy:

"These dreamlike images are small moments and scenes that linger in memory. They begin as photographs that are handembellished with wooden tools to more accurately represent my emotional response to the scene. By hand altering the photograph, the image becomes a recording of the *feeling* of the scene, rather than the literal recording of light and shadow associated with traditional photography. The original manipulated SX-70 photograph is then scanned and printed with archival ink onto canvas or watercolor paper."

PAVILION. 1998
20x20-inch giclée print of a 3x3 SX-70 Time Zero manipulation on stretched canvas.

Davis Freeman

serendipity, \ˌser-ən-ˈdi-pə-tē \ *n* : the faculty or phenomenon of finding valuable or agreeable things not sought for

Davis Freeman has been a successful commercial portrait photographer for the last twenty years. His clients include Microsoft, Time/Warner, *Money Magazine,* Starbucks, and Nordstrom. His portfolio includes images of Bill and Melinda Gates, Tom Skerritt, Ossie Davis, Tom Wolfe, and John Updike. While his work has been exhibited around the world and he has won numerous awards, it is, however, a serendipitous discovery of which he is most proud:

"In 1989, while working with my 4x5 Linhof camera on a biannual report, I ran out of my customary Polaroid Type 52 (ASA 100) film and grabbed a box of unusual Polaroid Type 53 (ASA 800) film. As I pulled apart the Polaroid Type 53 image, I noticed that the faint solarized impression on the paper backing was much more interesting than the positive image. With the approval of my client, I abandoned my original idea of creating contemporary black-and-white images for the unconventional impressions on the film backing paper. I made copy negatives of the paper backing that I then printed as silver prints. The results were remarkable. The client was delighted, and the images from the biannual report

JV STANDING. 2000
Illustratype print from Type 53 negative, enhanced in Photoshop.

CONTEMPLATION. 1998 *Illustratype print from a Type 53 negative, enhanced in Photoshop.*

HKJ. 1997 *Illustratype print from a Type 53 negative.*

went on to receive two international awards for creative use in industrial photography."

Freeman continued to experiment with this new look, making copy negatives of the solarized Polaroid paper backings and printing them as silver prints. Although the results were interesting, he wasn't able to produce the images he envisioned in his mind's eye through copy negatives and darkroom printing. In early 1995, an unexpected family crisis kept him near home for long months aiding his ailing wife. During this time, he began to teach himself Photoshop:

"A thought occurred to me to rework my earlier paper negatives with digital technology. After much experimentation, I purchased a flatbed scanner to scan the 4x5 Polaroid paper solarized negatives into my G4 Mac. Finally, I was able to overcome the limitations of the darkroom and realize my vision for these images.

"My primary Photoshop tools are the Dust and Scratches filter, Curves, Levels, and an occasional Invert. To isolate and enhance a specific area, I use the Lasso and Magic Wand tools. Burning and Dodging

tools are used to help provide touches of depth to the image. Finally, tonality is added and sharpening is employed to finish the image. My file sizes average 70 to 90 megabytes and final prints are as large as 40 to 50 inches. I have made digital negatives for both platinum and silver prints; however, I prefer giclée prints using archival inks.

"Although mastering the technique is important, I insist on letting the images speak for themselves. Therefore, I coined the term Illustratype to describe this process. From the Latin root *illustra-*, to enlighten, Illustratype is used in a long tradition of photographic terms (think daguerreotype, tintype, calotype) to take emphasis away from the process and place it squarely on the content.

"I am a receiver as much as a creator. The beauty I seek, I find in the interesting plays of light and dark across the topography of the body. I search for a heightening or deepening of a subject's expression, all revealed in the murk or luminescence of the capricious emulsion."

Michael Going

Michael Going is a Los Angeles-based photographic artist and educator widely acclaimed for his fine art and commercial altered Polaroid SX-70 work over the last twenty-two years: "The appeal of the SX-70, and altering the film, strikes an emotional chord with me. It's about fantasy, transformation, tactile appeals, instant gratification, and emotion. My photographs are emotional responses to people, places, and things. They reflect the allure of a subject alone in a place—concerns with form, shape, space, light, and the search for perfect composition."

Prior to specializing in his altered Polaroid work, Going shot (in formats ranging from 35mm to 8x10) award-winning commercial assignments in the studio and on location, focusing on annual reports and action motorcycle photography. His life changed in the late 1970s after he saw a photographer friend experimenting with the SX-70 process. He became obsessed with this medium and pursued his art to the point where *Photo District News* called him "the master of the manipulated Polaroid."

Going's work is grounded in a traditional sense of form and beauty, along with an early fascination with photojournalism and Cartier-Bresson's Decisive Moment. The SX-70 allows him to isolate an experience, capture it, and immediately interpret his impressions. Even though many of his images are carefully crafted, he strives for a candid look. The end result is part Decisive Moment and part Impressionism: "Although I rely on technique to obtain the impressionistic look, the most important thing is that one has to start with a good photograph on all levels: composition, lighting, color, and content. The technique only transforms the image to a different level; it will not make a mediocre photograph a good one."

Going makes his photographs with an SX-70 camera and Time Zero film. Besides available light, he often uses strobe lighting (both in the studio and on location), fill flash, filters, and other equipment. After the film fully develops, he handalters the

SEOUL. 1988
SX-70 manipulation.

image with various tools to achieve the brushlike strokes in his imagery. He then makes a 4x5 duplicate transparency of the original, which he uses to enlarge to a Cibachrome print. Recently, he has been experimenting with making high-resolution digital scans of the original and then outputting to 4x5 transparency film with a film recorder to make Cibachrome prints.

His limited edition Cibachrome prints are owned by museums, corporations, and private collectors worldwide, and he has shot major editorial and commercial assignments for clients such as *Time* magazine, *Sports Illustrated,* Hyatt Resorts, Fireman's Fund Insurance Company, and Princess Cruises (see *Ship's Stairway* opposite). Numerous profiles of his work have appeared in major graphic and photographic publications including *Communication Arts, American Photographer,* and *Photo/Design.* His image *Seoul* (above) for *Sports Illustrated* was selected by *Photo District News* as one of the most memorable editorial images of the past twenty years.

DANITZA III. 1996 *SX-70 manipulation.*

CLOCKS, PARIS. 1990
SX-70 manipulation.

SHIP'S STAIRWAY, CARIBBEAN. 1985
SX-70 manipulation.

Cynthia Johnson-Bianchetta

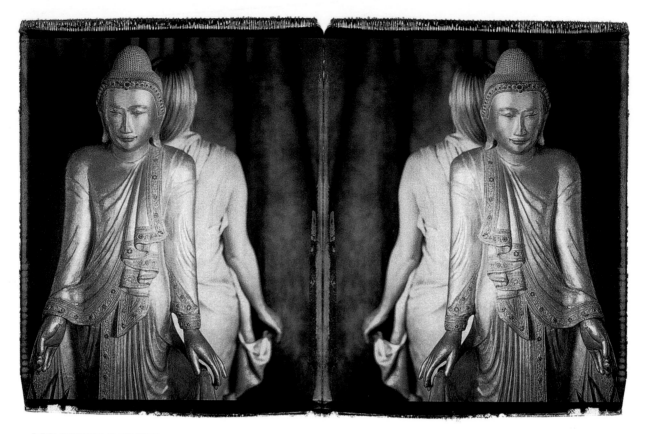

REFLECTING BUDDHA. 2000
20x24 image transfer, scanned, and printed twice.

Cynthia Johnson-Bianchetta has been a fine-art photographer for over twenty years, while being involved in her career as a curator and arts administrator. She was part of the founding staff and the assistant director of the Museum of Photographic Arts in San Diego's cultural center of Balboa Park, and later was the director of the Weston Gallery in Carmel, California. In addition, she has been a photographic assistant to Paul Caponigro in Santa Fe, New Mexico. She makes her home and studio on the cliffs of the Pacific in Big Sur, California, with her photographer husband, Daniel Bianchetta, and is a creative-uses consultant for Polaroid and on the board of directors for the Center for Photographic Art in Carmel. She leads workshops for the Taos Institute of Arts, Esalen Institute, Big Sur Photography Workshops, and with Kathleen Carr, coleads annual Women's Creativity retreats.

Johnson-Bianchetta's emphasis is in the intuitive aspects of the art form and exploring a blending of artistic mediums with personal process and spiritual practice. She has found that the image-transfer process creates the dreamlike states that have guided her in her creative work:

"The creative process calls me into the moment, to be present for the movement of creative inspiration to work through me. It is the same journey that many artists and mystics speak of. I may find my connection with it through my night dreams, or the daydreams or visions that come to me. Perhaps the image appears as a guide to healing that I, or the collective, or the planet may be in need of. I make myself available and open, and I respond by exploring through imagemaking.

"I feel as photographers we 'lift the veils on the unseen world' . . . offering a glimpse into other real-

ities that feed us and nurture us on a more spiritual level. Working with instant materials, I have an immediate palette to work with, and am as spontaneous and in the moment as I can be. I often use Polaroid slide film as well as Polacolor peel-apart films.

"For the most part, I transfer onto Arches 140lb hot-press watercolor paper, which gives the image a base of texture to create upon. I then work the image later with watercolor pencil, chalk, pastels, and raw metallic pigment. The process of image transfer has so many variables. I love the surprise of the mysterious taking over, as if I am cocreating with the Great Mystery as my hands rework the hue, shape, and form. By adding color, an entirely different mood may emerge from the original image and offer an unplanned experience.

"Recently, I have been working live with the 20x24 camera in San Francisco. Again, though I may have a plan in mind, the mysterious takes over in the actual creating of the image, and that continues to excite me. Unlike other photographic processes that require a great amount of preciseness and control, in working with the image transfer, I am taught to let go and that, to me, offers more creative freedom and excitement.

"I am interested in combining images to create an expanded image, as in turning the slide in different directions to form altar pieces, mandalas, diptychs, and triptychs—ultimately offering more movement—or perhaps using the photograph as storyteller. I am also a dancer, so when I place myself in an image it becomes not only a self-portrait, but also a performance art piece without an audience. Later the viewer becomes the audience and may have the possibility to also step into the dream, or hopefully invite healing. In the deepest sense, it is my desire to offer—through the images—visual prayers for healing."

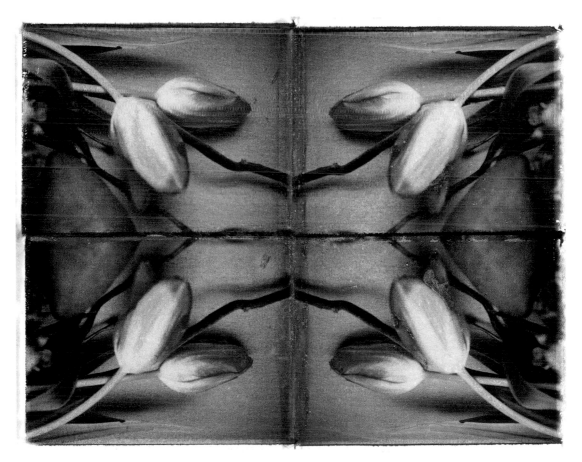

MANDALA II. 1999
Four image transfers handcolored with chalk pastel, watercolor pencil, and raw metallic pigment.

Dewitt Jones

LADY IN TUBE. 2001

"Using an SX-70 camera to do photojournalism is a bit of a challenge. This image worked out well, however. I manipulated the print with a burnisher on the spot. Then I used Photoshop as a digital darkroom to control the other elements of the final print."

Dewitt Jones has been a professional photographer and filmmaker for over thirty years. Twenty years as a freelancer for *National Geographic* earned him a reputation as a world-class photojournalist. As a motion picture director, he has had two films nominated for Academy Awards. His work is well known in the advertising world, as well, in national campaigns for clients such as Dewar's Scotch, Canon, and United Airlines. He has published ten major photographic books, and his column, "Basic Jones," appears monthly in *Outdoor Photographer* magazine. Jones is also an award-winning motivational speaker who speaks about the creative process at colleges, associations, and corporations throughout the world:

"I'm involved in SX-70 manipulation for the sheer joy it gives me. As a frustrated painter who never could learn to draw, this medium allows me to combine my photographic eye with a painterly feel. I love the challenge of the camera itself—one lens, no filters, limited speed and aperture control. And the film—high contrast, limited latitude. No technologic tricks to save you. It's all in the seeing.

NIGHT PALMS. 2001

"I started with a backlit shot of palm trees and used hard strokes with a clay sculpting tool to work the trees in the Time Zero print; then I took another image of a Hawaiian flowered shirt and scanned both into Photoshop. I removed the sky in the palm tree print and replaced it with the flower from the shirt photograph to give the effect of northern lights in the Southern Hemisphere."

PALM TREES AND WATER. 2001

"This image began with a Time Zero print of a palm tree grove. I shot late in the evening with a very long exposure and moved the camera vertically while the shutter was open. The result was an image where the trees were streaked and painterly. I manipulated the fronds of the trees with a burnisher. I then scanned the image into Photoshop and used the plug-in Flood to add the water effect in the lower half of the frame. Next, I used Photoshop as a digital darkroom to manipulate the contrast, saturation, and color of the final print."

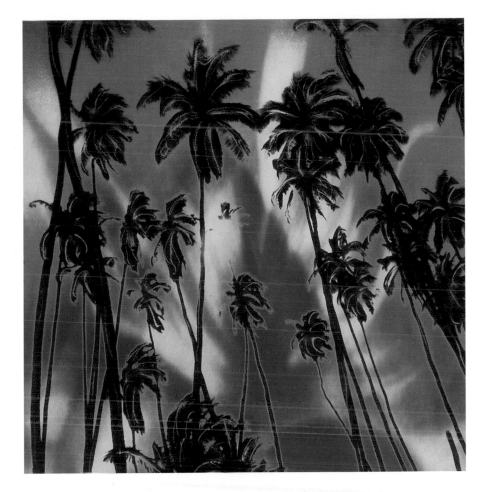

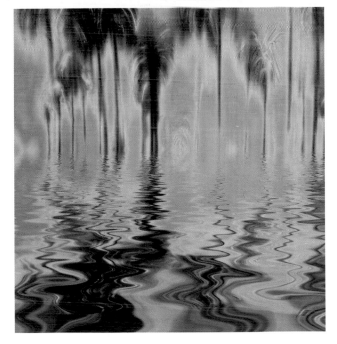

"I love the 'mushing.' The alchemy of the film, which no matter how skilled I become, still has a life of its own. Finding that 'life' and following it makes each print a delight.

"I'm an image maker, not a photographer, so Photoshop is just a logical extension of Polaroid manipulation. Sometimes I use it merely as a digital darkroom; other times it pushes me in a whole new creative direction. And then the print itself—either an Iris print or a pigment print from an Epson 2000P. What an age we live in! What fun!"

Kenario: Ken Dorr and Mario Marchiaro

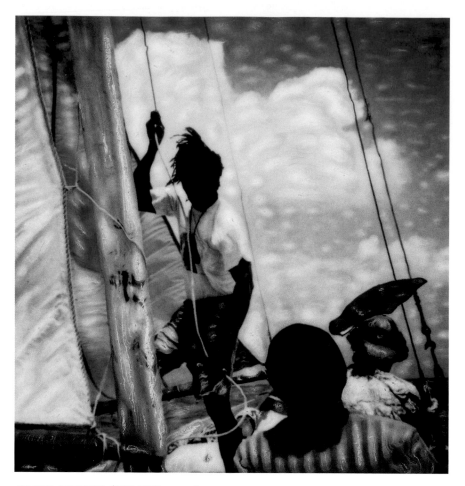

SALTY BREEZE (BELIZE). 1996
SX-70 manipulation.

Begun in 1997, Kenario is a partnership of two artists who have blended their work together: Ken Dorr from California and Mario Marchiaro from Italy. Their combined talents create a portfolio that explores photography with a mix of mediums and an added flare of romanticism.

Self-taught in photography and sculpting, Dorr furthered his education at Brooks Institute of Photography in Santa Barbara, California. His love for nature at an early age led him down a twenty-year path as a lead guide for Outdoor Adventures around the world. Location photography is one of his specializations.

Born in Italy, where art is a part of living, Marchiaro spent a successful artistic life onstage as a performer, choreographer, and teacher before evolving his creativity into the medium of photography.

Having traveled the world in search of its photos, Kenario offers a body of work that represents many countries and most continents. Clients and collectors are equally varied and include celebrities such as Lily Tomlin, Chita Rivera, Marvin Hamlisch, and Tracy Ullman. Corporate clients are IBM, Ralston Purina, MCA Records, and Ruth's Chris Steak House. A series of Kenario work is published and distributed worldwide by Bentley House Rhinehart Fine Arts.

The artists use two types of cameras when shooting Time Zero film. One is an SX-70 camera, the other a Mamiya RB 6x7 medium-format camera

with an SX-70 Polaroid back. Using this RB system allows them the luxury of many different lenses and filters, although most of their images were shot with the SX-70 camera, which they find more convenient for travel since it folds into such a small package. They then rephotograph the manipulated SX-70 images to make limited edition prints.

Dorr and Marchiaro's vision is to present the treasures of the planet in a way that combines many photographic elements, physical manipulations, foresight, and a touch of magic (a complete body of manipulated work can be seen in their gallery at www.kenario.com):

"We spent some time developing a technique to heat the SX-70 print on location anywhere in the world. We discovered that cautiously pouring boiling water over the image while it sits clamped down in a square plastic container softens the emulsion and allows a constant heat source. This lets the artist sculpt the image for fifteen to twenty minutes. The Mylar is very durable, and as long as you don't puncture it, you can get amazing results. Each person will have to experiment with a variety of timings such as development timing, when to pour the water, and how long to work the print. Filling a thermos to keep the water hot for up to ten hours allows us to travel to remote areas.

"We must warn everyone of the dangers of using hot boiling water. Safety first is the key. We are only describing our technique as it works for us and as an insight to how we create our images. Every one of our photo-impressionistic images was created under water using this technique.

"We are very spontaneous when we shoot and sculpt. In fact, we have a hard time remembering who shot what since our artistic compositions are very similar."

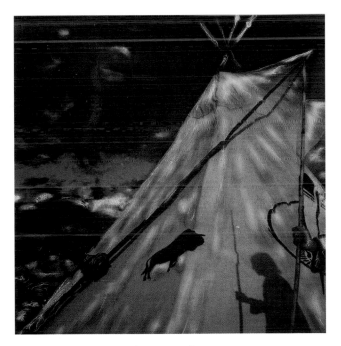

SPIRITS CONNECT (ARIZONA). 1998
SX-70 manipulation.

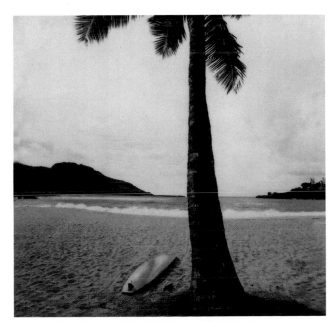

SOLITUDE, KAUAI (HAWAII). 2000
SX-70 manipulation.

Wendell Minshew

Wendell Minshew has worked in medium- and large-format photography for over twenty years in the tradition of the classic West Coast photographer. His major influences were Edward Weston, Brett Weston, Al Weber, and Ernie Braun:

"I first became interested in Polaroid SX-70 images around 1993, when I read an article in Polaroid's *Test* magazine. The process allows for an artistic interpretation of what we see and offers images that are immediately rewarding. I have found this process liberating and playful, and it has allowed me to explore a new and exciting side of my photographic vision—a departure from reality.

"My working method involves shooting the images in the field with a Polaroid SX-70 autofocus camera and manipulating the emulsion on the spot. Although this may prove slow for some, I enjoy slowing down and creating at the location. I use a variety of tools ranging from pencils to pens to crochet hooks to sharpened and carved wood sticks."

Back in the studio, the completed image is scanned into Photoshop at a resolution of 300 dpi and an image size of approximately 15.5 inches by 15.7 inches. The scan is made with minimal color or contrast adjustments, and without any sharpening. The resulting digital file is approximately 65 MB

TABLES IN RAIN. 1998
Field-manipulated and handcolored Polaroid SX-70 image.

THE BLUE DOOR. 2000
Field-manipulated Polaroid SX-70 image.

THREE BELLS AND A CROSS. 2000
Field-manipulated Polaroid SX-70 image.

and saved as an unadjusted *.psd file (native Photoshop file) and is archived on CD-R media. The image is color balanced, and any selective color enhancements are made in Photoshop. The final image is again saved in a *.psd format and archived on CD-R media. The resulting image file size varies from 80 MB to 200 MB, depending on the number of adjustment layers used.

"I view the image scanning and digital manipulation process as the equivalent to exposing and developing a negative or transparency—it provides an instrument in which a print can be produced and shared with others. And for me, the print is the final goal.

"After testing many papers and inks with my Epson 860, Epson 1160, Epson 3000, and Epson 7000 printers, I have chosen the Epson 3000 printer with Lyson E ink and Concord Rag paper as my standard printer, ink, and medium. I am very happy with the look of the Lyson ink on the Concord rag, and find the paper's feel and slightly warm color works well with the Polaroid images.

"This is also a very stable combination, with an expected print life in excess of twenty-five years. A custom printer profile is necessary to provide visual continuity from the monitor to the print. At the time of printing, the image is sharpened, and a profile-to-profile conversion is made using the printer profile and the monitor color space. The final result is an archival giclée print at sizes ranging from 7x7 inches to 15x15 inches."

Minshew's work has been exhibited in over forty solo and group exhibits, and is included in private and corporate collections in Europe and the United States, including at the United States Library of Congress. He has been actively involved in teaching photographic workshops for the last sixteen years, as well as in taking a leadership role in local art organizations in the Sierra Nevada foothills of California. Minshew's photographic interests have encouraged those around him, with many friends and family picking up cameras and pursuing their own artistic expression. His work is represented by the Focus Photography Gallery in Carmel, California.

Elizabeth Murray

Well known as a gardener and photographer of Monet's garden in Giverny, France, since 1985 Elizabeth Murray has returned annually to photograph and paint there. Her "painterly photography" images are romantic and impressionistic; she hand-renders and paints each photo.

A native Northern Californian currently living in Monterey, California, Murray is a distinguished alumna of Sonoma State University, where she received her degrees in fine art, environmental education, and botany. Exhibitions of her work have traveled with Monet's paintings to several museums, including the San Diego Museum of Art; Portland Museum of Art; Albright Knox Museum; Monterey Museum of Art; Phoenix Museum of Art; New Orleans Museum of Art; Walters Art Gallery, Baltimore; and the de Young Museum of San Francisco. In addition, she has had several one-woman shows across the United States and four in Japan to complement the Monet show.

Her work is sold at Photography West Gallery in Carmel, California, and a series of eleven romantic images from Monet's gardens are now posters, available on her website: www.elizabethmurray.com. She has

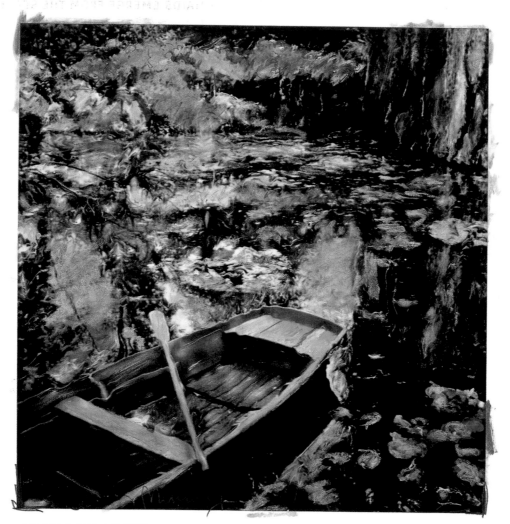

GREEN BOAT AWAITS 1993
SX-70 original, manipulated and handpainted on enlarged print.

also published three books (*Cultivating Sacred Space: Gardening for the Soul*; *Monet's Passion: Ideas, Insights and Inspiration from the Painter's Garden*; and *Painterly Photography: Awakening the Artist Within*), sixty calendars, and assorted gift items. Her articles have appeared in *Victoria* magazine, *Health & Spirituality,* and the *Ritz Carlton* magazine, among others.

"My favorite subjects are painterly compositions of gardens, landscape, architecture and still lifes. I begin with photographing with an old fashion SX-70 Polaroid I can render directly. Then I hand print the enlarged and softened images onto watercolor paper and paint them with Marshall oils, French metallic and opalescent pastels and colored pencils. The images begin to glow and flourish. I enjoy combining my great loves of painting and photography to create these personal views."

MERMAIDS EMERGE FROM THE SEA. 1993
SX-70 manipulation, unpainted.

GIVERNY IN PINK ROSE LIGHT. 1993
SX-70 manipulation, handpainted on original Polaroid and on enlarged print.

Elizabeth Opalenik

Elizabeth Opalenik is a fine art, editorial, and commercial photographer specializing in mordançage and other alternative processes. Her work has been shown in over sixty exhibitions internationally and is in museum, gallery, and private collections throughout the world. Portfolios have been published in six countries and such magazines as *Zoom, Camera Arts, PDN,* and *Collectors Photography* among others.

A sought after educator, she has led photographic workshops in Provence, Tuscany, and on barges in Burgundy since 1983. She also teaches for Maine Photographic Workshops, Santa Fe Photographic Workshops, British Guild of Portrait Photographers, and others. Nicknamed "the Martha Stewart of photography" by her workshop students, Opalenik tends to approach her work in alternative and Polaroid processes with a there-are-no-mistakes-only-possibilities attitude. Therefore, she seldom lets students throw anything away at first, for it could be used later and turned into a positive result. For her, that's the beauty of working with the unique possibilities that the Polaroid processes offer.

She has long loved creating the SX-70 manipulations, which she refers to as her therapy and as Pola Entrées. Since she spends a lot of time conducting workshops in Europe and elsewhere, these miniature jewels have opened many a door for her:

"They are easy to share, always draw a crowd while you work on them, and if you give one away, you are rewarded with an opportunity for something

ARRIVING IN STYLE WITH PILLARS. 2001
4x5 Polaroid image transfer on folded paper with an overlay of emulsion lift and rolled edges, mounted in a handmade book. Note: *The emulsion lift was stretched to about 5x7 to create extra drape on the body and edges for the roll.*

ARRIVING IN STYLE. 2001
Polaroid image transfer wet negative.

SPIRIT OF THE DANCE. 2001
Polaroid image transfer.

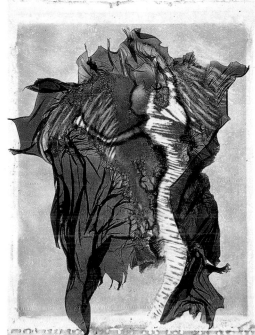

better. You will often find me leaning over a hot car or metal café table happily working on a manipulation. In the busy world of today, the SX-70 is always nearby, and if I haven't the time to make other images each day, I can keep my sanity with this instant gratification. Generally, I get lost in the process, and then realize that there is the time—and nothing is so important as giving it to yourself.

"As in all my work, I am fairly committed to one-of-a-kind images, experimenting a lot, and finding uses for all parts. Polaroid fulfills those needs and adds surprises. I also do not work on the computer, so all painting is done on the original SX-70 with pencils and paints. However, I do love the marriage of technology in outputting the finished pieces onto lovely watercolor papers as Iris/giclée prints."

REMEMBRANCE. 1997
SX-70 manipulation.

Catherine Peters

"I fell in love with SX-70 photographic art in Italy in 1998. I was fortunate to have Joan Emm as my instructor and inspiration. My first pieces were of the beautiful moods of Italy—architecture, flowers, country scenes, and close-up details that portrayed the Italian experience. I was advised to avoid doing people because the SX-70 technique doesn't work well on skin. However, I felt drawn to use my art to portray my love for children. I soon developed an illustrative style that captured the moods of childhood without showing a lot of faces. I now apply the style to create dreamlike images that express the natural charm and beauty of children being themselves. I strive to capture an intensity of feeling and take great pleasure in creating beautiful personal art for my clients' homes. I also love teaching adults and children to discover the artist within them.

"The painterly look of the images comes from the actual moving of the emulsion by applying pressure with a stylus on the surface of a freshly exposed SX-70 photograph. I have learned that if you work on a warm photo, the fluids move much easier. Dark colors are more difficult because they can cause white streaks. It's best to let the dark areas harden for a half-hour or so before working on them. Almost any tool with a sharp point will work, but there are many different effects that can be achieved with different tips or edges. My husband developed a special six-edged stylus plus a special work station that heats the photos so that you can work on them over a ten-hour period. These tools are included in the learning system that we have developed called the Monet Miracle Instant Artist System. Our system also includes a camera adapter so that you can use an inexpensive 600-series camera, plus two training videos and an illustrated manual. Everyone deserves the joy of creating their own art, and the SX-70 process makes it possible." (See www.monetmiracle.com.)

FAMILY OF FRIENDS. 1998
SX-70 manipulation.

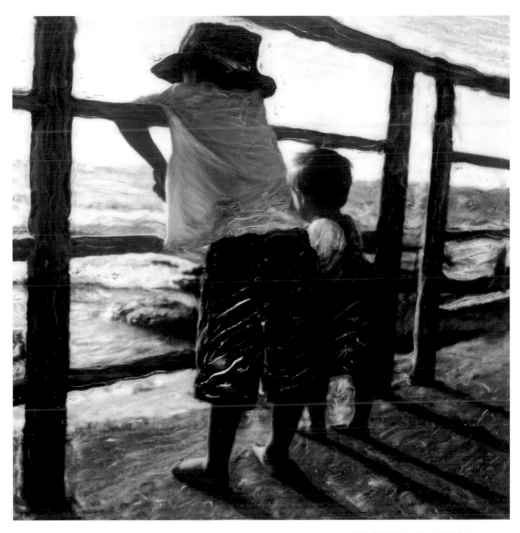

BROTHERLY ADVICE. 1999
SX-70 manipulation.

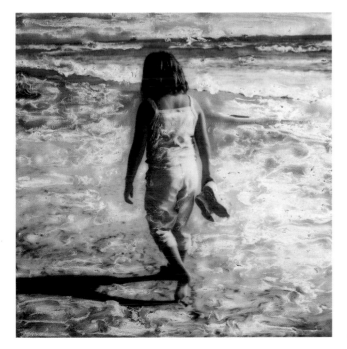

LONELY HEART. 2000
SX-70 manipulation.

John Reuter

John Reuter was born in Chicago, Illinois, in 1953. Raised in California, he moved to New York and then attended college at SUNY Geneseo. He studied with photographer Michael Teres, and painter and art historian Rosemary Teres. His early work took advantage of the photographic process to transform the camera's perspective into a more "mythic" reality. Reuter continued this work in graduate school at the University of Iowa, beginning his SX-70 collages.

Following graduate school, Reuter began working for Polaroid, first as a research photographer and later as main photographer and director in the 20x24 studio. There, he began collaborative relationships with artists such as William Wegman, Joyce Tenneson, Olivia Parker, David Levinthal, Timothy Greenfield Sanders, and many others. Throughout the twenty years of working with other artists, Reuter's own work and vision have gone in a very different direction. The SX-70 collages gave way to painted image transfers in formats ranging from 8x10 inches to 5x6 feet, and then to digital imaging:

"I usually regard the birth of my present-day work as residing in my SX-70 altered prints from 1975 to 1980. I was given a Polaroid SX-70 camera in late 1974, and my work was never the same. I was able to achieve in it the control over context and character relationships that I could only touch on in my black-and-white work. Combinations of painting and photography, which I had hinted at previously, came into full fruition in these reconstructed SX-70 prints. These pieces were actually photomontages contained within the frame of an SX-70 'instant' image. While they were anything but instant, they actually played off the notion of immediate feedback.

"I learned to work intuitively with the process, never certain about the narrative path an image would take in advance—it was always determined in process. One sort of manipulation would yield an expression in a face that would then determine the colors or collage pieces to go with the central figure. If I were to repeat the image with the same elements again, it would invariably come out differently. I would create images by assembling the elements and then learning from their juxtaposition where the essence of the image would lie. {I still do this.}

"The process I employed in my SX-70 collages has been impossible to do since 1979 with the introduction of Time Zero SX-70 film. Responding to a challenge from Kodak, whose instant film developed twice as fast, Polaroid rearranged some layers and sped up the transfer rate of the dyes. In addition, the chemical sandwich was much thinner, and I was no longer able to remove the dyes by rolling them out or performing what can only be described as an SX-70 version of emulsion transfer.

"In the prime of this process, I was able to shoot an image, allow it to cure for six to eight hours, and then carefully remove the negative backing. Placing the image on a light table, I was able to carefully cut around the image I wished to retain and 'roll' the dyes out I wished to remove. I was left with the remaining image and clear polyester film. In these clear areas I would introduce acrylic paint or collage elements. Everything was placed in from behind, so when you viewed the collage from the front it retained the smooth glossy appearance of a 'normal' SX-70 image. I felt the appearance of these rather surreal scenes in the frame of the SX-70 container added to the experience.

"In time, I developed a second technique of cutting and stripping the SX-70 moments after it began developing. This allowed an emulsion-transferlike technique with the dyes. I would place these images on watercolor paper temporarily and then pick them up into blank SX-70 frames, back paint them and paint or collage in background elements. Even though this film was discontinued in 1979, because I worked for Polaroid I had access to enough film to last me through 1980. I have always felt that I would have continued working with these techniques for many more years had the film not changed. The premature end of this body of work only adds to its special place in my heart."

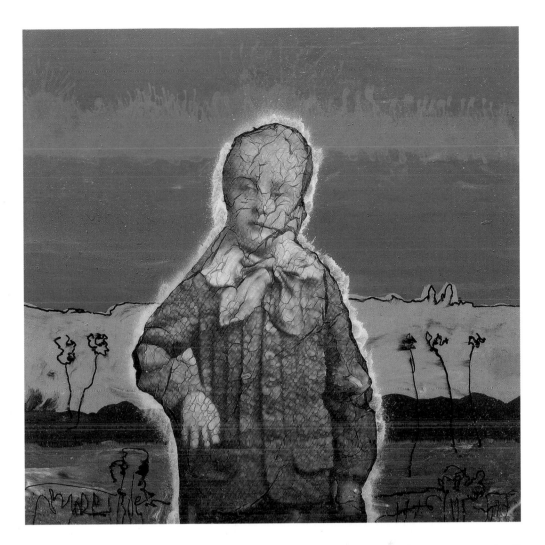

AFTERGLOW. 1979
SX-70 collage with acrylic paint.

CALLIGRAPHY. 1978
SX-70 collage with acrylic paint.

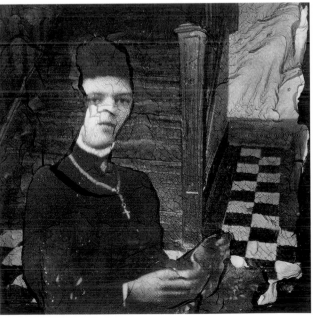

DELFT INTERIOR. 1978
SX-70 collage.

Louise Roach

Louise Roach has enjoyed a varied and unusual career in art. Beginning as a graphic artist, her pursuits have included professional portrait photographer, workshop instructor, gallery artist, and writer. Her photography, digital, and mixed-media images have been shown in over 100 local and national exhibitions, earning a variety of awards as well as publication in several magazines such as *THE, Camerawork, POZ, Angel Times,* and *Miracles.* She attended the SUNY at Fredonia, earned a Master of Photography degree from the Professional Photographers of America, and studied with international photographers Lizbeth Guerina and Joyce Tenneson. Working from her studio in Santa Fe, New Mexico, she is currently writing and illustrating a series of children's books.

"The discovery of an old, rusty mailbox lid was my inspiration to leave paper behind and experiment with such unusual receptor surfaces as steel. I had been transferring Polaroid emulsion onto various papers for some time and felt its expressive capabilities were limiting. Finding a discarded mailbox lid sparked my imagination. Maybe metal was a more appropriate solution for what I had in mind.

"Why steel? Due to its durability, steel is a surface that can take a lot of abuse. I've layered and collaged on it, painted and sanded its surface, deliberately rusted it, and even peeled the emulsion off in strips. Steel can be cut into different shapes, drilled, and distressed. If I'm disappointed with how an image is turning out, I can cover over it and begin again, or use it as an underlayer.

"After attempting an emulsion lift on my rusty mailbox lid, plus many trial-and-error attempts on other surfaces, I have derived a basic technique for transferring emulsion to steel (or plates made of other metals)."

Roach's first step is to prime and seal the surface. This is particularly important when a material is not archival. To do this, she first either cleans the steel with a degreaser or sands it to remove any oily

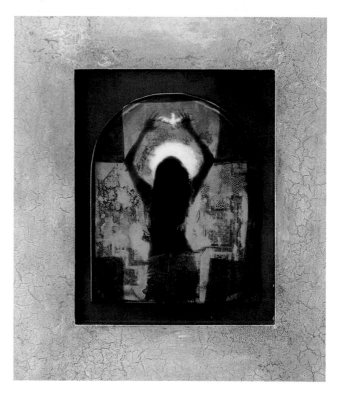

APHRODITE'S DOVE. 1998
4x5 emulsion transfer over collage on a steel panel with oil glaze.

residue left from manufacturing. Then, she paints the panel with two coats of clear, self-leveling acrylic gel medium made by Golden, which creates an acid-free surface on which to work. Next, she primes the surface with several coats of white acrylic paint. In order to "see" the emulsion placed on a surface other than paper, the surface must have a light-colored background. After the paint is thoroughly dry and has hardened for at least twenty-four hours, she uses an electric palm sander to sand the surface smooth. A final coat of clear acrylic gel medium seals the finished surface.

At this point the steel panel is now ready to accept an emulsion transfer. Roach uses the standard method for emulsion transfers, but instead of using a transfer sheet, she instead submerges the steel panel and floats the emulsion directly onto the surface. This cuts down on air bubbles being trapped beneath the emulsion.

ILLUMINATION. 1997
*9x9 emulsion transfers
over iridescent film on nine
individual steel panels
with oil glaze.*

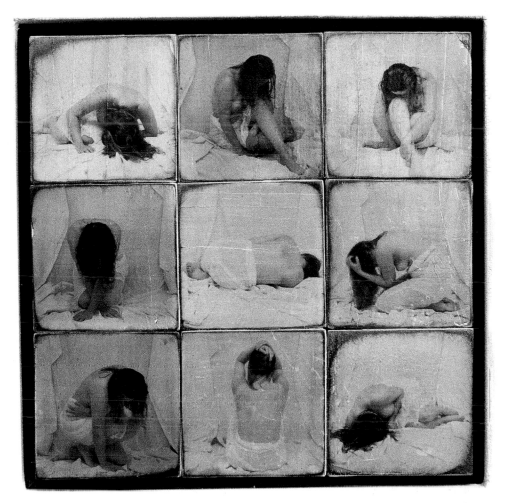

After the Polaroid emulsion has dried, she carefully paints a final coat of clear acrylic gel medium over the print to protect and toughen it. Now a variety of finishing techniques can be employed. Roach enjoys distressing the edges using a sander. She also experiments liberally with glazing techniques, using commercially prepared acrylic and oil glazes. She offers a word of caution: "When using oil glazes, you can paint oil over acrylic but never acrylic over oil—a chemical reaction will occur!"

When completing her first pieces using this technique, she realized that their unique quality would be lost if exhibited in ready-made frames. So, she designed and constructed her own frames specifically to be used with emulsion transfers done on steel panels: "My final goal is to create a one-of-a-kind art object that feels substantial in both quality and appearance."

ARISEN. 1998
12x12 emulsion transfer over collage on steel panel with oil glaze.

Ernesto Rodriguez

Ernesto Rodriguez was born in Cuba where his parents owned a business. The young Rodriguez was often left in the care of his grandfather, an artist specializing in murals. His fondest memories are of being an "artist" with his grandfather, making a mess of his paints, brushes, and home. When he was nine years old, his family left Cuba for the United States and, sadly, Rodriguez never had contact with his grandfather again. This was extremely traumatic for the budding artist, but he feels there will always be a strong spiritual connection.

Trained as a school psychologist, Rodriguez remembers the feelings of envy toward art students working on their assignments around campus. After graduation, he went on to work for the American School in Colombia where he began dabbling with photography; it wasn't until his transfer to Saudi Arabia that he started to get serious about pursuing it. An avid scuba diver, he befriended an underwater photographer from *National Geographic,* and for three years Rodriguez would guide his friend to interesting dive spots and the photographer would teach him about photography and light. These years of "photo apprenticeship" rekindled his love of art and encouraged him to pursue photography full time.

In 1988, Rodriguez and his family returned to the United States and Ernesto Rodriguez Photography was born. His advertising and commercial business flourished, and the wheels of fate turned and brought him to John and Maryann Doe, who in 1992 were inventing the giclée process. This meeting changed his life and the direction of his creative work. The impetus to pursue fine art professionally came when an important client mentioned searching for artwork for the boardroom. He provided the client with some of his personal work and word quickly spread. Rodriguez soon found himself doing gallery exhibitions and solo shows.

He has received many special awards and commissions for everything from festival posters and

BRUGGE. 2000
SX-70 manipulation edited in Adobe Photoshop, painted in Adobe Painter 5.0, and output to a 30x40 Iris print.

SONOMA. 1997
SX-70 manipulation edited in Adobe Photoshop, painted in Adobe Painter 5.0, and output to an 11x11 Iris print.

HAVANA VIEJA. 1999
SX-70 manipulation edited in Adobe Photoshop, painted in Adobe Painter 5.0, and output to a 40x40 giclée print.

merit awards to art competitions. His work is included in several corporate and public collections, including Atlantic Richfield, Chevron USA, The Port of Long Beach, and the American Embassy in Kuwait. Notable private collectors include the Wrigley family, Don King, and Rod Stewart.

Part of the appeal of Rodriguez's work is his unique style and technique. He first shoots a color Polaroid and then works on it with etching tools to give the image the right quality of atmosphere and intensity of feeling.

"All my work is on SX-70 Polaroid. I like to manipulate the Polaroid with a constant heat source. I have found a heating pad to be my favored choice of applying heat. The image is then scanned and edited in Adobe Photoshop, and the remainder of the details are painted in Adobe Painter 5.0. I want my imagery to be filled with an intensity of atmosphere that makes the viewer an insider—a living, breathing part of the image. I want my images to attract so that the viewer wants to know more— where it started, where it's going."

Amelia Tierney

After graduating in 1974 from Mills College in Oakland, California, with a degree in art and an emphasis in film and photography, Tierney studied photography, printmaking, and film at Oakland's California College of Arts and Crafts for three years, where one of her photography professors was Henry Holmes Smith. She then studied printmaking at the San Francisco Art Institute. She has exhibited in over 150 one-person and group shows.

"Photographing on the street with my 35mm Leica or one of my digital cameras is a favorite preoccupation for me. I endeavor to touch the pulse of contemporary attitudes through images in advertising, graffiti, street murals, window displays, etc. My interest is in capturing the most surreal-looking, yet real images possible. Stretching the limits of con-

ventional photography, using infrared film, printing dye-transfer prints from saturated color copy prints, printing color negatives on Ilfachrome paper, using my digital camera with a touch of Photoshop, or printing Polacolor images—all have helped me achieve this unreal quality. A classic balanced composition also adds to the believability of my work.

"The imagery most compelling and mysterious to me I make into 4x5 transparencies. Then I take these positives to the 'big Polaroid studio' in New York City and rephotograph them with the 20x24 camera. . . . After photographing each 4x5 image, the positive-negative is pulled out of the camera and the positive paper is immediately pulled off. Meanwhile, Fabriano Artistico watercolor paper is waiting in a tray of warm water (for only forty-five

ROBERT'S STRENGTH. 1997
20x24 Polaroid image transfer.

seconds, so as not to saturate it). This paper is placed on a piece of glass, and the negative, with its soft gel-like emulsion still intact, is placed directly on the paper and squeegeed to transfer the information. After five minutes, the plastic backing of the emulsion is carefully removed and my image, now 20x24, is revealed on the Fabriano paper. White vinegar mixed with a half solution of water is sprayed on and removed with a Mercedes Benz windshield wiper to remove developer and to help preserve it."

Tierney uses an 8x10 Polaroid film holder with 809 instant film to produce 8x10 image transfers in her darkroom from 35mm slides (Fujichrome, color infrared, or black-and-white slides of black-and-white infrared photos): "This is actually more difficult, as the emulsion is not as thick as the 20x24 and doesn't adhere as easily. I leave the negative on the paper for twenty minutes to two hours and, on occasion, overnight. I even press the emulsion and the Fabriano paper together between Plexiglas rectangles laminated to plywood, using C-grips."

INDOCHINE. 1997
24x20 Polaroid image transfer.

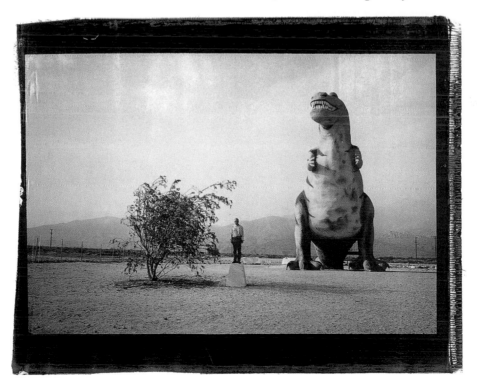

CABAZON GARDENS. 1998
20x24 Polaroid image transfer.

Anna Tomczak

Anna Tomczak holds a master's of fine arts degree in photography from the University of Florida, and she has studied with Evon Streetman, Jerry Uelsmann, and Wally Wilson. She has won numerous fellowships and grants including artist-in-residence at Loft Nota Bene in Cadaques, Spain. Her photographs are represented in many museum collections, and corporate collections include Sony Latin America, AT&T, IBM, McGraw-Hill, Disney/Euro Disney, Merck Pharmaceuticals, the Mayo Clinic, and Westin Resort, as well as many private collections.

"The 20x24 camera allows me to construct, paint, fantasize, envision, and 'transfer' my ideas onto the paper. There is a certain richness of subtle color, combined with a visual clarity, achieved with this process and camera with which I have become

PAPILLON DE DEUX. 1999
20x24 Polaroid image transfer.

CALLA AND HELICONIA. 1996
20x24 Polaroid image transfer.

FONTLEROI'S ENVELOPE. 1999
20x24 Polaroid image transfer.

intrigued and dedicated. In my scenarios, one object or figure is placed in the iconic position, surrounded by vibrant colors, texture, light, motion, ice, botanicals, memorabilia, or other artifacts.

"The objects I choose represent both memory and impulse. While carefully designed, there is an element which relies completely upon the impact of the moment. An electronic strobe records the split second, but the extended shutter time (usually five seconds) allows me to draw with sparklers, candles, and matches. These meteoric lines of light often separate and define the artifacts within the composition while adding a kinetic effect.

"All of the photographs were taken at the Polaroid 20x24 Studio in New York City, operated by John Reuter. In a sense, this is a collaborative effort—my arrangement of the assemblage/still life or figure and John's expertise with the camera, lighting, pulling transfers, and often the perfect decisive moment of capturing bubbles as they pass by in front of the camera. The prints are processed, sprayed with white vinegar (1:1 to neutralize the developer), and are coated with a UV inhibitor. I recommend that they be framed with UV inhibiting acrylic or glass, and be displayed sheltered from any constant UV light source.

"In *Papillon* the image is lit from underneath as well as above. Since the camera is too massive to shoot directly down upon the rather small, horizontally placed objects, John and his studio assistants meticulously rig a photo-quality mirror to reflect the still life into the camera's lens."

Joanne Warfield

Joanne Warfield began her study of photography with Brett Weston in the early 1960s. A subsequent meeting with Ansel Adams further deepened her appreciation and fostered a lifelong fascination with the myriad expressions possible with photography. Her view of photography as art comes through her thirty years of experience both as a gallery owner and private art dealer. This has given her a broad perspective of the art world. Consequently, her work has been influenced by great painters and printmakers, and the fine artists with which she was associated, as well as the work of renowned photographers such as Man Ray, Jerry Uelsmann, Joyce Tenneson, and Sean Kernan.

In 2000 and 2001, her work won the third place award at the Venice Visions competition, and honors in juried exhibitions at the San Diego Art Institute, Gallery 214 in New Jersey, the Venice Art Walk, and the prestigious Women in Photography International 20th Anniversary exhibition.

"I approach my art with a great sense of freedom from preconceived constraints (or what is considered traditional or expected in photography and other art forms). I stand aside and let the muse emerge. The discovery of what *might* happen is always exciting. The whole realm that is called 'alternative photography,' combined with any art medium, becomes a possible vehicle for my explorations.

"The work I have been doing with the various Polaroid alternative processes since 1997 has been very exhilarating for me. Through extensive experimentation with the wet paper negative, and by allowing the emulsion to flow out from the image, I developed my own unique process similar to *cliché verre*. Another method of working with the wet negative is as follows: I allow the film to develop the full sixty seconds before peeling it open, then let it thoroughly dry—usually several hours to overnight. When I am ready to begin working with water, I start by barely wetting the negative, then quickly but carefully put it face down on the scanner, which

FIVE ELEMENT GUARDIAN/GOLD. 2001
Wet paper negative, scanned into Photoshop with color adjustments.

has been prepared with a taped-off 'wet area.' I gently rub any bubbles out, being careful not to move the image, then scan. This results in colors that are very rich and saturated, which lends an air of antiquity to the images.

"The manipulated SX-70 print holds other interesting possibilities. When experimenting with cutting open the film, instead of throwing away the backing, I decided to see what would happen if I scanned it wet. The results were, once again, exciting. I call this process Time Zero Corrosion. I also scan my SX-70 manipulations and then inverse in Photoshop to get a 'negative' effect, adjusting with colors and curves.

"For me, creating a new process usually includes doing the opposite of what is suggested, then adding to that. And as much as I have a specific technique, it still remains illusive—like trying to catch mercury. The magic of the unpredictable is what I thrive on."

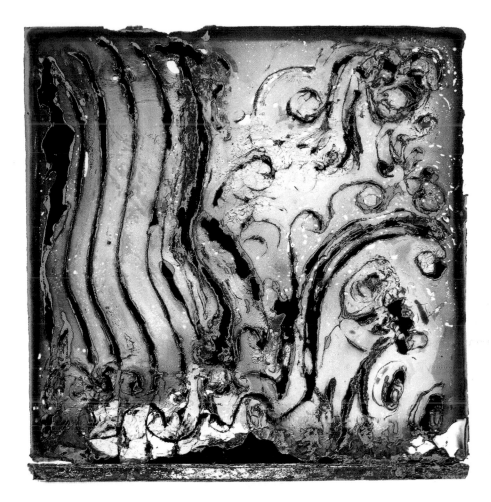

FILIGREE I. 2001
Time Zero corrosion (the film is cut open and the backing is scanned wet into Photoshop, where color adjustments are made).

BLUE VENUS. 2001
Wet paper negative with cliché-verre emulsion flow, scanned, and inversed in Photoshop.

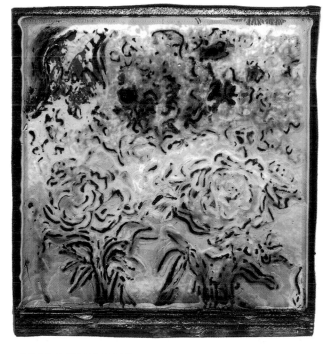

ROSA DOBLE GOLD. 2001
Time Zero corrosion.

SX-70 AND 600 SERIES CAMERAS AND ACCESSORIES

As mentioned previously, the first SX-70 single-lens-reflex (SLR) camera was introduced in 1972, and models with improved features were developed and sold until 1981. These were the folding SLR cameras, and they were fairly expensive in their day. The early models were covered in leather and later replaced with Porvair, a vinyl covering. Special-edition models had a five-year warranty and were distinguished by having blue shutter buttons. Sonar autofocus models, with remarkable focusing systems that used sound waves became available in 1978. Inexpensive plastic nonfolding cameras with viewfinders, not through-the-lens viewing, were marketed from 1976 on.

With the new faster 600 films, the Sun 640—the first of a series of inexpensive 600 series hard-plastic cameras—became available in 1981. Newer versions of these nonfolding plastic cameras are still in production today. In 1982 the 680—a folding style SLR based on the SX-70 Sonar OneStep, with a built-in flash—was born, to be followed by the similar 690 in 1996. Since there were so many models of SX-70 cameras produced, it can be confusing to know what used camera to buy or to figure out what you already have. This section gives an over-view of the common features of—and specific differences between—SX-70 models, some 600 series models, and many of the flash attachments and other accessories made for these cameras.

In my research on the various camera models, I came across Marty Kuhn's website at www.landlist.org, a vast collection of information about all types of Polaroid cameras and films. Marty has been kind enough to grant me permission to include much of his information about the various SX-70 Polaroid cameras

and accessories here, in addition to my research and photographs. He's not associated with Polaroid, nor does he guarantee the accuracy of all of his information. A few items are also from another excellent site, George's SX-70 Pages: The Hacker's Guide to the SX-70 at www.chemie.unibas. ch/~holder/ SX70.html.

Folding SX-70 SLR Cameras

All folding SX-70 cameras have: four-element 116 mm f/8 glass lens; minimum focus: 10.4 inches; front cell focusing via geared wheel at top of lens/shutter housing; electronic shutter; programmed automatic exposure: shutter speeds from over 10 seconds to 1/175 sec.; aperture range of f/8 to f/22 (f/8 to f/74 with the Sonar OneStep); smaller apertures possible with flash; autoflash exposure based on focus distance; maximum flash distance 20 feet with Flashbar or 14 feet with strobe (best results within 10 feet); built-in Flashbar socket (accessory electronic flashes also available); socket for an electrically actuated remote shutter release

SX-70 Original Model

Original SX-70 models, one with focus scale and an earlier one without.

Produced: 1972-1977
Original retail price: $180
Features: SLR (single-lens-reflex) viewing and focusing; chrome-plated plastic body with leather covering; most common SX-70 folding model

Important firsts: first camera using Polaroid integral print films; first ever production SLR with a folding body (Graflex doesn't really count in this respect, as the body itself doesn't actually collapse)
Notes: There are three minor variations of this camera: first-year production models (from October 1972 to October 1973) with plain ground-glass focusing screens and no focus scale; later models with split-image rangefinder (RF) circles and no focus scale; still later models with split-image RF circles and focus scales.

Due to focusing difficulties, Polaroid offered a retrofit service to install the split-image finder for owners of the older SX-70 models, so it may be possible to encounter an early SX-70 model with the RF circle. In addition, some late-production SX-70 models have the same fill flash feature of the Alpha 1, though this feature may be undocumented in the camera's instruction manual.

The SX-70 was definitely a landmark camera in the history of photography and was Dr. Edwin Land's masterpiece. A (very) limited edition gold-plated version was also produced. Some other limited production color combinations may exist, but beware that some may have been altered by their owners and were not produced that way at the factory. SE (Special Edition, with a blue rather than red shutter button) and BC (packaged for K-Mart) versions were also produced.

SX-70 Executive

Produced: 1975-1977
similar to original SX-70

SX-70 Alpha 1

Produced: 1977
Original retail price: $233

Alpha 1 and Alpha SE.

Features: fill flash capability (using Flashbars); tripod socket; neck strap lugs; all else similar to original SX-70
Notes: Early models are simply labeled "SX-70 Alpha" with no number. Color variations of this camera exist with chrome and tan, chrome and black, black and black, and tan and black being the most common. SE (Special Edition), Sears Special (for Sears stores), and SX-70 Alpha 1 Executive versions were also produced. There was also a Revue branded version for sale in Foto-Quelle camera stores in Europe.

SX-70 Alpha 1 Model 2

Produced: 1977
Original retail price: $180
Features: black plastic body with brown Porvair covering; all else similar to SX-70 Alpha 1; might also be known as the Alpha 2

SX-70 Model 2

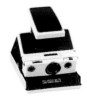

Produced: 1974-1977
Original retail price: $149.95
Features: white plastic body with brown Porvair covering; all else

similar to original SX-70
Notes: All Model 2 cameras have a split-image rangefinder circle. Most, but not all, have focus scales and some have a tripod socket. The top layer of Porvair covering on this, and the Model 3, camera becomes fragile with age and may be easily scuffed. The vinyl coverings on some Alpha and Sonar models are more durable by comparison.

SX-70 Model 3

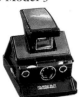

Produced: 1975-1978
Original retail price: $99.95
Features: plain optical view-finder—focus by scale only (not an SLR); black plastic body with brown Porvair covering; Flashbar socket relocated to top of viewfinder; all else similar to SX-70 Model 2
Notes: This is the only folding SX-70 that isn't an SLR camera. Even so, the shutter and mirror-flipping mechanisms function exactly the same as in its SLR cousins, even though the added complexity is unnecessary in this camera. The Flashbar is relocated because if it were in the same place as on the the other cameras, it would be directly in front of the viewfinder window.

SX-70 Sonar OneStep

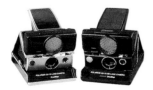

SX-70 and SX-70 SE Sonar OneStep AF.

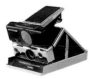

SX-70 Sonar OneStep gold-plated model.
CAMERA COURTESY STEVE SWINHART;
PHOTO RICH DeFERRARI

Produced: 1978
Original retail price: $249.95
Features: autofocus (AF)—uses

Polaroid Sonar AF system; AF preview available before exposure is made; full manual focus capability; low-light warning in view-finder; all else similar to SX-70 Alpha 1
Notes There are several color variations and a limited-edition gold-plated model.

SX-70 Polasonic Autofocus Model 2 and Time Zero SX-70 AF

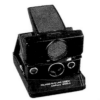

SX-70 Polasonic Autofocus Model 2.

Produced: 1981
Original retail price: $279.95
Features: both similar to SX-70 Sonar OneStep Time Zero SX-70 AF

Nonfolding SX-70 Cameras

All nonfolding SX-70 cameras have electronic shutter; programmed autoexposure (long exposures possible on most, if not all models); Flashbar socket for flash (accessory electronic flashes also available); rigid plastic body

Pronto!

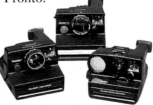

Pronto! Pronto SE, and Sonar OneStep.

Produced: 1976-1977
Original retail price: $66
Features: three-element 116 mm *f*/9.4 plastic lens; minimum focus: 3 feet; shutter speeds: 1/125 sec. to 1 second; front cell focusing with focus scale on lens ring; black plastic body
Notes: This was the first non-folding SX-70 camera and also among the most common. SE, BC, and Sears Special versions were also produced. Pronto! Plus came

with carrying case, photo album, film, and Flashbar. Pronto! S and SM models were also made.

Super Clincher

Produced: 1976
Features: two-tone brown-and-tan-colored plastic body; all else similar to Pronto!

Pronto! B

Produced: 1977
Original retail price: $59
Features: silver-and-black plastic body; lens is manual focus by distance: 3 feet to infinity; color-coated plastic lens; all else similar to Pronto!

Pronto! Extra

Produced: 1977-1978
Features: self-timer; tripod mount; all else similar to Pronto!

Pronto! RF

Produced: 1977
Original retail price: $88
Features: single-window super-imposed image rangefinder; all else similar to Pronto!
Notes: This is a fairly uncommon model. The design of the range-finder in this camera is somewhat unusual in that the windows are vertically displaced (the RF patch image moves up and down rather than side to side) and, from the looks of things, aren't even in precisely the same axis. SE, BC, and Sears Special versions were also produced.

Encore!

Produced: 1977
Features: similar to Pronto!

OneStep

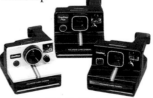

OneStep, OneStep Plus, and Time Zero OneStep.

Produced: 1977
Original retail price: $39.95
Features: single-element 103 mm *f*/14.6 plastic lens; fixed focus

from 4 feet to infinity; fixed aperture at *f*/18 (f/14 in flash mode); variable shutter speeds from 1/125 sec. to 1 second; white-and-black plastic body
Notes: The less-expensive OneStep models were produced after the Pronto! line, with a single-element lens. SE, BC, and Sears Special versions were also produced.

Pronto! Sonar OneStep

Produced: 1978
Original retail price: $99.95
Features: autofocus (uses Polaroid Sonar AF system); full manual focus capability; low-light warning in viewfinder; extra set of flash contact behind Flashbar socket; all else similar to Pronto!
Notes: The extra flash socket mates with a special electronic flash designed specifically for this camera, but I don't know what use these flash contacts might have provided (the flash otherwise seems similar to those sold for other Polaroid camera models). The wording of the camera instruction manual suggests that the extra socket may have been intended for a future accessory that was never marketed.

Presto!

Produced: 1978
Features: gold-colored plastic body; all else similar to OneStep

Time Zero OneStep

Produced: 1981
Original retail price: $49.95
Features: similar to OneStep aside from a few cosmetic styling changes

Time Zero Pronto AF

Produced: 1981
Original retail price: $109.95
Features: similar to Pronto! Sonar OneStep

The Button

Produced: 1981
Original retail price: $29.95
Features: similar to OneStep

Accessories for Folding SX-70 Cameras

Many accessories were made for the SX-70 folding cameras. You can find them on the used-camera market, especially at online auctions and photo swap meets.

#111 Tripod Mount

For use with all folding SX-70 cameras.

#112 Remote Shutter Button

For use with all folding SX-70 cameras; the electrical push-button switch plugs into the socket on the side of the shutter housing.

#113 Accessory Holder

For use with all non-Sonar folding SX-70 cameras; it attaches to camera by means of Flashbar socket; used with #120 lens shade and #121 close-up kit.

#114 Carrying Case

A tan leather soft-pouch case with shoulder strap; for use with all non-Sonar folding SX-70 cameras.

#116 Compartment Case

For use with all non-Sonar folding SX-70 cameras. Slim compartment, semihard case holds camera, film, and Flashbars.

#117 Photo Album

Stores eight SX-70 prints per page—four on the front, four on the back.

#119 and #119A Telephoto Lens Converters

For use with all folding SX-70 cameras, these supplementary lens converters provide 1.5X telephoto effect. They don't require the #113 accessory holder

and can be used with Sonar models. The #119 is intended for the original SX-70. The #119A is intended for the Sonar SX-70 models plus the SLR 680/690 cameras. However, it is, apparently, possible to use them interchangeably with some modification. Call Polaroid Customer Service for instructions.

#120 Lens Shade

For use with all non-Sonar folding SX-70 cameras. Requires use of the #113 accessory holder.

#121 Close-Up Kit

For use with all non-Sonar folding SX-70 cameras. Allows for life-size close-ups and copying; includes flash diffuser, which clips over Flashbar. Requires use of the #113 accessory holder.

#132 Self-Timer

For use with Pronto! and other rigid plastic SX-70 cameras. The mechanical self-timer clamps to the side of the camera's shutter housing; a mechanism pushes shutter button after the set time has elapsed.

#184 Accessory Kit

For use with all non-Sonar folding SX-70 cameras, the kit includes #111, #112, #113, #120, and #121 (listed above), all packaged in a hinged presentation box.

#2352 Pod

For use with SX-70 cameras with a tripod mounting socket, the pod screws into the camera's socket, and its wire frame can be set up to support the camera in a level position on a tabletop.

#0137 Microscope Adapter

Powered by the SX-70 film pack through the camera's remote and flash contacts. Exposure time is set by a LED that illuminates the electric eye of the camera.

CU-70 Macro Kit

A rare macro outfit in a Polaroid aluminum suitcase, it includes three different strength macro lens attachments: 1X, 2X, and 3X—all with built-in flash directors and meter windows. This system allows focusing continuously from 1 foot to 1.5 inches. Also included are three dedicated brackets, the camera mounting platform, and the flash adapter plug for Alpha cameras. This system was used by law enforcement for crime scene investigation.

Photo Cassette for SX-70 and 600 Photos

A smoked plastic storage case for SX-70-type photos, it's about the same size as the film box. Each holds at least fifteen photos and also serves as a display stand for the pictures.

Lumix Wide-Angle and Tele Lens Converters

Included adapter attaches to #113 accessory holder. The 1.4 tele converts a 116mm lens to a 152mm one. The 0.7 wide-angle converts a 116mm lens to a 90mm one. (Made in Japan.)

Folding Camera Case

This is made of hard leather and allows the photographer to open

and use the camera while it's still in the case. Brown and black models are imprinted with the word "Polaroid."

Polapulse Flashlight, Polapulse Scale, Polapulse Emergency Flasher, Polaroid 600 Radio

Polapulse flashlight, Polaroid 600 radio, and Polapulse emergency flasher

These items use the Polapulse battery contained in the SX-70 and 600 film packs—the perfect way to reuse the batteries that still have a lot of power left when the film is finished.

Flashbars, Electronic Flash Units, and Flash Adapters

Flashbars

Made by GE and Sylvania, each Flashbar has ten flashbulbs, enough for a box of film.

#2209 Polatronic 2 Flash

For the Pronto! Sonar camera, this flash clips to the top of the camera, mating to the camera's Flashbar socket.

#2350 Polatronic Flash

For use with all SX-70 cameras, this is a handle-mount electronic flash that connects to the camera via the Flashbar socket. The included camera bracket doubles as a tripod mount. The flash has

two sets of contacts for SX-70 Sonar or Pronto! Sonar. The range is 10.4 inches to 12 feet at 1/1000 sec.

#2351 Q-Light

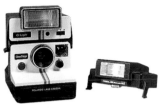

Q-Light and Focal 600.

For use with the Pronto! and other nonfolding, non-Sonar plastic SX-70 cameras. This electronic flash has a one-piece design to match the camera and clips to the top of the camera, mating to the Flashbar socket. Flash range is 4 to 9 feet.

Unomat SFX 70 Flash

A new product, this flash slides onto the top of all SX-70 folding cameras and, with the two accessory brackets, will fit onto any hard-plastic nonfolding SX-70 camera. Currently available from Cress Photo (see Resources).

ITT Magicflash

For use with folding SX-70 cameras, there were two models made: one for a straight Flashbar connector slot and that can be used in all folding models; the

other for only the U-shaped Flashbar slot of the Sonar folding SX-70 (with two extra connectors). The battery area (for four AA batteries) slides onto the bottom of the camera and has a tripod socket. The flash itself fits into the Flashbar connector slot on the top front of the camera.

Nissin Electronic Flash

Clips onto the bottom of the SX-70 camera, and the flash itself fits into the Flashbar slot on the top front of the camera.

Focal Flash Model S-70

This flash fits folding SX-70 Sonar models and Pronto! cameras with tripod sockets. The flash mount screws into the socket. The flash head has two rotating sets of contacts. One is the normal single type, and the other is a double connector. The flash prevents the camera from taking a shot until the flash is fully charged. The original K-Mart price was $28.88.

Flash #4075 by J. C. Penny Co.

For Pronto! and OneStep plastic-body cameras; has a Hi/Lo flash setting (low is 4 to 5 feet and high is 6 to 8 feet), test button, and flash-ready indicator light.

Continental InstaFlash Model D

This flash came with brackets for Kodak Instant and Polaroid cameras and an adjustable flash focus for close up. Maximum range was 10 feet.

Acme-Lite Model 170S

The Acme-Lite has flash-socket adapter plugs for Sonar and non-Sonar models, and a bracket with a tilting head for Sonar models.

SX-70 Flash Adaptor

The SX-70 flash adaptor allows you to connect a regular electronic flash to the SX-70 camera. It plugs into the Flashbar slot and

has a pc-socket to plug in the flash unit. Currently available from Cress Photo and from George of George's SX-70 Pages website (see page 196).

SX-70 Land Films

Unless otherwise noted, all SX-70 Land Films are: color; ISO 150; self-developing, integral; packaged ten prints to a pack; equipped with self-contained battery to power camera; 3⅛ x 3⅛ inches (actual image area)

SX-70 Film

Produced: 1972-1979
Original retail price: $6.90
Notes: Introduced with the original SX-70 camera, this film was as much of a breakthrough product as the original Polacolor film (i.e. Type 48) in 1963. It was truly a marvel of chemical engineering and marked the first time Polaroid film was sold in a ten-frame pack. It was replaced by SX-70 Time Zero film in 1979.

SX-70 Time Zero Film

Introduced in 1979 and still produced, this film is similar to the original SX-70 film but with improved color rendition and much faster development time (hence the "Time Zero" part of the name). The emulsion stays soft for a much shorter time— one to two days rather than three to five days. The thinner emulsion doesn't yellow and crack like the earlier SX-70 film did.

600 Series Integral Print Folding SLR Cameras

The following are all domestic models.

SLR 680

Produced: 1982
Original retail price: $265
Features: uses 600 film; built-in automatic electronic flash; flash

SLR 680 and SLR 680 SE.

reflector automatically tilts depending on focus distance; all else similar to Time Zero SX-70 AF
Notes: The later production models of this camera, sold as the SLR 680 SE (Special Edition), have slightly different trim than the earlier ones.

SLR 690

Produced: 1996
Original retail price: $399
Features: analog metering/timing circuitry replaced by a four-bit microcontroller; rubber boot (keeps it light tight) is thinner than that of the 680; motor is not as heavy duty as the 680; all else similar to SLR 680
Notes: This model was originally intended as a limited production item but, evidently, turned out to be more popular than anticipated. The actual model designation of this camera may be simply "690" rather than "SLR 690." There was also an extremely limited edition version of this camera issued in 1998 to commemorate the 50th anniversary of Polaroid instant photographic products. This camera came with a wood display case and was apparently distributed only in Europe.

600 Series Nonfolding Cameras

The following are all domestic models.

Sun 640

Produced: 1981
Original retail price: $70
Features: the first nonfolding plastic 600 camera; 116mm *f*/11 single-element plastic lens; fixed focus; electronic shutter: range around 1/4 to 1/200 sec.; programmed automatic exposure system; built-in electronic flash; automatic flash exposures for all pictures (flash always fires); black plastic body (somewhat similar to Pronto! but flash unit flips down to protect lens and controls)

Sun 660

Produced: 1981
Original retail price: $95
Features: fixed 109mm double-element plastic lens for each of four focus positions; sharpest lens; best of the plastic models; aperture: *f*/10 to *f*/45; automatic focus (uses Polaroid Sonar AF system); minimum focus 2 feet; all else similar to Sun 640

Sun 650

Produced: 1982
Original retail price: $85
Features: built-in close-up lens for subjects 2 to 4 feet away; all else similar to Sun 640

Amigo 620

Produced: 1982
Original retail price: $56.95
Features: no electronic flash (has socket for Flash 600-style Flashbars); no fill-flash for daylight pictures (flash automatically fires in low light if Flashbar is installed); tan plastic body; Flashbar socket is elevated on a plastic flap that flips down to protect lens and controls; built-in close-up lens; all else similar to Sun 640
Notes: This model was often a giveaway item printed with a company's name on it.

Spirit

Similar to the Amigo 620, some models have a black instead of a tan body.

Spirit 600

Similar to the Sun 640, it appears to have superseded the regular Spirit.

Spirit 600 CL

Similar to the Sun 650, it appears to have superseded the Spirit 600.

600 LMS

Produced: 1983
Original retail price: $39.95
Features: similar to the Sun 640, it has the new Light Managing System

OneStep 600

Produced: 1983
Original retail price: $24.95
Features: black body; no close-up lens; all else similar to Amigo 620

Cool Cam

Produced: 1988
Original retail price: $69
Features: body available in flashy fluorescent colors; all else similar to Sun 640

Impulse

Features: built-in close-up lens; body style: a streamlined Pronto! with pop-up flash; lens cover slides into place when flash is pushed back down (which also turns off the camera); shutter release is on top, toward rear of camera; vinyl covering on body; all else similar to Sun 640

Impulse AF

Features: 116mm *f*/9, three-element plastic lens; autofocus uses Polaroid Sonar AF system; minimum focus; 2 feet (manual focus not possible); electronic self-timer

Impulse QPS

Features: no built-in close-up lens; all else similar to Impulse
Notes: This is a "Special Markets" camera.

OneStep 600 Flash

Similar to the Sun 640, it replaced the OneStep 600. Later models have a built-in close-up lens.

OneStep 600 Flash Close-Up

Produced: 1997
Original retail price: $29.95
Features: built-in close-up lens; restyled body with rounded corners and different front panel; all else similar to OneStep 600 Flash
Notes: Starting in late 1998 or so, this camera was relabeled simply the OneStep, thus bringing the naming patterns of this line of fixed-focus integral print cameras full circle.

OneStep 600 Express

Produced: 1997
Features: hunter green body with upgraded trim; sold as kit with matching carrying case; all else similar to OneStep 600 Flash Close-Up

OneStep AF

Produced: 1997
Original retail price: $49.95
Features: wider maximum aperture than OneStep 600 Express (may be similar to lens arrangement on Sun 660); simple two-zone autofocus system (AF is non-Sonar; appears to be simple IR "wink" variety, rather than true IR rangefinding system); all else similar to OneStep 600 Flash Close-Up

OneStep Talking Camera

Barbie, OneStep Talking, and Cool Cam models.

Produced in 1997, it is similar to the OneStep 600 Flash Close-Up except that it has a built-in digital sound record/playback system. The intent is to play a recording of a funny saying to make your subjects laugh and smile just before taking their picture. The camera can be set to play back either a user-recorded message or one of three built-in messages.

Barbie Instant Camera

Produced: 1999
Features: pink with green and blue trim; supplied with metallic flower decals; all else similar to OneStep 600 Flash Close-Up
Notes: Special 600 Barbie film was also offered simultaneously with this camera. It had decorative Barbie-themed borders overlaid on the film surface.

RESOURCES

Polaroid and Daylab

In most parts of North America and, indeed, the world, you will be able to locate outlets for SX-70 and 600 series Polaroid cameras, films, and supplies.

**Polaroid Corporation
Customer Care Center**
201 Burlington Road
Bedford, MA 01730
ph: (800) 343-5000
Technical information
(Monday-Friday, 8 a.m.-8 p.m. EST): (800) 225-1618
www.polaroid.com *(for consumer products)*
www.polaroidwork.com *(for professional products)*
www.polaroiddigital.com

Polaroid also maintains numerous service centers throughout the United States and internationally. The websites provide up-to-date online information on a variety of topics, including products, processes, *Test* magazine, and a gallery of photographers using Polaroid films.

Polaroid Express
ph: (800) 552-0711
For ordering products at list prices when no local dealer is nearby.

Daylab Corporation
400 East Main Street, Unit E
Ontario, CA 91761
ph: (800) 235-3233
fax: (909) 988-0715
www.daylab.com
Manufacturers of Daylab slide printers and products, Daylab offers information on all slide printer models and bases, Polaroid films, and standard black-and-white and color processing.

Polaroid Recycling

National Recycling Center
Polaroid Corporation
5601 Fulton Industrial Boulevard
Atlanta, GA 30336
For recycling, ship anything from Polaroid films here.

Polaroid 20x24 Camera Rental Studios

The 20x24 Polaroid camera produces a full-color 20x24-inch contact photograph in seventy seconds using Polacolor ER film. Call if you're interested in working with this camera.

Polaroid 20x24 Studio (New York)
888 Broadway, Suite 1010
New York, NY 10012
director: John Reuter
ph: (212) 925-1403
fax: (212) 925-2239

Polaroid 20x24 Studio (San Francisco)
Blue Sky Rental Services
2325 3rd Street
San Francisco, CA 94107
studio manager: Tracy Storer
ph: (510) 526-8581
www.mammothcamera.com

Polaroid 20x24 Studio (Prague)
Studio 3000
Cistovicka, 44
CZ-16300
Prague, Czech Republic
director: Jan Hnizdo
ph: 011-420-230-22787
fax: 011-420-230-24606

Polaroid Workshops, Instruction, and Seminars

Many photography instructors around the country have expanded their curriculums to include instruction in Polaroid manipulations and transfers. Community education courses available through junior colleges are a good place to look for these classes. Off campus, your local camera store or art center may know of, or even sponsor, private classes.

You can also look on the Polaroidwork.com website for a listing of instructors, and check the Shaw Guides workshop resource under photography at www.shawguides.com. And, refer to the artist contact information below; many artists teach workshops.

Technical Resources

The Land List at www.landlist.org—Marty Kuhn's thorough site on Polaroid cameras, accessories, and films—is another resource. Also try George's SX-70 Pages, or The Hacker's Guide to the SX-70, at www.chemie.unibas.ch/~holder/SX70.html and Polaroid transfer and SX-70 resource Marek Uliasz at www.frii.com/~uliasz/photoart/polaroid. Information, galleries, books, and links on Polaroid art.

Rich DeFerrari
ph: (781) 878-6338
email: RDeFerrari@aol.com
DeFerrari is a former Polaroid technical specialist who is available on a consultant basis for problem solving, seminars, and the like.

Other Photography Suppliers, Services, and Manufacturers

You can find Daylab slide printers and Polaroid film at most larger camera stores and mail order companies. If you can't find Daylab slide printers in a store, have your dealer order them from Daylab.

You can order Kodak color correction (CC) and color printing (CP) filters, and Rosco lighting gel samplers through your local photography outlet, as well as through mail order companies. You can also contact Rosco for sampler packs.
Note: For older Polaroid cameras, you can purchase batteries through Polaroid. The following are companies I've dealt with that supply equipment, Polaroid film, and photographic supplies.

Adorama, Inc.
42 West 18th Street
New York, NY 10011
orders: (800) 223-2500
information: (212) 741-0052
fax: (212) 463-7223
www.adorama.com
Retailer with excellent prices on film, great catalog, good service, and prompt delivery.

B&H Photo-Video
420 Ninth Avenue
New York, NY 10011
ph: (800) 606-6969
fax: (800) 947-7008
www.bhphotovideo.com
Retailer with a huge inventory of new and used photographic equipment and supplies, excellent prices on film, and prompt delivery.

Calumet Photographic, Inc.
890 Supreme Drive
Bensenville, IL 60106
ph: (800) CALUMET
fax: (800) 577-FOTO
www.calumetphoto.com
Call for a catalog with many photographic items, including Polaroid and Daylab equipment.

Columbus Camera Group, Inc.
55 East Blake
Columbus, OH 43202
orders: (800) 325-7664
information: (614) 267-0686
fax: (614) 267-1037
www.columbuscameras.com
Short-dated Polaroid and other films for good prices.

Cress Photo
P.O. Box 4262
Wayne, NJ 07474-4262
ph: (973) 694-1280
fax: (973) 694-6965
www.flashbulbs.com
www.flashpans.com
www.rollei35cameras.com
World's largest distributor of photographic flashbulbs, flashguns, the SFX70 flash, and related products. Cress also provides technical information and special effects.

Four Designs Co.
20615 NE 22nd Avenue
Ridgefield, WA 98642
orders: (800) 468-3399
tech line: (360) 887-1555
fax: (360) 887-1549
www.fourdesigns.com
Source for quality refurbished Polaroid products, custom conversions, and repairs on Polaroid cameras and equipment.

Freestyle Photo
5124 Sunset Boulevard
Los Angeles, CA 90027
orders: (800) 292-6137 or
 (323) 660-3460
fax: (800) 616-3686 or
 (323) 660-4885
www.freestylesalesco.com
Offers free shipping in California, and a free catalog four times a year, with a friendly staff.

Fuji Photo Film USA, Inc.
ph: (800) 800-FUJI
www.Fujifilm.com
Manufacturer of slide films for use with Daylab slide printers.

Kodak, Inc.
www.kodak.com
Manufacturer of slide films for use with Daylab slide printers.

Porter's Camera Store, Inc.
Box 628
Cedar Falls, IA 50613-0628
orders: (800) 553-2001
customer service: (800) 682-4862
fax: (800) 221-5329
www.porters.com
Catalog filled with the usual, plus some rather unusual items; technical questions answered about products.

Precision Camera and Video Repair, Inc.
41 Sheridan Street
Chicopee, MA 01020
ph: (800) 655-6515
fax: (413) 594-7298
www.precisioncamera.com
Repairs Polaroid and other cameras.

Art Supplies (Retail)

Brayer rollers, burnishing tools, ceramic tools, watercolor and other types of papers and surfaces, and handcoloring materials such as pencils, paints, and pastels are available from most art supply stores and mail order catalogs. Mail order ready-made mats and frames are a low-cost alternative to custom framing.

Artists' Connection
20 Constance Court
P.O. Box 13007
Hauppauge, NY 22788-0533
ph: (800) 851-9333
fax: (800) 852-9333

Daniel Smith
4150 First Ave. South
P.O. Box 84268
Seattle, WA 98124-5568
ph: (800) 426-7923 or
 (206) 224-0411
fax: (800) 238-4065 or
 (206) 224-0406
www.danielsmith.com
Art paper and materials, plus archival art and photo supplies.

Dick Blick
P.O. Box 1267
Galesburg, IL 61402-1267
ph: (800) 828-4548 or
 (309) 343-6181
fax: (800) 621-8293
email: info@dickblick.com
www.dickblick.com
A popular and extensive mail order catalog.

Graphik Dimensions Ltd.
2103 Brentwood Street
High Point, NC 27263
ph: (800) 221-0262
www.pictureframes.com
Mats, frames (a wide variety of metal and wood frames), and framing supplies.

The Jerry's Catalog
5325 Departure Drive
Raleigh, NC 27616
ph: (800) 827-8478
www.jerryscatalog.com
Popular catalog; good prices.

Light Impressions
P.O. Box 22708
Rochester, NY 14692-2708
ph: (714) 441-4539
customer service: (800) 828-6216
fax: (800) 828-5539
email: LiWebsite@limpressions.com
www.lightimpressionsdirect.com
An excellent selection of archival materials for presentation and storage of your work; mail order catalog available.

New York Central Art Supply
62 Third Avenue
New York, NY 10003
ph: (800) 950-6111 or
 (212) 473-7705
fax: (212) 477-0400 (24 hours)
email: sales@nycentralart.com
www.nycentralart.com
Art supplies, and handmade and art papers.

Orille Enterprises
7971 Center Parkway
Sacrmento, CA 96823
ph: (916) 424-8637
email: eorille@yahoo.com
Custom mats, reasonable prices, and quick service.

Structural Industries
96 New South Road
Hicksville, NY 11801
ph: (800) 645-3993 or
 (576) 822-5200
fax: (516) 822-5207
email: info@structuralindustries. com
www.structuralindustries.com
Good prices on frames.

University Products, Inc.
517 Main Street
P.O. Box 101
Holyoke, MA 01041-0101
orders: (800) 628-1912
fax: (800) 532-9281
customer service: (800) 336-4847
email: custserv@universityproducts. com
www.universityproducts.com
A large selection of hard-to-find archival museum-quality presentation items, and products you didn't realize you needed.

Art Supplies (Manufacturers)

Ampersand Art Supply
1500 East 4th Street
Austin, TX 78702
ph: (800) 822-1939
fax: (512) 322-9928
email: bords@ampersandart.com
www.ampersandart.com
Clayboard products.

Blair Art Products (Loctite Corp.)
1001 Trout Brook Crossing
Rocky Hill, CT 06067
ph: (800) 842-0047
fax: (203) 571-5430
Spray fixatives.

Bookmakers International
6701B Lafayette Avenue
Riverdale Park, MD 20737
ph: (301) 927-7787
fax: (301) 927-7715
Bookmaking tools and supplies.

Brandess Kalt Aetna Group
701 Corporate Woods Parkway
Vernon Hills, IL 60061
ph: (847) 821-0450
fax: (847) 821-5410
email: bkaservice@bkaphoto.com
www.marshallcolors.com
www.bkaphoto.com
Marshall's oil paints, pencils, wands, retouching dyes, art supplies.

Caba Paper Company
1310 Don Gaspar Avenue
Santa Fe, NM 87505-4628
ph: (505) 983-1942
fax: (505) 988-7183
orders: (800) 877-5754
www.handmadepapers.com
Handmade bark paper and bark paper sketchbooks.

Canson, Inc.
www.Canson-us.com
www.Talens.com
French art paper manufacturer. Canson's papers and their Rembrandt pastels are at art supply stores worldwide.

Caran d'Ache
19 West 24th Street
New York, NY 10010
ph: (212) 689-3590
fax: (212) 463-8536
Water soluble wax crayons, wax oil crayons.

DecoArt, Inc.
P.O. Box 386
Stanford, KY 40484
ph: (800) 367-3047
www.decoart.com
Specialty art painting supplies.

Deka Paints & Dyes (Decart Inc.)
Lamoille Industrial Park
Box 309
Morrisville, VT 05661
ph: (802) 888-4217 or
 (800) 232-3352
fax: (802) 888-4123
*Fabric paints and dyes. Catalog
available.*

Design A Card/Art Deckle
P.O. Box 5314
Englewood, FL 34224
ph: (941) 475-1121
fax: (941) 475-2773
www.ArtDeckle.com
*The tool for real deckle edges or
templates for special effects on paper.*

Fiskars
305 84th Avenue South
Wausu, WI 54401
ph: (600) 233 8767
www.fiskars.com
*Specialty scissors, paper edgers, rotary
trimmers, papers, and burnishing tools.*

Golden Artist Colors, Inc.
Bell Road
New Berlin, NY 13411
ph: (607) 847-6154
fax: (607) 847-6767
*Artist colors, varnishes, and protec-
tive coatings.*

Griffin Mfg Co., Inc.
1656 Ridge Road East
P.O. Box 308
Webster, NY 14580
ph: (716) 265 1991
fax: (716) 265 2621
email: grifhold@aol.com
*Precision cutting tools and specialty
art items.*

Hunt Corporation
One Commerce Square
2005 Market Street
Philadelphia, PA 19103-7085
ph: (800) 955-4868 or
 (215) 656-0300
www.hunt-corp.com
*Conté crayons and pencils; X-Acto
and Bienfang products.*

Impact Images
4961 Windplay Drive
El Dorado Hills, CA 95762
ph: (916) 933-4700 or
 (800) 233-2630
fax: (916) 933-4717
www.clearbags.com
*Clear bags for storing and display-
ing prints.*

Jacquard Products
Rupert, Gibbon & Spider, Inc.
P.O. Box 425
Healdsburg, CA 95448
ph: (707) 433-9577 or
 (800) 442-0455
fax: (707) 433-4906
email: orders&info@jacquard-
products.com
www.jacquardproducts.com
*Pearl-Ex, textile paints and dyes,
natural fiber fabrics, and creative
kits. Available at arts-and-craft
supply stores everywhere.*

Krylon
31500 Solon Road
Solon, OH 44139
hotline: (800) 4-KRYLON
ph: (216) 498-2300
fax: (800) 243-3075
*Clear aerosol coatings, art sprays,
and a variety of spray paints.*

Lineco
P.O. Box 2604
Holyoke, MA 01040
ph: (800) 322-7775 or
 (413) 534-7204
fax: (800) 298-7815 or
 (413) 534-7815
www.lineco.com
*Archival photo supplies available
at most art stores and Michael's
Stores.*

Liquitex Acrylics (Binney and
Smith)
P.O. Box 431
Easton, PA 18044-0431
ph: (610) 253-6272
fax: (610) 253-5267
*In addition to Liquitex acrylics,
Binney and Smith produces oil
paints, painting mediums, markers,
and brushes.*

Loew-Cornell, Inc.
563 Chestnut Avenue
Teaneck, NJ 07666
www.loew-cornell.com
*Brushes, tools, and accessories for
the artist, ceramist, and hobbyist.
Available through arts-and-craft
stores.*

Masterpiece Artist Canvas, Inc.
1415 Bancroft Avenue
San Francisco, CA 94124
ph: (415) 822-8707
fax: (415) 822-2124
www.masterpiecearts.com
*Stretched canvases in 100 percent
cotton, Belgium linen, and portrait
smooth. Sizes from 4x4 inches to
48x72. Handcrafted in the United
States. Catalogs available.*

McDonald's Protectacote
(Sureguard)
2350 114th Street
Grand Prairie, TX 75050
ph: (214) 647-9049
fax: (214) 606-0098
Protective photo lacquers.

Nielsen Bainbridge
40 Eisenhower Drive
Paramus, NJ 07652
ph: (800) 526-9073 or
 (201) 368-9191
fax: (201) 368-0224
email: info@nielsen-bainbridge.
com
www.nielsen-bainbridge.com
*Aluminum moldings; wall frame
collection includes mats, hardware,
backing, and glass or Plexiglas;
Letraset Tria markers.*

Preservation Technologies
111 Thomson Park Drive
Cranberry Township, PA 16066
ph: (800) 416-2665 or
 (724) 779-2111
fax: (724) 779-9808
www.ptlp.com
*Products and services that neutral-
ize acid in paper, using no toxic,
flammable, or environmentally
dangerous chemicals.*

Pro Tapes & Specialties
100 Northfield Avenue
Edison, NJ 08837
ph: (800) 345-0234
fax: (732) 346-0777
email: sales@protapes.com
www.protapes.com
*Pressure sensitive tapes for graphic
and specialty arts.*

Rosco Laboratories, Inc.
1120 North Citrus
Hollywood, CA 90038
ph: (800) ROSCO LA or
 (323) 462-2233
fax: (323) 462-3338
email: info@rosco.com
www.rosco.com
*Manufacturers of cine gels and
reflector materials. See website for*

local dealers and catalog.

Savoir-Faire
40 Levaroni Court
Novato, CA 94949
ph: (800) 332-4660 or
 (415) 884-8090
fax: (415) 884-8091
email: info@savoir-faire.com
www.savoir-faire.com
*Importers of fine materials for the
arts. See website for local dealers.*

Speedball Art Products
Company
P.O. Box 5157
2226 Speedball Road
Statesville, NC 28687
ph: (704) 838-1475
fax: (704) 838-1472
www.speedballart.com
*Manufacturer of pens, rubber brayers,
and other art products. See website
for local dealers.*

SpotPen
P.O. Box 1559
Las Cruces, NM 88004
ph: (505) 523-8820
fax: (505) 647-8786
Photo retouching and spotting pens.

Winsor & Newton (ColArt
Americas, Inc.)
P.O. Box 1396
Piscataway, NJ 08855-1396
ph: (908) 562-0770
fax: (908) 562-0941
*Watercolors, inks, and acrylics.
North American distributor of
Derwent fine art pencils. Catalog
available.*

Digital Suppliers and Resources

You can purchase a flatbed or
transparency scanner through
local computer stores, computer
mail order catalogs, ads in digi-
tal photography and computer
magazines (such as *MacWorld*
and *PC World*), or from com-
puter manufacturers' websites.
In addition, many websites offer
information about digital print-
ing with inkjet printers and
about purchasing color manage-
ment systems, inks, and media
for printers.

Adobe Systems, Inc.
www.adobe.com
*Software updates, new products,
and technical help.*

Apple
www.apple.com
Apple computers, products, and services.

Atlantic Exchange, Inc.
www.atlex.com
Inkjet and media information and sales; great prices.

Auto FX Software
31 Inverness Center Parkway, Suite 270
Birmingham, AL 39242
ph: (205) 980-0056
fax: (205) 980-1121
www.autofx.com
Special Effects Software, which can be purchased via the company's website or by phone.

The Big Picture
www.bigpicture.net
Wide-format printer information.

Brightcube, Inc.
www.brightcube.com
Developer and provider of digital imaging technology, products, and services.

CIS-Continuous Inking Systems
6516 Forest Ridge Drive
Durham, NC 27713
email: questions@nomorecarts.com
www.nomorecarts.com
Manufacturer of the first continuous ink-feed systems for Epson printers in the United States.

Cnet News
news.cnet.com/news
Product comparisons.

Colorblind
www.color.com
Color management systems including Prove it! monitor calibration, Colormatic Matchbox, and Colorblind Professional.

ColorVision
www.colorcal.com
Digital color control, color calibration system.

Digital Dog
www.digitaldog.net
Color management information and tips.

Digital Fine Art Magazine
www.digitalfineart.com
Excellent magazine.

Energy Federation, Inc.
www.efi.org/products/lighting
Verilux Happy Eyes viewing lights.

Epson America, Inc.
3840 Kilroy Airport Way
Long Beach, CA 90806
ph: (800) 463-7766
www.epson.com
Image-capture and image-output products—including color inkjet printers, color flatbed scanners, digital cameras, and LCD projectors—for the consumer, business, graphic arts, and photography markets.

Graphic Software
www.graphicsoft.about.com
Links to Photoshop and digital printing articles.

Handcolor.com
www.handcolor.com
Information, resources, tips, and links about handcoloring.

Ilford
www.ilford.com/html/us_english/prod_html/archiva/archiva.html
Archival inks, papers.

Improved Technologies
www.itnh.com
Digital imaging equipment.

Inkjet Mall
www.inkjetmall.com
Archival papers, inks, inkjet research.

Leben
www.leben.com/lists/
Online discussion of Epson inkjet printers and printing issues.

Legion Paper (NY)
11 Madison Avenue
New York, NY 10010
ph: (800) 278-4478
international: (212) 683-6990
fax: (800) 275-3380

Legion Paper (CA)
6333 Chalet Drive
Los Angeles, CA 90040
ph: (800) 727-3716
fax: (562) 927-6100
email: info@legionpaper.com
www.legionpaper.com
Leading supplier of digital fine art papers. Contact for local distributors

Media Street
www.mediastreet.com
Generations inks.

MIS Associates, Inc.
www.inksupply.com
MIS inks, inkjet supplies.

Monaco Systems
www.monacosys.com
Color calibration software.

Parrot Digigraphic
www.parrotcolor.com
Solutions, color management.

Photoshop for Photographers Online
www.photoshopforphotographers.com
Color management excerpts from the book of the same name.

Photoshop User magazine
www.photoshopuser.com
Excellent magazine for information and tips.

Profile City
www.profilecity.com
Profiling tools and services.

Roland
www.rolanddga.com
Large-format, eight-color printers.

The Stock Solution
www.tssphoto.com
Inkjet materials; InkjetArt.com.

Verilux, Inc.
ph: (800) 786-6850
www.verilux.net
Manufacturer of Happy Eyes daylight-balanced viewing and reading lights.

Wacom Technology Corporation
1311 SE Cardinal Court
Vancouver, WA 98683
ph: (800) 922-1488 or
 (360) 896-9833
fax: (360) 896-9724
www.wacom.com
Manufacturer of computer graphics tablets and pen systems. See website for local dealers.

Wide Format Printers
www.wide-format-printers.org

Wilhelm Imaging Research, Inc.
www.wilhelm-research.com
Print longevity research.

Worldwide Imaging Supplies
www.WeInk.com
Inkjet supplies.

Digital Studios

Service bureaus and digital studios can scan transfers, enhance them, and output the images for you. Check your local area; more digital studios appear all the time. Research first for quality, cost, and service. Depending on how you want to output the transfer, you may want to ship your transfers, or transparencies of them, to a specialty digital studio. I list serveral that I've used or that have been highly recommended.

Color Folio
2550 Lewis Drive
Sebastopol, CA 95472
ph: (888) 212-7060 or
 (707) 824-8910
fax: (707) 824-8635
email: bob@colorfolio.com
www.colorfolio.com
Full range of services including scanning; imaging, and fine are Giclée, Lightjet, Fujix Pictrography 4000, and Piezography black-and-white printing. Also offers digital workshops and consulting.

Harvest Productions
(same address as previous listing)
ph: (714) 279-2300
fax: (714) 279-2301
www.harvestproductions.com
The largest giclée printer worldwide with ten Iris 3047 printers.

Nash Editions
2317 North Sepulveda Boulevard
Manhattan Beach, CA 90266
ph: (310) 545-4352
fax: (310) 796-1418
www.nasheditions.com
The first fine art digital studio (opened in 1991 by Graham Nash and R. Mac Holbert), it's still one of the finest for Iris printing.

Skylark Images
365 Tesconi Circle, Suite B
Santa Rosa, CA 95401
ph: (707) 528-9192
fax: (707) 528-9195
email: info@skylarkimages.com
www.skylarkimages.com
Specializes in fine art print services for artists and photographers, with an extensive line of giclée printers, including Iris 3047, 8 Color 52" Roland, 72" Mach 12 Color Span, and Iris 3047 dedicated to black-and-white output.

Thunderbird Editions
34 North Fort Harrison Avenue
Clearwater, FL 33755
ph: (727) 449-0949
fax: (727) 442-6919
www.motors.com

Gallery Artists

Armadillo Artworks
Mitchell Shenker and Diane
Dias
101 Valley Circle
Mill Valley, CA 94941
ph: (415) 381-2240
fax: (415) 383-5136
email: armadillos@earthlink.net
www.armadilloarts.com
*Giclée prints of any image in the
print collection in several sizes for
sale. Call for information.*

Tony De Bone
ph: (510) 655-7559
fax: (510) 652-4354
email: goldentony@aol.com
*20x24 Polaroid image transfers;
3x4, 4x5, and 8x10 Polaroid for-
mats; and multiple-image formats.
Accepts commissions. Available for
slide lectures and workshops.*

Dayle Doroshow
Zingaro: Stamp of Distinction
P.O. Box 354
Fort Bragg, CA 95437
ph: (707) 962-9419
email: dayledoroshow@hotmail.
com
*Workshops, and handcrafted wear-
able art and home decor for sale.*

1Barbara Elliott
1045 Blue Oak Place
Santa Rosa, CA 95404
ph: (707) 538-4070
email: beemine@sonic.net
www.barbaratransfers.com
*Barbara Elliott's work can be
found at Kiss My Ring, 2514
San Pablo Avenue, Berkeley, CA
94702, (510) 540-1282, and at
HeeBee Jeebe, 46 Kentucky Street,
Petaluma, CA 94952,
(707) 773-2880.*

Joan Emm
Joan Emm Photography
P.O. Box 2465
Fort Bragg, CA 95437
ph: (707) 964-6319
fax: (707) 964-7265
email: joanemm@mcn.org
www.joanemm.com
*Two day workshops for individual/
small group instruction at her studio
or elsewhere. Offers handaltered
SX-70 images and giclée prints on
canvas. Represented by the Wilkes
Bashford Company, WilkesSport,
10466 Lansing Street, Mendocino,
CA 95469, (707) 937-1357.*

Davis Freeman
Davis Freeman Photography
365 Wheeler Street
Seattle, WA 98109
ph: (206) 284-1767 or
 (800) 995-6223
fax: (206) 284-6831
email: davis@davisfreeman.com
www.davisfreeman.com
*Portrait photographer working with
corporate, advertising, and graphic
design firms and individuals to create
unique images in black and white,
color, or Illustratype. Available for
assignment anywhere in the world.*

Michael Going
Michael Going Photography
ph: (323) 913-0034
email: mg@goinggallery.com
www.goinggallery.com
*Fine art prints, private workshops,
lectures, stock licensing, commercial
assignment commissions.*

Cynthia Johnson-Bianchetta
Burns Creek, Hwy 1
Big Sur, CA 93920
ph/fax: (831) 667-2502
email: cjohnsonbianchetta@
earthlink.net
www.sacredearthphotography.net
*Johnson-Bianchetta offers work-
shops for Esalen Institute, Big Sur,
CA; Taos Institute of Arts in New
Mexico; and at her home/studio in
Big Sur. She exhibits her work at
the Gallery Guesthouse B&B in
Big Sur and her studio in Carmel.*

Dewitt Jones
Dewitt Jones Productions, Inc.
416 Durant Way
Mill Valley, CA 94941
ph: (415) 381-9993
fax: (208) 692-1523
email: Dewitt@DewittJones.com
www.DewittJones.com
*Prints available from the artist or
from Kamakana Fine Arts Gallery,
Ala Malama Avenue, Suite 210,
Molokai, HI 96748.*

Kenario
Ken Dorr and Mario Marchiaro
Kenario Fine Art Photography
Gallery
384 North Palm Canyon Drive
Palm Springs, CA 92262
ph: (760) 318-9111 or
 (877) KENARIO
email: art@kenario.com
www.kenario.com
*Fine art photography, specializing
in Polaroid SX-70 manipulation.*

Wendell Minshew
3320 Wood Lane
Cameron Park, CA 95682
ph: (530) 672-1245
fax: (530) 676-4234
email: minshew@pacbell.net
*Giclée prints of original Polaroid
images; personal and group work-
shops on Polaroid emulsion transfers
and SX-70 manipulations; scan-
ning and digital reproduction and
assistance; workshops in traditional
photography techniques.*

Elizabeth Murray
62 Ave Maria Road
Monterey, CA 93940
ph: (831) 375-1613
fax: (831) 375-2953
email: emurray@sacredsite.com
www.elizabethmurray.com
*Offers workshops, custom commis-
sions, books— Painterly
Photography: Awakening the
Artist Within (Pomegranate
Publications: 800-227-1428)—
and posters of Painterly Photos.
Gallery: Photography West Dolores
and Ocean, Carmel, CA 93921,
(831) 625-1587.*

Elizabeth Opalenik
5921 Chabot Crest
Oakland, CA 94618
ph: (510) 652-6414
fax: (510) 652-6414
email: elizabeth@opalenik.com
www.opalenik.com
*Fine art sales and stock, represented
by Amy Sarat Gallery in Sonoma,
CA, and Corbis StockMarket.
Editorial assignments sought and
workshops offered throughout the
United States, France, and Italy
on the figure and alternative
processes.*

Catherine Peters
Monet Miracle
323 Bridge Way
Nevada City, CA 95959
ph: (510) 478-9359
fax: (510) 478-9598
email: cathpeters@yahoo.com
www.monetmiracle.com
*SX-70 photo art instruction videos,
tools, and illustrated manual.*

John Reuter
Polaroid 20x24 Studio
588 Broadway, Suite 1010
New York, NY 10012
ph: (212) 925-1403
fax: (212) 925-2239
email: mail@johnreuter.com
www.johnreuter.com
*Photographer, educator, and digital
artist. Represented at the Catherine
Edelman Gallery in Chicago.*

Louise Roach
Pardus, Inc.
28 Moya Loop
Santa Fe, NM 87508
ph: (505) 466-3860
email: Pardus@ix.netcom.com
www.geocities.com/~louiseroach
*Represented by Segreto Gallery in
Santa Fe, NM.*

Ernesto Rodriguez
Ernesto Rodriguez Photography
P.O. Box 2589
Avalon, CA 90704
ph: (310) 510-0541
fax: (310) 510-3543
email: Roigas@aol.com
*Images available through Harvest
Fine Art Publishing at (714)
279-2300, New Era Publishing
at (512) 928-3200, and Grand
Image at (800) 900-3551.*

Amelia Tierney
Tierney Fetty Studios
5507 John Anderson Highway
Flagler Beach, FL 32136
ph: (904) 439-2546
fax: (904) 439-4777
email: amimilia@aol.com
www.ameliatierney.com
Fine art photographs for sale.

Anna Tomczak
340 New York Avenue
Lake Helen, FL 32744
ph: (904) 228-3404
fax: (904) 228-3274
email: atom@ixnetcom.com
www.annatomczak.com
Workshops in Polaroid transfer, alternative processes, handpainting, and artist bookmaking. Yearly workshops through ARTIS to Florence, Italy; The Atlantic Center for the Arts, New Smyrna Beach, FL; and the Chautauqua Institute, NY. She is represented by numerous galleries in the United States.

Joanne Warfield
Venice, California
ph: (310) 313-2297
fax: (310) 313-1913
email: Joanne@JoanneWarfield
FineArt.com
www.JoanneWarfieldFineArt.com
Fine art photography specializing in alternative processes as well as stock photography. Designs music CD covers, and accepts commissions for public and private installations. Fine art prints available.

Other Artists

Theresa Airey
1222 Corbett
Monkton, MD 21111
ph: (410) 771-4318
fax: (410) 771-4432
email: aireyt@aol.com
Offers private workshops on Polaroid processes, handcoloring, infrared (digital and traditional), and digital printmaking in her home studio. She is the author of Creative Photo Printmaking *(Amphoto Books, 1996) and* Creative Digital Printmaking *(Amphoto Books, 2001).*

Linda Barrett
Kozo Arts
1969A Union Street
San Francisco, CA 94123
email: lmbphoto@aol.com
www.kozoarts.com
Offers workshops and information on using various transfer methods for book projects.

Judi Bommarito
Judi PHOTOgraphics
13938 Renfrew Court
Sterling Heights, MI 48312
ph: (810) 446-8784
email: jabphotos@home.com
Fine art conceptual still lifes and collage art.

Patti Bose
2 Mariano Road
Santa Fe, NM 87505
ph: (505) 466-6652
fax: (505) 466-6653
email: bosepics@rt66.com
Bose is available for assignment, stock, and print, and teaches workshops. She has taught at Southeast Center for Photographic Studies in Daytona Beach, Florida.

Diane Fenster
ph: (650) 355-5007
email: fenster@sfsu.edu
www.dianefenster.com
Fine art digital photography and photoillustration. Representation: Gallery Henoch, New York, NY.

Heath Frost
2 Moyer Place
Oakland, CA 94611
ph: (510) 655-5090
fax: (510) 655-3448
email: hfrost@speakeasy.net
Polaroid transfer prints, photographs, and handmade artists' books.

Jack Iskin
6064 Dassia Way
Oceanside, CA 92056
ph: (760) 941-7002
Offers classes in creative photography through Palomar College in San Marcos, CA, at www.palomar. edu; ph: (760) 744-1150.

Christopher Knoppel
XTOPHE
3660 Country Club Drive
Redwood City, CA 94061
ph: (650) 368-6757
email: CKnoppel@aol.com
Private and group workshops, including Polaroid emulsion and image transfers/mixed media techniques. Original art work for sale.

Aubri Lane
Aubri Lane - Fine Art
Photography
P.O. Box 73
Graton, CA 95444
ph: (707) 829-5651
email: aubri_lane@yahoo.com
Original artwork, photographic prints, greeting cards.

Diana Lee
ph: (707) 568-5889
email: diana@dianalee.com
www.dianalee.com
Professional artist available for technical and fine art drawings, and print and T-shirt sales.

Norman Locks
email: norman@cats.ucsc.edu

Amy Melious
Grain of Sand
P.O. Box 87
Willits, CA 95490
ph: (707) 459-9286
fax: (707) 459-9286
email: amy@grainofsand.com
www.grainofsand.com
Private commissions, and sales of original artworks and reproductions. Permanent display at North Coast Artists gallery in Fort Bragg, CA.

Maureen Mongrain
2628 N. Willamette Boulevard
Portland, OR 97217
ph: (503) 314-7103
email: light_box@mindspring.com
Owner of the Lightbox, designs and makes her own jewelry line. Custom commissions. Polaroid transfers and manipulations, large-format photographs, and monoprints also available.

Patricia (Friedman) Ross
416 Donahue Street
Sausalito, CA 94965
ph: (415) 331-1979
email: ep42n8@msn.com

Lucas Samaras
Pace Wildenstein Gallery
32 East 57th Street
New York, NY 10022
ph: (212) 421-3292

BIBLIOGRAPHY

Books

Adobe Creative Team. *Adobe Photoshop 5.0 User Guide.* San Jose, California: Adobe Systems, Inc., 1998

Airey, Theresa. *Creative Digital Printmaking: A Photographer's Guide to Professional Desktop Printing.* New York: Amphoto Books, 2001

Airey, Theresa. *Creative Photo Printmaking.* New York: Amphoto Books, 1996

Blacklow, Laura. *New Dimensions in Photo Imaging.* Focal Press, 1995

Blatner, David and Bruce Fraser. *Real World Photoshop 6.* Berkeley, California: Peachpit Press, 2000

Boursier, Helen T. *Watercolor Portrait Photography: The Art of Polaroid SX-70 Manipulation.* Buffalo, New York: Amherst Media, Inc., 2000

Carr, Kathleen Thormod. *Polaroid Transfers: A Complete Visual Guide to Creating Image and Emulsion Transfers.* New York: Amphoto Books, 1997

Cohen, Sandee and Robin Williams. *The Non-Designer's Scan and Print Book.* Berkeley, California: Peachpit Press, 1999

Columbus, Nicole, ed. *Innovation, Imagination: 50 Years of Polaroid Photography.* New York: Harry N. Abrams, Inc., 1999

Evening, Martin. *Adobe Photoshop 6 for Photographers: A Professional Image Editor's Guide to the Creative Use of Photoshop for the MacIntosh and PC.* Woburn, Massachusetts: Focal Press, 2000

Gibson, Ralph, ed. *SX-70 Art.* New York: Lustrum Press, Inc., 1979

Grey, Christopher. *Photographer's Guide to Polaroid Transfer Step by Step.* Buffalo, New York: Amherst Media, Inc., 1999

Gruber, L. Fritz, ed. *Selections 1.* Schaffhausen: Verlag Photographie, 1982

Hirsch, Robert and John Valentino. *Photographic Possibilities: The Expressive Use of Ideas, Materials and Processes* (second edition). Focal Press, 2001

Hitchcock, Barbara. *Selections 5.* Cambridge, Massachusetts: The Polaroid Corp., 1990

Hitchcock, Barbara. *Selections 4.* Cambridge, Massachusetts: The Polaroid Corp., 1988

Jacobs, Jr., Lou. *Instant Photography.* New York: Lothrop, Lee and Shepard Company, 1978

Langford, Michael. *The Instant Picture Camera Book.* New York: Alfred A. Knopf, 1987

Langford, Michael. *The Book of Special Effects Photography.* New York: Alfred A. Knopf, 1981

LaPlantz, Shereen. *Cover to Cover, Creative Techniques for Making Beautiful Books, Journals and Albums.* New York: Lark Books, 1995

Locks, Norman. *Familiar Subjects.* San Francisco: The Headlands Press, 1978

Murray, Elizabeth. *Painterly Photography: Awakening the Artist Within.* Petaluma, California: Pomegranate Artbooks, 1993

Olshaker, Mark. *The Polaroid Story.* Briarcliff Manor, New York: Scarborough House, 1978

Rose, Carla. *Teach Yourself Adobe Photoshop 6 in 24 Hours.* Indianapolis: Sams Publishing, 2001

Samaras, Lucas, *Photo-Tranformations.* New York: E. P. Dutton & Co., Inc., 1975

Sayag, Alain, ed. *Selections 2.* Schaffhausen: Verlag Photographie, 1984

Sealfon, Peggy. *The Magic of Instant Photography.* Boston: CBI Publishing Company, Inc., 1983

Sicilia, Dominic. *Instant Photo, Instant Art.* Los Angeles: Price/Stern/Sloan Publishers, Inc., 1977

Smith, Becky and Scott. *Pola Painting: The Art of SX-70 Manipulation.* Self-published, 1999

Steadman, Ralph. *Paranoids.* London: Harrap Limited, 1986

Sullivan, Constance, ed. *Legacy of Light.* New York: Alfred A. Knopf, 1987

Ulrich, David. *The Widening Stream: The Seven Stages of Creativity.* Beyond Words Publishing, Inc., 2002

Wensberg, Peter C. *Land's Polaroid.* Boston: Houghton-Mifflin Company, 1987

Wilhelm, Henry. *The Permanence and Care of Color Photographs.* Grinnell, Iowa: Preservation Publishing Company, 1993

Articles

DeNicola, Linda. "Hidden Lives." *Digital Fine Art Magazine* (spring, 2001): 28–52

Wasserman, Cary. "SX-70 Manipulation." *Darkroom Techniques* (March/April 1983): 54–56

———. "Making Their Mark." *Test*, vol. VII (spring/summer 1992): 10–11

———. "So You Don't Have an SX-70 Camera." *Test*, vol. VII (spring/summer 1992): 12

Williams, Tina. "Pressing Tools of the Trade." *Test*, vol. VIII (fall/winter 1993): 5–8

Booklets

Creative Techniques. Cambridge, Massachusetts: Polaroid Corporation

Instant Innovations: Creative Uses for Polaroid Film. Cambridge, Massachusetts: Polaroid Corporation, 1992

Periodicals

Kelby, Scott, ed. *Photoshop User*, vol. 3, no. 6 (special edition 2000)

Lester, Peter, ed. *Polaroid International Photography Issue 18.* Hertfordshire, England: Polaroid Europe, 1999

Lester, Peter, ed. *Polaroid International Photography Issue 19.* Hertfordshire, England: Polaroid Europe, 2000

Lester, Peter, ed. *Polaroid International Photography Issue 20.* Hertfordshire, England: Polaroid Europe, 2000

Online Books

Dupré, Holly. *Polaroid Image Transfers Tools and Techniques.* www.pacificsites.com/~hdupre/, (1997)

INDEX